WORK
AND
STRUGGLE

WORK AND STRUGGLE

THE PAINTER AS WITNESS
1870-1914

Edward Lucie-Smith and Celestine Dars

PADDINGTON PRESS LTD

NEW YORK LONDON

Library of Congress Cataloging in Publicaton Data

Lucie-Smith, Edward.
 Work and struggle.

 Includes index.
 1. Narrative painting. 2. Labor and laboring
classes in art. 3. Realism in art. I. Dars, Celestine,
joint author. II. Title.
ND1450.L83 754 76-53622
ISBN 0-448-22616-2

Copyright © 1977 Paddington Press Ltd.
All rights reserved
Filmset by Tradespools Ltd., Frome, Somerset
Text and illustrations printed and bound in England by
Garden City Press Ltd., London and Letchworth
Designed by Richard Johnson

IN THE UNITED STATES
PADDINGTON PRESS LTD.
Distributed by
GROSSET & DUNLAP

IN THE UNITED KINGDOM
PADDINGTON PRESS LTD.

IN CANADA
Distributed by
RANDOM HOUSE OF CANADA LTD.

IN AUSTRALIA
Distributed by
ANGUS & ROBERTSON PTY. LTD.

Table of Contents

Narrative Painting-
an introduction

N O GREATER ANTITHESIS CAN be imagined than that existing between the painters who seek nature, things themselves, and those who seek merely the impression of things. The naturalists—like the Italians of the fifteenth century, the Flemings and the Germans—unite an endless series of visual acts in their paintings. They have previously studied each object and every part of it, and assigned each figure its place in the foreground, middle-distance or background, they have learnt anatomy and perspective. They approach objects fully-armed, as if to carry off a golden fleece, and this in truth is what things are for them: sublime riches which they look at with covetous eyes. For they are truly sensual and lovers of the earth and the realities of the earth. Their eyes adjust themselves to each distance and each object; they labor mightily in its pursuit. Reality reigns over the painter like the beloved mistress at the moment of paroxysm.

ORTEGA Y GASSET—*"On Realism in Painting" (1912)*

This book is one of a series designed to explore a hidden aspect of nineteenth century art—the work of the narrative painters who flourished during the period 1870–1914, the golden age between the Franco-Prussian War and the First World War. Almost immediately, two questions arise: "What is a narrative painting?" and "Why have these artists been neglected?"

6

A narrative painting is, as its name suggests, essentially one that tells a story. But there are many ways of telling a story by purely visual means. In the late Middle Ages, Christian art produced the great fresco cycles by Giotto and his followers which are rightly regarded as being among the most important of its achievements. The actual narrative techniques employed—among them the trick of showing two phases of one action within the same frame—still survive centuries afterwards, but only in debased forms such as in newspaper strip-cartoons.

With the coming of the Renaissance, the importance of the narrative element gradually declined. One important reason for this was that art ceased to be popular. It became, instead, increasingly hermetic, and addressed itself to an elite which shunned direct statements. The prejudice against direct narrative, in particular, was not easily removed. Even the religious fervor of the Counter Reformation, with the concurrent interest in making effective propaganda for the Faith, failed to change matters much. The art theorists of the eighteenth century relented a little, at least to the extent that they gave "history painting" a place above all other genres. But history was a word they used in two senses. While it implied that the painting told a story, it also implied, and far more strongly, that it represented a historical or mythological subject. Paintings which represented some aspect of contemporary life were regarded as artistically inferior.

It is at this period that the word "contemporary" becomes crucial. Though the elite disapproved, painters who showed scenes from contemporary life had known an increasing degree of success from the seventeenth century onwards. But the genre painters who flourished in the Dutch "Golden Age" differed from their successors in important respects. They were more interested in the social milieu than in the story it might give rise to. Artists such as Hogarth reintroduced a strong narrative element, and an equally strong and obvious concern for morality, in their depictions of contemporary life. And these works enjoyed a big success, in the form of the reproductive engravings made after them, with a middle-class and lower middle-class public. Narrative painting, which had enjoyed one heyday in the Middle Ages as the instrument of Christianity, was now to enjoy another one as the visual equivalent and parallel of the novel. It is no coincidence that its first real upsurge of activity, in the post-Renaissance period, coincides with the publication of the first recognizably modern novels, such as Richardson's *Pamela*. The painters and the novelists appealed to what was essentially the same audience.

One result of the growth of the novel was that it conditioned people's expectations about the arts in general. Gradually it came to be assumed that the main

business of the artist, in whatever medium he practiced, was to reflect life; and the more perfect the reflection, the more satisfaction the work of art was likely to give. This did not prevent both writers and artists from tackling subjects which had nothing to do with the life they saw being lived around them. Neither painting nor the novel escaped from the historicism of nineteenth-century taste. But the artist tried to paint, and the novelist tried to write, as if he had actually been an eyewitness of what was shown or described. Historical pictures of the period are monuments of (often misguided) historical research.

Yet the paintings that today survive best for us are those where no such effort has been made, and where the painter shows us what is strictly contemporary with himself. There are a number of reasons for this. One is that works with contemporary subjects have a convincing authenticity of detail which springs from a natural command of the material, rather than painstaking toil in museums and libraries. In addition to this, when the nineteenth-century painter tackles a historical subject, his depiction of it is inevitably distorted by his attitudes toward the past. When we look at such paintings today, the attitude counts for more than what is depicted. Of course, personal attitudes and prejudices also affect the presentation of contemporary scenes, but in this case the bias becomes a part of the message which the work of art conveys, and enriches rather than diminishes its value as information.

The paintings reproduced in this book represent, among other things, a rare moment of harmony between the artist and his public. The painters who created these works were for the most part acclaimed and fêted in their own lifetimes. They were loaded with both honors and commissions. They had no reason to doubt what everybody told them: that the art they produced represented a high point in the history of art in general. The approval they enjoyed in their own epoch is one reason that we find it hard to make a sensible assessment of their work today, because it runs counter to our fundamental assumptions about the relationship between art and society.

Before tackling the reasons that painting of this sort went out of favor, we must take a closer look at its situation at the very height of its popularity. The paintings shown here are typical of one aspect of the art to be found in the Salons, the great officially organized and officially sponsored exhibitions which formed the backbone of artistic life and the main channel of patronage, both public and private. But even in the Salons, contemporary realism was not unopposed. It was opposed by historical painting on the one hand, and then, as the years wore on, by kinds of art that seemed to challenge the very basis of realism itself.

8

In the earlier part of the nineteenth century, the conflict to be seen in the Salons had been between the followers of David—the Neo-Classicists—and the followers of Delacroix—the Romantics. To this, in the years after 1870, there succeeded the battle between the Naturalists and the Symbolists. Naturalism and Symbolism were originally designations given to literary, rather than artistic movements, but nevertheless the division in the visual arts was very real, and we cannot understand the painting of the 1870–1914 period without alluding to it.

If the Naturalist, as the label suggests, was content to reflect life, and felt that the inner nature of things was to be deduced by meticulously studying their surface appearances, the Symbolist was far from accepting this proposition. Symbolism sought the inner core of experience, regardless of appearances, and tried to produce an image which would "stand for" what was essentially incommunicable. The tendency of Symbolism was always hermetic. It was not for nothing that Symbolist poets and artists were fascinated by black magic and the occult. In addition to being hermetic, the movement was exclusive. The Symbolists, content to paint and write for the few, often regarded broad popular appreciation as a sign of artistic failure.

In many of its attitudes, Symbolism harked back nostalgically to the "pagan spring" of the early Renaissance. One of the Symbolists' favorite artists was Botticelli, and the thought that secrets were hidden in his works was as attractive as his wistful mood. On the other hand, Symbolism was also the direct precursor of the Modernism which was to spring up during the first decade of the twentieth century.

For the Spanish philosopher Ortega y Gasset, whose description of Naturalist painting is quoted at the head of this essay, the fundamental characteristic of Modernism was what he called "The Dehumanization of Art." He published an essay under this title in 1925. In this great essay, he saw the art of his time reacting away from the democratic popularity which it had courted throughout the nineteenth century:

> Accustomed to dominate in everything, the masses feel that their "rights" are threatened by modern art, which is an art of privilege, an aristocracy of instinct. Wherever the young muses make their appearance, the crowd boos.

One of the things which Ortega y Gasset saw as fundamental to the new art was its avoidance of the human, and this was something of which he approved:

> The works of the nineteenth century, far from representing a normal art, are perhaps the greatest anomaly in the history of taste. All the great periods of art have avoided making the human element the center of gravity in the work of art. That demand for exclusive realism which governed the tastes of the past

century precisely demonstrates an aberration without parallel in the evolution of aesthetics.

Fifty years after these words were written, this emphasis on the human element is an aberration which well deserves to be re-examined.

When debating the aesthetic history of the late nineteenth century, the tendency has been to cast Naturalism in a conservative role and give Symbolism the radical one. Ortega y Gasset at least avoided this error. It is interesting to note, for example, that if we use the words "radical" and "conservative" as strictly political terms, we discover that in France the Symbolists were often men of the right, though elsewhere, particularly in Belgium, Symbolism and Socialism were almost synonymous. On the other hand, Zola, the standardbearer of Naturalism in literature, was very much identified with radical causes, and in particular with the pro-Dreyfus side during the Dreyfus case.

Zola is in many ways a key figure in our understanding not only of the literature, but of the art of his time. Yet his own achievement as a writer is difficult for us to assess. This is because he does his utmost to convince us that the material he is presenting to us is "a slice of life," and that his own contribution is to report what he knows, rather than to re-create it imaginatively. In fact, his novels are so convincing in this sense that it takes some effort to realize the true measure of his talent. To a lesser extent, this is also true of our reaction to many Naturalist paintings.

The attempt to use Zola as a kind of measure for Naturalist art is complicated by his own relationship to painting. Art historians remember him almost exclusively as the friend and defender of the Impressionists. Cézanne was Zola's boyhood companion in Aix; Manet painted a memorable portrait of him. In 1866, Zola, still only at the beginning of his career as a writer, defended Impressionism in *Mon Salon*. Our instinctive reaction, therefore, is to think of Impressionism as supplying a strict equivalent, in the visual arts, of Zola's methods as a writer. In fact, this is not true, and, in looking at the reasons why it is not, we encounter clues which illuminate the achievement of Naturalist painting taken as a whole.

Impressionism is indeed an offshoot of Naturalism—an offshoot of a special sort. Ortega y Gasset doubted its lineage on the grounds that "there are no things, no solid bodies, and space is not a cubic boundary" in typically Impressionist paintings. But to believe this is not to look closely enough. What made Impressionism different from other kinds of Naturalist painting was chiefly its insistence that art could be quasi-scientific, that the painter could proceed according to the laws of optics. The Impressionist treatment of color, which so much shocked people when

10

they first saw the canvases of Monet and Pissarro, is in this sense more intellectual and "conceptual" than true Naturalism would permit itself to be. By the time Impressionism reached its second generation, with the elaborately orchestrated compositions of Seurat, the conceptual element had taken over almost completely. *La Grande Jatte* is as formal as Poussin, and in direct line of descent from him.

Certain painters who showed in the Impressionist exhibitions were already more interested in breaking down current ideas about composition than they were in experiments with color. The two most important form an interesting contrast with one another. One was Cézanne, who was the chief progenitor of the process of dehumanization already alluded to. The other was Degas, who is in fact a key figure in relation to Naturalist art in general—at once its finest flowering, and the man who transcends its limitations.

Degas began as a disciple of Ingres, and some of his early works are ambitious historical compositions—*Semiramis Founding a City, Spartan Girls and Boys Exercising*. In conception, these were old-fashioned even at the time they were painted. Soon, however, the artist became fascinated with the details of ordinary life. Some of his first compositions of this type, such as the *Musicians in the Opera Orchestra*, date from just before 1870. It was soon apparent that Degas' chief originality lay in his total lack of theatricalism, even though subjects from the theater had a permanent fascination for him. It was only gradually, however, that he developed the new compositional formulae, derived from snapshot photography and Japanese prints, which were to distinguish his work. *The Cotton Exchange in New Orleans*, painted in 1873, is still completely conventional in spatial organization, with the figures arranged in a well-defined spatial box, against a grid of windows and partitions.

Yet there was something about this picture that might have seemed innovative to a spectator of the 1870's. This was the absence of overt drama. If Degas is telling a story, it is one about the nuances of daily relationships, of the way in which people are united both by environment and by work done in common. The lack of theatricalism in Degas's art must nevertheless not be taken to imply that the people in his pictures are unaware of one another, though usually they are sublimely unconscious of being regarded from outside.

The particular character of Degas's work brings me to a subject which has, up to now, been very inadequately researched, and this is the close connection between the theater and the painting of the eighteenth and nineteenth centuries. In the eighteenth century, the theater rose to be the art form that encompassed all the

others. Its influence is vividly present in the paintings of Hogarth, a number of which are direct representations of plays. We find similar influences almost everywhere we look, regardless of stylistic affiliation. For example, the theatrical element is very much apparent in the work of the great French Neo-Classicist Jacques-Louis David, and the key work in his career, *The Oath of the Horatii*, might easily show a scene from one of the classical tragedies of the time. Like everyone else, the painters avidly attended the playhouse, and from it they borrowed a whole repertoire of gestures and expressions. Perhaps more important still, their sense of the relationships between the various figures in a narrative composition was colored by what they saw on the stage, and they sought for a particular kind of rather artificial intensity.

After 1870, the theater was undergoing great changes, many of which sprang from the fundamental assumptions of the Naturalist movement in the arts taken as a whole. When George Bernard Shaw served as a theater-critic in the 1890's, he launched an impassioned attack on what he dubbed "Sardoodledom"—the kind of playwriting perpetrated by the popular French dramatist Victorien Sardou and his imitators. Essentially this was an attack on cheap emotionalism and falseness of effect. The kind of drama Shaw wanted had, as he saw it, been pioneered by Ibsen, and he had this to say about the work of the new school:

The conflict is not between clear right and wrong: the villain is as conscientious as the hero, if not more so: in fact, the question which makes the play interesting (when it *is* interesting) is which is the villain and which the hero. Or, to put it another way, there are no villains and no heroes. This strikes the critic mainly as a departure from dramatic art; but it is merely the inevitable return to nature which ends all the merely technical fashions. Now the natural is mainly the everyday; and its climaxes must be, if not everyday, at least everylife, if they are to have any importance for the spectator.

These words cast an interesting, if slightly oblique, light on our reactions to naturalistic genre-painting. Like the theater, painting reacted toward what Shaw called "the everyday." The problem we now have with it is admirably summed up in a question asked by the art historian Fritz Novotny:

One has to ask oneself: does not this kind of painting, by its renunciation of stylization, symbolism, distortion and imagery render itself, precisely because it is so well done, incapable of conveying anything but the merely visible?

In fact, the revolution which has taken place in the visual arts has been so violent that we have almost lost the knack of interpreting painting of this type, and tend to

underrate it for its very virtues, which are those of submission to the thing seen.

What can we expect to gain by looking at these works today, and what is their position in the history of European painting? In the first place, and this is a humble but important function, they provide a magnificent and rather neglected source of information about the time at which they were painted. In comparison with photography (which certainly influenced almost all of the artists whose work is reproduced here), they offer not merely an accidental fragment, but a fully synthesized image. This is not merely how people looked, but how they looked to themselves. On the other hand, the process of synthesis has not been carried so far that we are more conscious of the painting as "art"—as an arrangement of colors and forms on a surface—then we are of it as a representation of something. Ortega y Gasset uses the old metaphor of the work of art as a screen, something which stands between the spectator and what is depicted. Here the screen, if it exists, is so diaphanously transparent that we are scarcely conscious of its presence.

In the second place, they raise the question of the way art functions within the society which produces it. We have seen that Ortega y Gasset dismisses Naturalist art as an anomaly in the history of European painting, and we have seen, too, that he admits its democratic character. His conclusion is that a truly interesting art, in modern circumstances, can only appeal to an elite, and therefore must be at vigorous and perpetual war with the majority. This is a perfectly logical conclusion, given the premise, but it is one which members of the contemporary avant-garde have been increasingly reluctant to accept. Their frantic struggles to escape the elitism of the Modernist aesthetic provide a spectacle which is at once tragic and full of irony.

One of the things we have to realize about the Naturalist style is how triumphant it was in its own day, how completely it dominated European art. In a number of countries—Scandinavia, Russia and Hungary for example—the continuous history of the national school only begins with Naturalism. In general, painting of this type was closely linked to the growth of national consciousness, and yet at the same time the style itself was the most universal to have flourished in Europe since International Gothic. If we reject this art altogether, we reject an important segment of the European heritage, and seriously curtail our knowledge of nineteenth-century culture and its aspirations.

But these are somewhat negative reasons for respecting the work I have been discussing here. This is fully developed art, of enormous skill and professionalism. The artists were conscious of their own aims, and perfectly capable of fulfilling them. They differ from their degenerate successors, the twentieth-century Social

13

Realists, thanks to their confidence and their firm grasp of the world as they experienced it. With Social Realism, we are shocked not only by the uncertainty of aim but by the technical incompetence of the result. The best Naturalists have a subtle feeling, not merely for social detail, but for human relationships; the narrative element, though often somewhat disguised, continues to make itself felt in all their representations of contemporary life, and the story implied triggers a response which goes beyond our response to what is purely documentary. If these are documents, then they spring to life of their own accord in a way that such things seldom do. Looking at them, we are plunged back into the whole flux and ferment of one of the most fascinating periods of European history.

The Color Plates

16

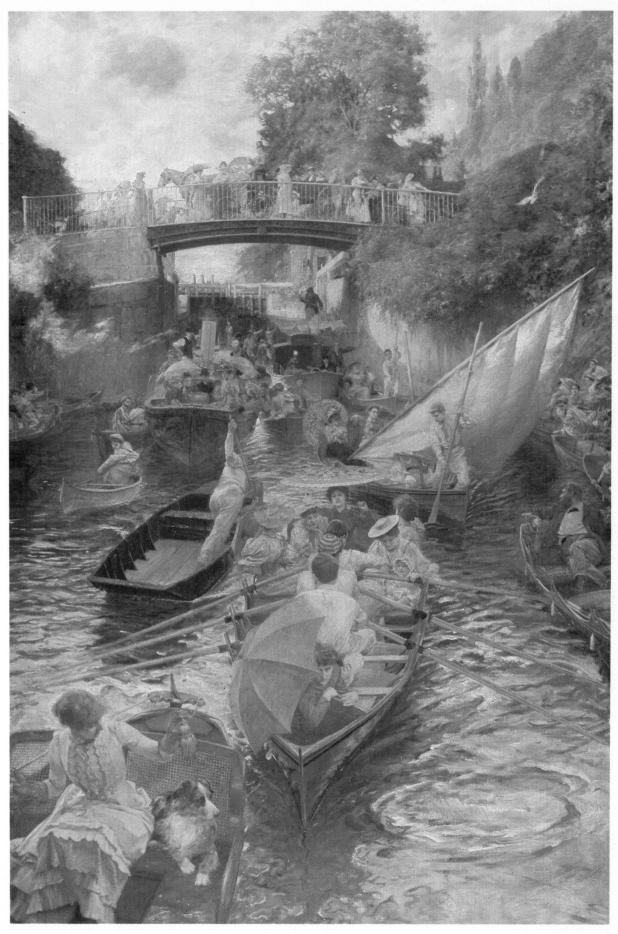

I

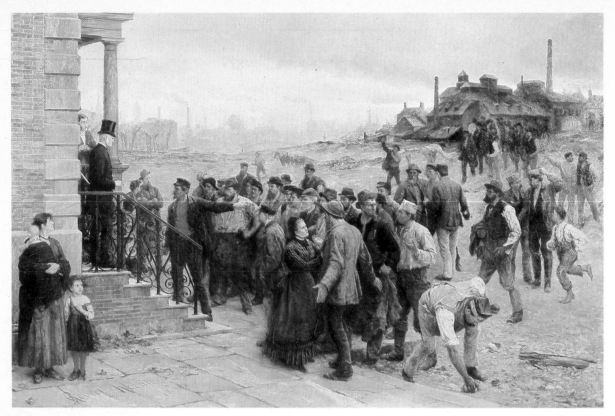

II

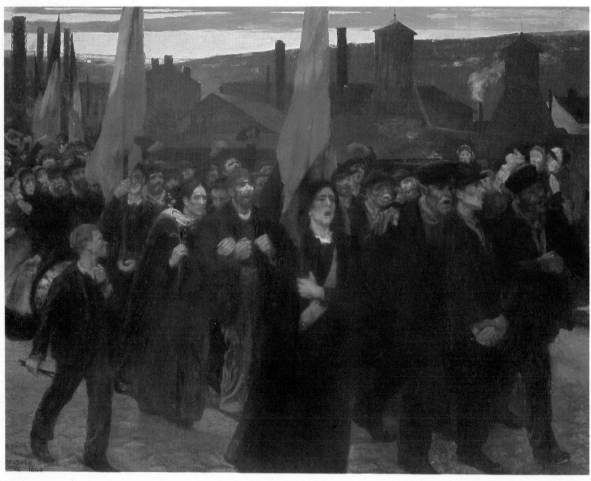

III

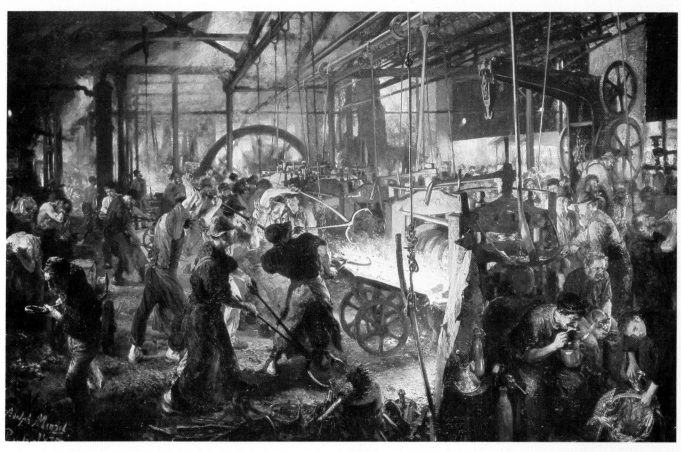

IV

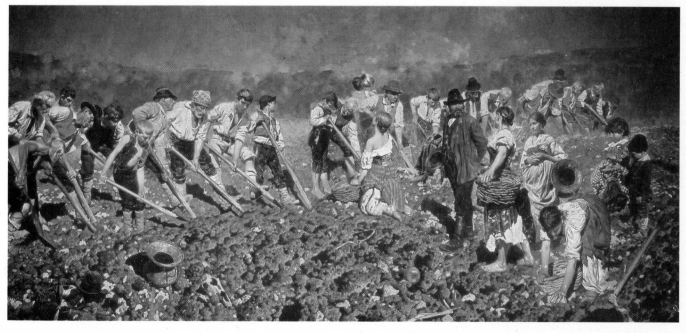

V

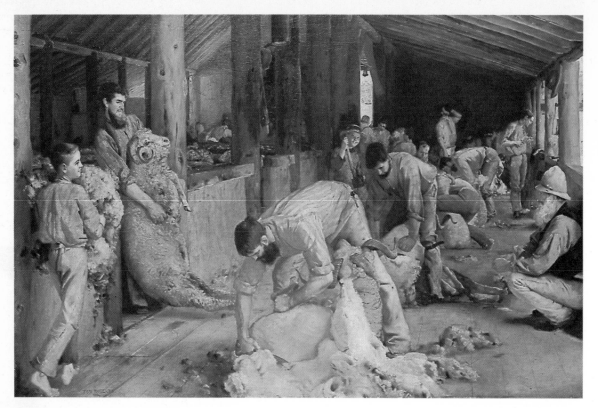

VI

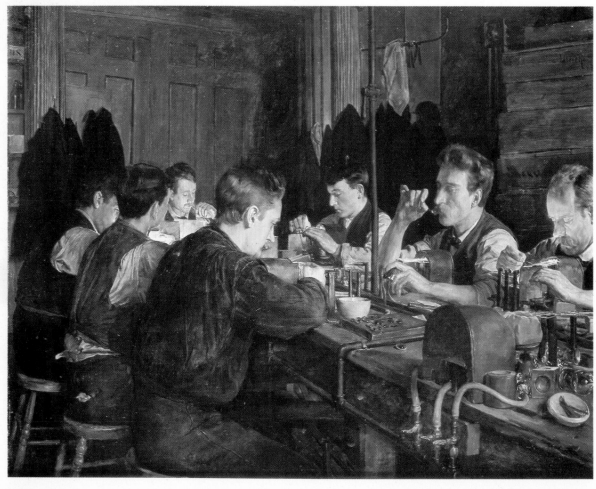

VII

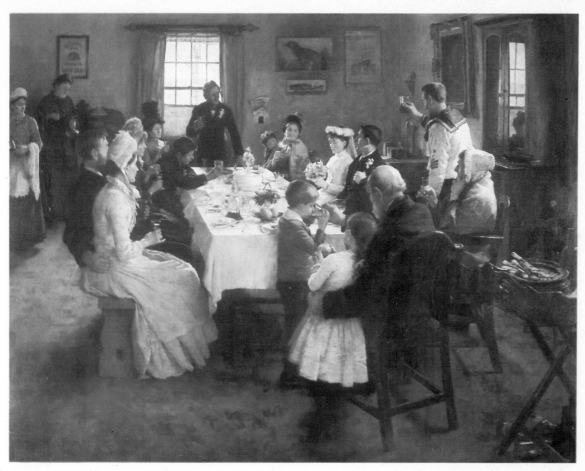

VIII

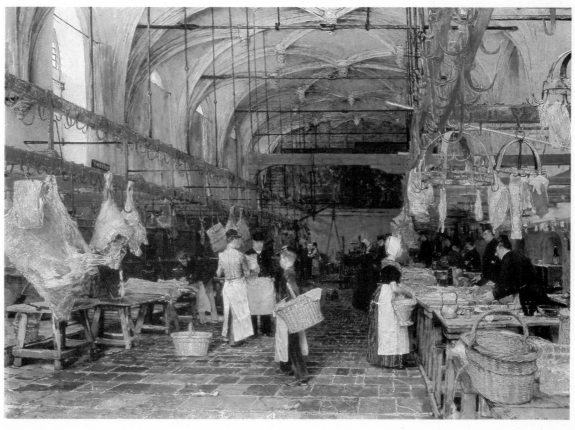

IX

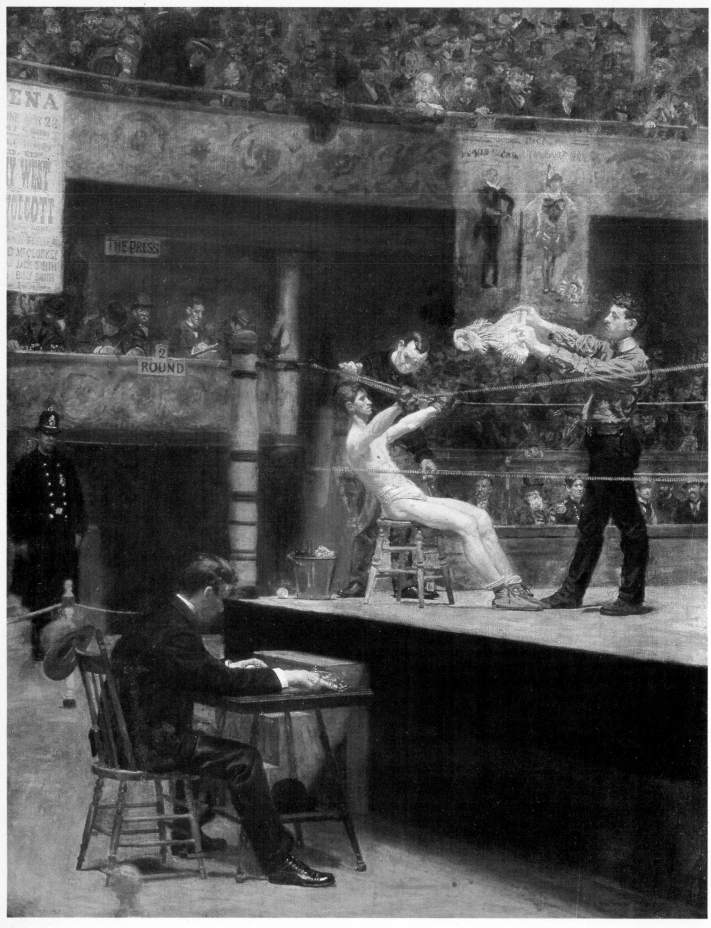

X

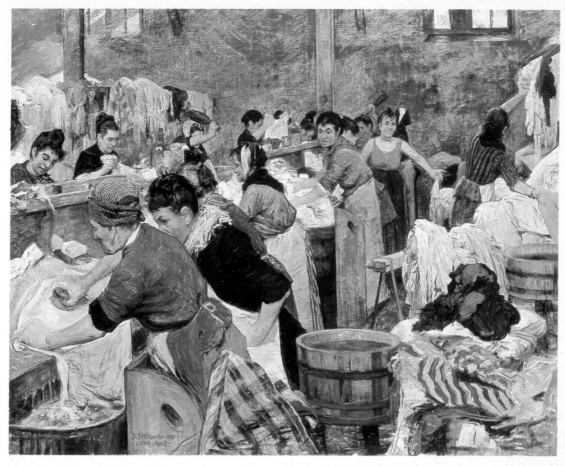

XI

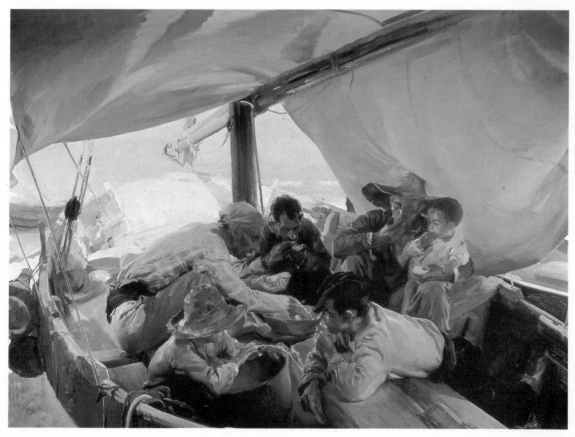

XII

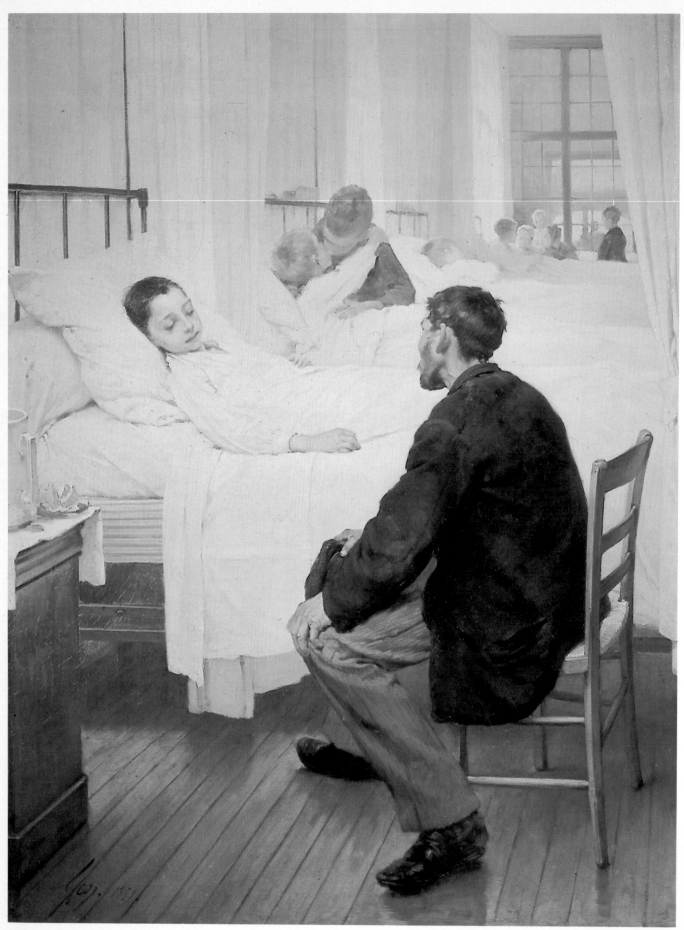

XIII

Work and Struggle-
the painters' view

THE LARGE NUMBER OF late nineteenth-century genre paintings that represent the life of the contemporary working-class may perhaps surprise those whose knowledge of this period of European painting is largely confined to the work of the Impressionists and the Symbolists. In fact, paintings of this kind are, if anything, more numerous than those that show the middle and upper class at their ordinary occupations.

The subjects include a broad spectrum of employment: glass-makers, cobblers, seamstresses and garbage collectors, the inevitable foundrymen and miners. We are shown political agitators at work and prisoners in jail, or on their way to exile in Siberia. There are some powerful canvases of strikes, reminding us that this was an age of industrial unrest. Other paintings take us more intimately into the lives of the workers. We are shown the markets where they shopped, and the pawn-shops they went to when money was short. We see their terror of the sudden illness or accident that might take away a breadwinner and reduce a whole family to poverty. We are given glimpses of what the existence of the really poor was like: licensed beggars besieging a fashionable shop, a mother and her child waiting outside a barracks for the soldiers' leavings. And we are shown the old people's homes and the orphanages which rescued a few from destitution.

Not everything is gloomy, however. We are also shown the rumbustious entertainments that clearly fascinated the painters as much as their intended

25

working-class audience—the circuses, fairgrounds and music halls which entertained the mass in the days before the triumph of moving pictures and television.

II.

If we attempt to use this great mass of imagery as evidence about the way people lived, caution is necessary for two reasons in particular. The first is that paintings showing the lives of the poor, and even those that showed the operations of industry, were not a novelty in European art. They formed part of a tradition that stretched back as far as the early fifteenth century. Much of the material here can be referred to one or another aspect of this tradition, and we must assume that the nineteenth-century artist's response to his material was influenced by knowledge of what his predecessors had done.

The value of these paintings as evidence may also be affected by the fact that they were not produced for a working-class audience. The pictures that show how prosperous people lived and behaved address themselves to the very group they depicted. But these others are different. Working people may sometimes have known how the artists saw them through cheap prints—but one suspects that these, on the whole, were not the most popular pictures with the mass audience. And they seldom came in contact with the originals. It was not a working-class custom to pay an annual visit to the Royal Academy or the Paris Salon. The feelings that give the paintings their effect are middle-class feeling, and the motivating force that produced them had more to do with middle-class conscience and middle-class curiosity than it did with the indignation of those who found themselves oppressed.

Gothic art showing the everyday occupations of humble folk existed well before the fifteenth century. Such representations can be traced back to the romanesque period, for example in the carvings on the apse of the church of St. Eucise at Selles-en-Berri, which show the saint as a shepherd and a baker. But they rarely appeared as the main subject of the work, and when they did so it was only because, as in the St. Eusice carvings, they served to illustrate some particular sacred episode.

In the early fifteenth century, this situation began to change, with the fashion for elaborately illuminated calendar pages in books of hours. These calendar pages generally showed "The Occupations of the Month," and the most celebrated are the work of the brothers Jean and Pol de Limbourg, which form part of the

26

Tres Riches Heures (c. 1416) of the Duke of Berri. In many of the pages of this cycle peasant occupations are depicted for their own sake, and carry no religious overtone or allegorical content.

With the coming of the Renaissance, the fashion for paintings showing peasants at work persisted, but was now detached from any sacred context. Such representations were particularly favored in Northern Europe. We find minor examples among the paintings produced by artists of the School of Fontainebleau, for instance the threshing scene attributed to Giulio Camillo which is now at Fontainebleau itself. The most celebrated producer of these scenes of everyday life was, like the Limbourgs, from Flanders. It is Pieter Breughel the Elder who has fixed indelibly in our minds the image of sixteenth-century peasant life.

The question of Breughel's audience is somewhat vexed. Did he paint entirely for the court, or did he also address a broadly based middle-class? The engravings made after his work, which were supervised by himself, suggest the latter. One thing is certain: Breughel was no peasant painting for peasants. He was a friend of leading humanists and was universally regarded by his contemporaries as a well-bred, cultivated man. Though his scenes of popular life (and particularly those that illustrate Flemish proverbs) evince considerable knowledge about the life of humble people, the general atmosphere of his art is one of serene and stoical detachment, rather than identification with what is going on. Art historians have compared him to the great philosopher-essayist Montaigne, who has the same keen eye for the follies of mankind.

Breughel was the founder of a tradition of northern realism, which led eventually to the so-called "Golden Age of Painting" in seventeenth-century Holland. Many of the leading Dutch painters of the time, such as Esias Bousse and Adrian van Ostade, became specialists in tavern and kitchen scenes, and the contemplation of low-life occupations seems to have given particular pleasure to their prosperous bourgeois patrons. One detects in these works a shift of emphasis from Breughel's time. Where Breughel often showed humble people at work, the Dutch genre-painters tend to show them at play. Those whom we see working are often women—kitchenmaids and other domestics.

In Catholic Flanders, tavern scenes and other representations of low-life were just as popular as they were in Holland. In fact, two of the greatest specialists in art of this kind were Flemish—David Teniers the younger and Adriaen Brouwer. Brouwer, who was greatly admired by Rubens, puts particular emphasis on the squalor of his subject matter. Yet here, too, we are conscious of a cultivated mind

27

at work. His painting of a *Boor Asleep* (c. 1635), now in London's Wallace Collection, seems to be based on the *Barberini Faun*, a famous Hellenistic statue now in the Glyptothek at Munich.

Developments in the art of Italy, and in that of Spain and France, were perhaps more significant than this continuation of the northern realistic tradition. The end of the sixteenth century was a period of crisis for Italian art. Mannerism had reached extremes of artificiality and exaggeration, and the times were ripe for a change. One of the architects of this change was the astonishing Michelangelo Merisi, called Caravaggio. Caravaggio pioneered a reaction toward realism that had tremendous consequences for the whole of European painting. He began as a rather precious (and precocious) young artist, using realistic devices almost as an extension of the prevalent cult of the *outré* and the extreme. Pictures like his flamboyantly decadent *Bacchus* (c. 1596) in the Uffizi were clearly designed to shock. From these unpromising beginnings, he developed a profoundly original religious style. A picture like the famous *Calling of St. Matthew* (c. 1598–1601) in S. Luigi dei Francesi in Rome sets the miraculous event in the very midst of ordinary life, and imparts deep emotion to the humble and the everyday.

The impulse toward realism was not felt by Caravaggio alone. The founders of the seventeenth-century Bolognese School, the brothers Annibale and Agostino Carracci, also show the same tendency, particularly in their earlier painting. Annibale's large canvas of a *Butcher's Shop*, (c. 1585) now at Christ Church, Oxford, presents an ordinary genre subject with a new, if rather sardonic, solemnity, and the work is on the scale generally used for major religious pictures or scenes from classical mythology.

Caravaggio and the Carracci family were the founders of the Baroque, the style that was to dominate in Italy throughout the seventeenth century and during the first half of the eighteenth. Realism was always to be an important element in this style, though as it developed there were other conflicting strains as well. On the whole, Baroque realism flourished best in slightly provincial centers—not in Rome, which had been the focus of Italian artistic life since the mid-sixteenth century, but in Bologna some decades after the departure of the Carracci, and in small northern towns such as Bergamo and Brescia.

Even in Rome, however, realism found a foothold in the work of the Bamboccianti. They were a group of Flemish and Dutch emigré artists who flocked to Italy and who formed a special artistic community of their own, the first completely recognizable artistic Bohemia. The Bamboccianti continued to work on a small

scale, just like their colleagues who had remained in Flanders, but their work has a merrier and more raffish air than the genre-painting done in the north. Because they lived among them, they recorded the beggars and other marginal people—hucksters, entertainers, humble tradesmen of all kinds—who scraped a living on the fringes of papal Rome.

When Italian-born artists take up such subjects, they record them with much greater sympathy than their northern contemporaries, even when the pictures conform to the usual convention for genre-painting by remaining small in scale. In Bologna, for example, at the beginning of the eighteenth century, Giuseppe Maria Crespi reacted against the solemnity of the established Bolognese academic style. His varied production (part of which makes him a precursor of the rococo) includes unpretentious scenes of ordinary life which are suffused with feeling for the lives of humble people.

Lombardy produced, from the 1640's to around the 1740's, a series of realist painters of genuine if somewhat eccentric distinction. Some of these, like Evaristo Baschenis, were specialists in still life. Others, such as Fra Galgario, produced excellent and unsparing portraits of members of the professional class. But a few painted the very humblest members of society. The most talented of these, working from about 1720 to about 1760, was Giacomo Ceruti, known as *il Pitochetto*—"the beggar-painter." Ceruti shows us the poorest of the poor, the homeless beggars who wandered the countryside, and he shows them life-size, in the format his contemporaries used for kings and noblemen.

Ceruti was not the first to depict the deprived and the outcast with such solemnity. In the seventeenth century Jusepe Ribera, a Spanish painter who had settled in the Spanish dominion of Naples, was producing canvases of the same kind. The best-known example is his *Boy with a Clubfoot*, dated 1642, which is now in the Louvre. The taste not only for this kind of subject matter but for this kind of approach to it was already established in his native Spain. Around 1620 the young Velasquez, who had not yet been summoned to court, made a series of paintings of humble subjects, the most famous of which is the *Water Seller of Seville*, which was captured by Wellington at the battle of Vittoria, and is now at Apsley House in London. This is one of the most moving statements about the dignity of humble people ever to be made in art.

France, too, had specialists in low-life subjects during the early seventeenth century. Among them were Louis Le Nain, the most gifted of three artist-brothers, and the mysterious Georges de la Tour, who made his career in the independent

29

duchy of Lorraine. Le Nain's genre-scenes, which show peasants at table or in the fields, have a calm solemnity which is missing from the work of the Dutch artists who seem to have influenced him. When he shows us peasants eating, for example, the meal takes on a sacramental quality. The borderline between the secular and the sacred is even more difficult to trace in the case of La Tour. His *Nativity* in Rennes (c. 1644–9) which shows us two women and a swaddled infant qualifies as a "religious" work because of its atmosphere, not because of any specific symbol. La Tour's paintings of the *Repentant Magdalen*—a favorite subject—are recognizable because of the presence of a skull and a mirror, emblems of mortality and vanity. But they differ little, in their total effect, from the painting (now in Nancy) where the same model is shown searching for a louse by the light of a candle.

The paintings of Caravaggio and Annibale Carracci, of Ribera and Velasquez, Louis Le Nain and Georges de la Tour, reflect a current of emotion that is typical of the seventeenth century, and particularly of reformist movements within seventeenth-century Catholicism. The religious teaching of the time, as represented by the French Jansenists of Port-Royal, stressed not only scorn for the vanities of the world but quietism, a concentration upon the movements of the soul. The harsh competitiveness of the Renaissance was replaced by a more intimate and tender feeling for the misfortunes of one's fellow men. It was at last possible to identify with apparent failure. Paintings of humble people by the great seventeenth-century artists are in effect moral emblems. They reveal the presence of God in the basest surroundings. Ceruti, working in a very provincial environment, demonstrates how the influence of this way of thinking could, in favorable circumstances, linger on for a considerable time. On the whole, however, eighteenth-century artists tended to take a very different view of working-class life.

Hogarth and Boucher represent what are perhaps the eighteenth-century extremes. In a Hogarth composition such as *Gin Lane,* the working-class environment—the life lived by the poor in towns—is characterized by a comic squalor and violence. Boucher, on the other hand, in his Arcadian landscapes, presents us with an impossibly prettified version of peasant existence—a world that glories in its own mendacity. Later in the century Jean-Baptiste Greuze was to falsify the life of the poor in another way, by filling it with heart-stirring incidents. His pictures are designed to trigger off the sentimentally self-conscious pity for the unfortunate which Jean-Jacques Rousseau recommended to his middle- and upper-class disciples.

Greuze stands at the beginning of the development which eventually resulted in the paintings illustrated in this book, but, he is not by any means their only source. When artists began to show peasant occupations for their own sake at the beginning of the fifteenth century, they also started to show an interest in manufacturing processes. The British Museum has a set of illustrations to *Mandeville's Travels*, dating from the early fifteenth century and probably of Bohemian origin, one of which shows the techniques of glass-making in minute detail. But industrial and technological development, at least until the middle of the eighteenth century, progressed only by fits and starts. As soon as the Industrial Revolution got into its stride, painting began to respond to what was happening. It is not surprising that the earliest works of art to show industrial subjects should have been produced in England. Joseph Wright of Derby's *Iron Forge*, painted in 1772, is a direct forerunner of paintings illustrated here, and has aptly been described as "an imaginative forecast of the forces to be developed by the Industrial Revolution." One of the most notable things about it is the dispassionate curiosity with which the artist examines this new category of subject matter.

With the coming of Romanticism this curiosity about the forces of industry was changed for something very different. Gericault's *The Plaster-Kiln* (1821–2) stresses the satanic aspects of the new industrial age, but at the same time finds a kind of grandeur in its ugliness. In two lithographs, *Pity the Sorrows of a Poor Old Man* and *The Paralytic*, he once again takes up the theme of the outcast, but now with a note of social criticism. These prints, unlike Ceruti's paintings of beggars, suggest that both the present condition and ultimate fate of those who are portrayed are in some sense the spectator's responsibility.

Turner represents another aspect of the Romantic response to industrialism. *Rain, Steam and Speed* (1844) glories in the power of the new machines. *Keelmen heaving in Coals by Night* (1835), a masterpiece now in the National Gallery of Art in Washington, gives an even subtler interpretation of the new age, contrasting the unaltered silvery radiance of the moon with the smoky haze and industrial bustle of Tyneside. The picture was meant to shock, and it did. When it was first exhibited in 1835, the critic of the *Literary Gazette* waxed indignant over "a flood of glorious moonlight wasted upon dingy coal-whippers, instead of conducting lovers to the appointed bower."

On the whole, the Romantic masters reacted to the triumph of the Industrial Revolution by shying away from it, and by retreating into the historicism and the worship of nature (nature idealized and unsullied) which typify the art of the first

half of the nineteenth century. It was only when the Romantic movement began to lose its original impetus that painters were able to return to the contemporary scene with renewed appetite. They were particularly interested in the notion of work. Indeed, *Work* is the title of the best-known of Ford Madox Brown's paintings, which dates from the early 1860's. *Work* is not so much a representation of one particular incident as a complex essay upon a theme. An opposite yet related approach was adopted by Gustave Courbet and J. F. Millet, the champions of the new French Naturalism, who were reaching their full strength in the middle decades of the century. Millet particularly seems to make an enormous effort to gather all the sensations felt by the worker—earthbound peasant or straining quarryman—to create from these an image which puts us in the very midst of the work situation. He makes us feel the ache in the muscles and the sweat on the brow of the brutish, almost animal-like creature who leans upon his hoe to take a moment's respite.

The artists I have enumerated are the ancestors of those whose work is reproduced in this book, and they deserve detailed discussion for several reasons. First, the historical development of painting of this kind is often misunderstood. Secondly, in the period 1870–1914, the painters and their public were keenly aware of the burden history had laid upon the artist. And thirdly, the appetite for representations of work and workers was not new. It had always existed among the members of a more fortunate and leisured class.

III.

Because paintings of low-life subjects had long had their place in western art, because people were used to their presence, it is hard to assess the critical response aroused by such paintings among critics contemporary with the painters themselves. The most substantial body of contemporary criticism available to us is the series of accounts, often written by distinguished men of letters, of the annual Paris Salon. These accounts have more usually been combed by historians of Impressionism, but they offer equally valuable information about the way in which the rather different paintings illustrated here were received by the more thoughtful section of the public.

Victor Cherbuliez, for example, gives us an account of the first Salon—that of 1872—to be held after the crushing defeat of the Franco-Prussian War and the

bloody terror of the Commune:

> On the opening day, it seemed to me that it was not the public that looked at the pictures, but the pictures that looked at the public. These seemed to be saying to the spectators: "So, after two years, we have come back to you! How many things have happened! What a state France was in, only a few months ago? And now you have enough leisure and tranquillity of spirit to think about us, who are the representatives in this world of pure appearances, sacred uselessness, tranquil and eternal thoughts."[1]

This passage is a useful reminder, not only of the traumatic shock which French culture in particular had just suffered, but of the then generally accepted view of the purpose of art.

Cherbuliez, who is on the whole a conservative, has stern words to utter to the painters of contemporary genre-scenes:

> They should not only give up the insignificant subjects, with which they too often occupy themselves, but also the sentimental ones, for nothing wearies quicker than sentimentality, and above all motifs which are only piquant. An artist cannot have too much wit, nor indeed can his brush. But his wit must most often serve him best by not showing itself: nature does not pride herself on being clever, and the greatest merit of the painter of genre, as of the landscapist, is to show her own adorable good humor. A painting which is a good joke runs the risk of all good jokes; one does not want to listen to them twice.[2]

Jules Claretie, a less conservative critic, writing about the Salons of the middle seventies, prefaces his collection of essays with the following declaration, which represents another aspect of thoughtful French taste:

> Sincerity and the constant study of modern life are everywhere gaining ground. Art is emancipated, set free, and, if our artists no longer produce masterpieces, they cannot attribute this to any obstacle in their path. Let them be active and let them go forward. The road is open!
>
> Our ideal can be summarized thus, in art as in literature: to live one's own life; to take one's inspiration from modern life; to create rather than copy; to look at living nature rather than at what is dead; to belong to one's own time and not to the past.[3]

Basically, this is a statement of the prevalent artistic creed of Naturalism; but it also demonstrates how, to the late nineteenth-century painter, the investigation of all aspects of society could present itself as a duty, a matter in which he had no real choice.

In his account of the Salon of 1873, Claretie demonstrates where his own sympathies lie by according lavish praise to a picture of a provincial butcher's shop by Albert Aublet, one of the leading realists of the period. His description of the work has a certain relish:

M. A. Aublet has depicted this corner of a butcher's shop with much power and precision—the blood runs with the true color of spilt blood. This intimate scene of carnage, which would give the vapors to a fine young miss, is a triumph of skill and of resemblance.[4]

On the other hand, Claretie is not so enthusiastic about Munkaczy's *Arrest of the Night Tramps* (Plate 50), which was exhibited in the following year:

By an affectation of realism, M. Munkaczy has given the same dreadful faces, whether hollow-cheeked or chubby, to all the actors in this drama, nocturnal brigands and honest men alike. Both species are simultaneously livid and black as if they had, each in turn, been plunged in a bag of flour and then one of coal.[5]

The implication here is that it is not so much the extreme realism of Munkaczy's work, as some ambiguity of its moral content, that makes the critic feel uncomfortable. But the real ambiguity is in Claretie's thinking: he feels that low life is an acceptable subject for the artist only if certain aspects of it are avoided.

With the Salons of 1879 and 1880, we reach the work of a far more distinguished writer than the two who have just been cited—J. K. Huysmans, the author of *A Rebours*. Huysmans began in the camp of the Naturalists, as a follower of the Brothers Goncourt, and later, with the books that made him famous, became a leading symbolist. He is thus well placed to interpret the conflict between symbolist and naturalist painting which began at this time. Huysmans is thoroughly aware of the paradoxical nature of the artist's reaction to his own circumstances:

The less education a painter has had, the more he wants to produce art in the grand style or painting with elevated sentiments. A painter brought up among workers never represents the workers but instead the men in frock coats, with whom he is not familiar.[6]

We are fortunate in possessing from Huysmans' pen a detailed description of one of the paintings included in the present collection, Dagnan-Bouveret's *A Wedding Party at the Photographer's* (Plate 203). He does not find the work wholly successful, though he is willing to concede it some merits:

The man who blows pipe-smoke into the child's face is droll enough; the married couple is not bad, above all the husband, with his foppish air and his

head frizzled like a cauliflower. The trouble is that the limits of the comic are nearly always crossed. This is not coarse farce or off-color jesting, but a studio joke or the quips of vaudeville.[7]

Huysmans concludes that the grouping of the figures is too self-conscious to give a convincing impression of reality, and that "the flavor of the picture is therefore banal."

There are some kinds of realist art, however, which Huysmans greatly admires. In the Salon of 1880, his enthusiasm was aroused by *The Strike*, a painting by Roll. He says of the artist, by way of commendation: "He has dared to paint, without cold-cream or cherry-juice. He will hear it said that his painting is "common," and that he lacks taste. He will, I hope, be proud to be judged thus foolishly."[8]

What Huysmans dislikes, in fact, is the theatrical aspect of the genre-scenes that passed before him—everything the painters had inherited from Greuze and the "cult of sentiment" in the eighteenth century. Confronted by a painting that shows the poorest of the poor, he remarks that it seems to him false because, according to his own observation, the poor do not behave like that:

All these men in rags did not grimace like the personages of M. Goeneutte; the horror of the starvation they had suffered and the vices they had slowly exhausted did not translate itself into self-conscious poses and gestures; these poor devils were, as they talked, laughed, kept their place, pitiable and sinister; without having any need to raise themselves toward the heavens to implore or to curse them—their ravaged countenances said it all.[9]

This passage is a reminder that the prosperous middle-class visitors to the Salon were not entirely protected from the facts that surrounded them. The hugger-mugger quality of nineteenth-century life, especially in the rapidly expanding cities, meant that the rich often lived in close physical proximity to the poor. The huge gulf between the fortunate and the unfortunate was graphically demonstrated every day, in the streets and public places of any big city.

The quotations from Claretie and from Huysmans also serve to indicate a difference between French and English taste. The French, even at this period, had a much less pronounced liking for outright sentimentality than did the subjects of Queen Victoria. Gustave Geffroy, one of the most intelligent art critics of the period and a defender of the Impressionists, is severe about the contemporary English paintings shown at the Universal Exhibition of 1900. One of the paintings he singled out for condemnation was a late work by Millais, which he considered only too typical of the faults to be discovered in the rest: It is impossible to put the

sign of sentimentality more in evidence, and it is impossible, too, to paint in a drier and more mannered way.[10] Not that Geffroy had any objection to the artist's effort to depict scenes taken from contemporary life. Very much the contrary. For him, the Pre-Raphaelites and the Symbolists made "too many efforts to achieve combinations inferior to reality," He was willing, however, to admit that

Personal visions are of necessity rare. The artist, forced to live the social life of his time, escapes with difficulty from the conditions imposed by this life. He thus becomes, by an obligation which is really quite natural, the painter of a class, a man who supplies what is wanted by the prevailing taste.[11]

Yet he was also forced to note that simple submission to the taste of the day was not enough: "an interior power must reveal itself."

Geffroy had a profound and some might say prophetic belief in the social mission of the artist:

I believe that artists are destined, more than ever before, to exercise an influence over the destinies of the mass. Art demonstrates what life is. It penetrates life, summarizes it, causes it to be understood, and it will play a more important part than anyone supposes in the social transformation of the future. What I mean by this, of course, is art in its entirety, art mingled with existence, with manual labor as well as the labor of the mind, with the leisure of the individual and with the manifestations of national existence, the art of books and of music, of painting and theater, or architecture, sculpture, and the object. Its mission is to replace, by giving life its true value, the vaunted splendours of religious ritual, the panoply of processions (spectacles for the masses), and the military glories of which the mass is victim. It can bring to all, at the same time as it brings the enjoyment of a spectacle, the joy of creativity.[12]

While this passage takes us a long way beyond the paintings illustrated here, and opens questions that have still not been resolved by the triumph of modernism, one can see that a critic like Geffroy would find it both natural and necessary for the artists of his time to direct their attention to industrial scenes and to the daily life of the working-class. Nor were the artists reluctant to heed his call, despite their allotted role as purveyors to the bourgeoisie. In another passage, written a few years later, Geffroy noted the "passionate interest in the life of the masses" being shown by the painters who then exhibited at the annual Salons.

But perhaps it must be left to that remarkable woman Beatrice Webb to supply the reason that the late nineteenth century was so prolific in painting of this type.

She supplies it despite the fact that she herself was almost totally lacking in visual sensibility. As a young woman in the 1880's, she became keenly aware of a new restlessness among the members of her own class:

> The origin of the ferment is to be discovered in a new consciousness of sin amongst men of intellect and men of property The consciousness of sin was a collective or class consciousness: a growing uneasiness, amounting to conviction, that the industrial organization, which had yielded rent, interest and profits on a stupendous scale, had failed to provide a decent livelihood and tolerable conditions for a majority of the inhabitants of Great Britain.[13]

If we extend the scope of that "consciousness of sin" to all of Europe and the industrialized portion of North America, we have the beginnings of an explanation as to why these paintings were produced in such quantity. They reflected a deep-seated unease, which we also find expressed in the work of most of the leading novelists of the period. The legend of Victorian complacency dies hard, but in fact one of the valuable aspects of the culture of the period was the extreme seriousness with which the great social questions of the day were examined and debated by intelligent, well-educated people such as Beatrice Webb. By the last decades of the century the full consequences of the Industrial Revolution had had time to come home to people, and there was an impatience to find solutions for what now seemed intolerable evils.

IV.

If the painters formed part of a general intellectual movement, and were not content simply to reflect the life around them, we would expect them to find means of signaling their intentions. There are many clues to be found in the paintings themselves, and one of the most basic is the scale on which the artist works. (This point is so obvious that it is often overlooked, especially in an age when people are more familar with printed reproductions than with the originals.) Seventeenth century Dutch genre-scenes tend to be small canvases; many of the pictures reproduced here are ambitiously large. The implication in the later paintings is that everyday activity is central, not marginal, to the problems of human existence. Another clue as to the painter's intentions is the relative size of the figures within the composition. The larger the figures are, the more emphatic becomes the artist's assertion that it is *their* actions and gestures and emotions which form

the true subject of the work. In late nineteenth century art, as in that of the Baroque period, we often find extremes of simple dignity and excited rhetoric. Some famous Spanish paintings, notably Velasquez's *Water Seller*, fit with astonishing ease into a far later context. This masterpiece shows the same fascinated respect for the mysteries of the human personality, the same attempt to find the individual in the type, which typify the best post-Romantic art and literature. The link is important because it serves to stress a general resemblance between the sensibilities of the two epochs. The tenebrous, brooding quality of seventeenth century thought and emotion, expressed literally by the chiaroscuro of Caravaggio and his followers, appears again in the nineteenth; similarly, the intense effort to understand the physical nature of the world, glimpsed in the work of Newton and his contemporaries, is found again in the age of Darwin. The nineteenth century, like the seventeenth, is divided against itself, and the deep fissure gives the period a keen sense of the tragic.

V.

No one would pretend, however, that the seventeenth century and the nineteenth set identical problems for the artist. In the first place, the challenge to religion, and to received ideas of all kinds, was now much stronger. The poor quality of nineteenth century religious art makes a striking contrast to the power of the Christian images created two centuries previously. In the second place, reality itself—what the painter was trying to grasp and convey to the spectator—had become more complex.

The artists of the late nineteenth century were not as yet ready to admit what is universally admitted today—the fact that what we call "reality" is both subjective and multiple. Psychologists point out that the things we think of as real are in fact only a selection. The mind somehow winnows the sensations which impinge upon it, and chooses a portion of these for incorporation into its own cosmos. The selection is guided by many factors, but chiefly by previous conditioning. Enormous gaps of experience and perception are left—things that we do not possess the necessary machinery to deal with. At the same time, our sense of reality is not fixed. We ourselves act upon the world simply by being in the midst of it, and by our action we alter our surroundings. Limited as it may be in some respects, the mind is quite capable of perceiving this alteration and reacting to it.

38

We gain some idea of the gaps in nineteenth century perception when we look at the paintings of rural life included in this collection. These paintings have the longest tradition behind them. They are the direct successors of what was done by the Limbourg brothers and by Breughel, and the continuity of agricultural occupations is such that the material available to the artist must have seemed superficially unaltered, despite the passage of nearly five centuries. The intensive mechanization of agriculture had not yet taken place.

Yet I do think that anyone looking at these paintings showing peasants at work would grasp from them alone that the period after 1870 was one of severe agricultural depression in Europe, thanks to the competition of the new farm lands which had been opened up in the United States and in Russia through the development of the railways.

The conditions of life for rural workers were so bad that they led to strikes and disturbances even in this notoriously conservative and quiescent section of the community. In the north of England and in Scotland the traditional hiring fairs were transformed into centers for discussion and agitation. There were farm-workers' strikes in Spain and Italy. In France, the rebellion came later. It was not until 1903–4 that there were serious strikes. The outbreak affected the whole of the huge wine-growing region stretching from the Loire to the Pyrenees. But from the narrative paintings of the period we might never be aware of these events. For the artists, strikes and political disturbances took place in a strictly urban context.

Yet we do find reflected in art both peasant grievances and the changes that were overtaking peasant life. A painting such as Benjamin Vautier's *The Landlord's Visit* (Plate 62) shows a keen sense of the distinction between rich and poor, employer and employed. The same note is struck by Lhermitte's *The Harvester's Payday* (Plate 87). Changes are reflected chiefly by paintings that show how agriculture was starting to diversify thanks to the economic pressures of the time, though another "missing" subject is the introduction of agricultural machinery, which was very much a feature of the period.

Two important topics in late nineteenth-century art are emigration and military service. The great movement of emigrants that took place at this time was one of the most important results of the crisis in European agriculture. It forms the subject of a number of pictures, some of which, such as Erskine Nicol's *An Irish emigrant landing at Liverpool* (Plate 137), are distinctively ambivalent in their attitudes. Army service is more straightforwardly treated, but some paintings, most of them the work of French artists, show a humorous awareness of what happened

to the raw conscript as he became accustomed to military life. These works are a reminder of the fact that the large standing armies maintained by most European nations in the period after the Franco-Prussian War played a prominent role in the break-up of traditional peasant culture. It was peasants who formed the bulk of these armies; and conscription, by removing the young men from the enclosed rural communities in which they had grown up, gave them an entirely new perspective on the world.

In general, however, the tone of most of the art showing scenes from rural life or anything connected with the peasantry was nostalgia. One can go so far as to say that this nostalgia was itself the product of a keen awareness of change. Artists saw it as part of their task to record customs that were in danger of vanishing. H. G. Gourse's *Pig Market in the Pyrenees* (Plate 91) and Charles Giron's *Wrestlers' Festival in the Swiss Alps* (Plate 96) are examples of the impulse towards documentation of this type. Subtler and more pervasive is the emphasis on rural peace and tranquillity, and on the simple vigor of the rustic temperament. The latter is tellingly rendered in Anders Zorn's *Midsummer Dance* (Plate 94).

In France, the remote and backward province of Britanny enjoyed a special popularity not only with artists who were French by nationality but with others who had settled in France. This cult exemplifies the nostalgia just described, and at the same time time draws attention to the huge gulf now opening between the middle-class and usually town-bred artist and the peasants who formed his subject matter. The picturesque Breton costumes, the colorful Breton *pardons*, had an irresistible appeal because they were so exotic, so remote from the ordinary experience of both the painter and his audience.

This appeal extended a long way beyond the painters who belonged to the Naturalist camp. Britanny, with its mysterious Celtic legends, made an equally great impression upon the Symbolists. Gauguin's first visit to Pont-Aven, in 1866, was a watershed in the development of Symbolist art. It was here that Gauguin painted his first undoubted masterpiece, the *Vision after the Sermon (Jacob and the Angel)* of 1888, in which we see a group of Breton peasant-women watching the supernatural combat.

The curious thing is that Gauguin, for all his apparent fascination with the life of the Breton countryside, and his imaginative sympathy with peasant ways of thinking and feeling, really had very little time for the indigenous population. His letters written from Britanny reveal how detached he was from anything rooted there; his concern is not with the peasants but with the group of rival artists who

surround him:

I am doing a lot of work here to some purpose; people respect me as the best painter in Pont-Aven; true this does not put a penny in my pocket. But perhaps it is an augury for the future. In any event, it gives me a respectable reputation and everybody here (American, English, Swedish, French) is anxious to have my opinion, which I am foolish enough to give because eventually people make use of it without proper recognition.[14]

However wide the stylistic gap between Gauguin's work and that of the Salon artists, there is at least this much in common in their attitudes toward their subject matter: when they visited Britanny and observed its people, they seem to have had an unacknowledged but intense feeling of alienation. Ambitious paintings of Breton peasant customs—which appeared so regularly in the Salon but are lightly represented here—do indeed have that falsity which is still often attributed to all kinds of Salon art. The organic connection between painter and subject which can be discovered in the work of Louis Le Nain was now finally dissolved. Pictures of this type are both typical products of an industrial and technological society and proofs that, as early as the 1870's, we find ourselves on the other side of the great divide which separates the traditional culture of Europe from the one we know today.

VI.

Since Britanny lived by fishing almost as much as it did by agriculture, one would expect to find a number of fishing-scenes among the paintings produced by artists who specialized in Breton subjects. And so one does. But the fishing and in fact all "sea" subjects assembled here tend to fall into a special category of their own. Paintings showing the sea, and the work of fishermen and sailors, were produced in tremendous quantity at this period. The handful we have chosen to reproduce represent only a very small fraction of the total number. It is worth asking why subjects of this type should have been so popular with both artists and public.

The answer seems to be that the sea retained a particular kind of symbolic value, even for the least mystical of nineteenth-century artists. At a time when religion seemed to be everywhere in retreat before the relentless advance of science, when Darwin's discoveries were thought to threaten the very foundations of faith, the sea acquired an increased fascination as the most powerful and least controllable

41

of natural forces. It was almost a secular metaphor for the deity. The Romantics had worshipped the mountains, as an embodiment of the undefined life-force which they worshipped. The sea exercised an even more enduring spell over the nineteenth-century imagination.

When Naturalism replaced Romanticism, the ocean tended to be viewed in its relationship to working men, rather than as a mirror held to the emotions of the Byronic hero. One of the tenets of Naturalism was that all men had within them the capacity for being heroic. Another was that heroism could be collective. Hence a new emphasis on fishing-subjects in particular, and a tendency to paint large canvases showing lifeboatmen, or even ordinary sailors, at some particularly dramatic juncture of their lives. During his period of exile in the Channel Islands, which is to say toward the end of his career as a writer, the arch-Romantic Victor Hugo produced the *Toilers of the Sea*, a novel, that in some respects foreshadows Kipling in its command of technical maritime detail. Hugo's own comment on his book seems to have particular relevance to some of the paintings we reproduce:

> I wanted to glorify man's work, man's will, man's devotion, everything that makes a man great. I wanted to show the most relentless of all abysses is the human heart, that he who escapes the sea cannot escape a woman.

To us, today, these pictures of fishermen and lifeboatmen may often seem banal, but to the late nineteenth-century public they had a special resonance. Occasionally that resonance becomes explicit even for a modern audience—for example in Winslow Homer's extraordinary *The Gulf Stream*, which anticipates the Hemingway of *The Old Man and the Sea* even more precisely than Hugo anticipates Kipling.

VII.

If paintings showing the life of the land, and to some extent those showing the perils and grandeurs of seafaring, were rooted in a long-established artistic tradition, so too were those that took beggars and tramps for their subject matter. These can be traced on the one hand to the tradition of Breughel and even to that of Breughel's master Hieronymous Bosch, and on the other hand to the *bamboccianti* and their successors in Italy. Occasionally we find a painting whose sardonic irony rivals that of Georges de la Tour, in the paintings of beggars he did

42

at the start of his career—we are thinking of the *Old Man with a Hurdy Gurdy* in the museum at Nantes and of the *Musicians' Brawl* which recently entered the collection of J. Paul Getty. *The Fallen Star*, by Jan van Beers (Plate 166) is a work of this type, the more interesting because it was painted at a time when La Tour himself had fallen into complete obscurity. Stranger, and far more unexpected, is a painting called *Wrestlers in Devonshire*, by Jan Veber (Plate 161). The wrestlers are naked women, with a bowl of coins beside them, and the audience seems to consist of a row of harridans. The precise significance of the composition is as difficult to determine as the artist's intention in painting it. Is this supposed to be a transcription of a folk-custom, perhaps read about in a book, or is it an ambitious attempt to rival the "black paintings" of Goya? In any case, it presents us with a strangely haunting image of human desperation and evil.

Desperation, too, is often the keynote of the pictures that show circus people and other entertainers. Even a work as apparently straightforward as Lucien-Simon's *Fairground Wrestlers* stresses the shabbiness of the setting in which the encounter takes place. Pictures showing vagrants and circus life are infused with a particular brand of nineteenth-century sentimentality which makes us resist the message they are trying to put across. The gross impresario, watching the efforts of two undernourished acrobats, may seem to us a cliche. But one does not have to read far into the theatrical autobiographies of the period—for example, Chaplin's account of his early years—to realize that images of this kind do embody, beneath the sentimental coating, harsh truths which the artist's contemporaries would have found perfectly recognizable.

French art in particular had long used the figure of the wandering comedian to suggest, not only alienation from organized society, but a certain kind of doomed melancholy. It was Watteau who created the type, using hints discovered in the work of Jacques Callot and Claude Gillot. The revival of Watteau's reputation in the mid-nineteenth century—pioneered by rich collectors such as the Marquis of Hereford and confirmed slightly later by the writings of the brothers Goncourt—affected many artists thenceforward. It was Symbolists such as Charles Conder and Aubrey Beardsley who were best equipped to receive Watteau's message. But we see here that even the most stringent Naturalists felt the attraction of this class of subject matter, and tried to translate it into their own purely mundane and realistic terms.

According to the Naturalistic credo, it was wrong to suggest emotion in the vague and ambiguous way favored by their Symbolist rivals. They had to invent

43

specific narrative situations within which to display the personages who attracted them. Daumier, who used vagrant entertainers as a vehicle for specific social criticism, was obviously an important source, but here, too, the Naturalists were forced to discard the most important quality of the man they had chosen as a model—his capacity for entering the inner lives of those whom he chose to depict. Daumier's distortions spring not only from his training as a caricaturist but from the deformations imposed by feeling. What we look at in his paintings and drawings is an image of how the subject seems to himself, how he apprehends his own reality.

VIII.

This difference between Daumier and his Naturalist followers brings us to a very important point. The paintings reproduced in this book strive to give the spectator an accurate reflection of what the artist has seen, but they are not an "objective" account of industry, poverty and the class struggle. In a sense, what gives them their value as historical evidence is precisely this lack of objectivity. They show us how the men of the period tried to deal with evidence that, in many cases, they found it very difficult to accept.

If one reads the contemporary accounts given by those people who were actually in the thick of events, who lived through all the changes, one gets a picture of the way in which European society evolved during a crucial period. Those who bothered to examine and describe the condition of the poor often did so with striking thoroughness. The great series of volumes produced from 1889 onward by the British philanthropist Charles Booth, under the title *Life and Labour of the London Poor,* gives an incredibly detailed picture, often street-by-street and house-by-house, of conditions in the poorest areas of the city. But Booth, like so many other investigators, was unable to accept the conclusions that should have been forced upon him by the evidence he had been at such pains to bring together. He tried, for example, to draw a distinction between the poor who were self-sufficient, and those for whom there was no hope. The latter, he considered, tended to drag down the former. He therefore proposed that compulsory labor camps should be established, where poor men and women could be taught skills and discipline in an environment sealed off from the rest of society. As for derelicts and semi-criminals—the lowest of the low—they should be "harried out of existence."

44

And yet, inevitably, the investigators were forced to propose radical measures. In Paris, Louis Paulian made himself the greatest living authority on the various stratagems practiced by the beggars who swarmed in the streets of the capital. His conclusions were pitiless:

The first necessary reform, without which it will never be possible to diminish the number of the poor, consists in the total, absolute, and radical suppression of alms-giving in the streets.[15]

At the same time, Paulian's researches filled him with an impassioned radicalism and desire for social justice:

A country which possesses a Ministry for commerce and industry is under an obligation to have an administration for the dispensing of public and private charity, charged with the duty of ensuring by equitable measures, and by the application of the laws of forethought and economy, bread to the old soldiers of agriculture, commerce and industry, and to all those who, after having by their hard labor contributed to the riches of the country, have often received but too small a share in those riches. We have arrived at an epoch when in order to govern it is no longer sufficient to rely upon the unalterable principles of right. No, it no longer suffices to base law upon justice and liberty. Charity, fraternity and even generosity must be introduced.[16]

IX.

The period reviewed in this book represents a distinctive phase in the history of industrialized Europe, different from anything which preceded it. The characteristics that make it new are paradoxical, not to say contradictory, and these paradoxes are reflected, naturally enough, in art.

Simply because this book is concerned with painting which is a direct response to social change, we must not allow ourselves to forget that what is reproduced here existed side by side with very different kinds of artistic expression. For us today, it is still Impressionism that seems to be the opponent of academic Naturalism. Contemporaries would have made a different distinction. For them, the enemy of Naturalism was Symbolism. Impressionism took Naturalism to extremes: it implied, or seemed to imply, that the visible surface was the only thing that mattered. In this sense, therefore, it can be interpreted as a withdrawal from the more complex reality which Naturalism wanted to render. But Symbolism implied a total rejection of the real, a retreat into an aesthetic ivory tower. Those Symbolists

45

who were socialists—and many of them were, especially in the United Kingdom and Belgium—had to create a gulf between their aesthetic beliefs and their work.

The Arts and Crafts Movement, which many scholars have regarded as a mere offshoot of Symbolism, in fact represented an attempt to reconcile opposing aesthetic and political convictions. Its adherents maintained a dedicated opposition to industrialism and its consequences—the sacrifice of beauty to cheapness, of human lives to the Moloch of the machine. But they were no longer content merely to try and shut industrialism out: behind the movement lay a vision of an ideal society, and one of the cornerstones of that society was to be honestly executed handwork, a challenge to the machine on its own ground.

Nevertheless, the middle-class promotors of the new philosophy were rapidly discovering that the way of life they advocated could rapidly degenerate into a form of sweated labor. C. R. Ashbee, founder of the Guild of Handicraft in England, wrote in 1908:

> If we have decided no longer to rebel against the Industrial system, which chains us together, but to quietly and firmly set to work and reconstruct it We find industrial organization ever screwing down and screwing down, we find the drive severer, the competition keener, we find industrial democracy ever closing in[17]

More valuable still were ordinary workers, who suddenly found themselves the victims of a new surge of mechanization:

> Sweating reduced to its true meaning was not the oppresstion of the poor in the interests of the poor; but the effort of an uneconomic system to extract from the misery of the unorganized, ill-equipped worker the equivalent of organized, well paid and well equipped industry. It was the competition of flesh and blood with machinery.[18]

The period 1870–1914 saw a significant division of the working class. Workers in some industries—mostly heavy industry—became increasingly well-organized and militant. They were more aware of their own identity as workers, and increasingly self-assertive. It was an age of strikes. Contemporaries, indeed, regarded strikes as one of the most alarming phenomena of the period. Some had a particularly strong psychological impact, notably the London dock strike of 1889, represented in this book in a painting by Dudley Hardy (Plate 55). The surprisingly numerous paintings of striking workers produced at this period are a tribute to the concern people felt, and certainly they add an entirely new subject to Western art. Though there were complaints that strikes in fact gained the

workers nothing, since any rise in wages was immediately eaten away by a rise in the cost of living, there was an improvement in the living-standards of those who could organize themselves, in addition to a huge increase in self-respect.

For others, self-respect was an undreamed-of luxury. These were people— many of them women—who worked at home or in small workshops, making matchboxes and cheap toys, laboring as tailors and seamstresses, working in the heat and steam of big laundries. (In England, laundry workers could legally be asked to work for fourteen hours at a stretch, and the limit was often exceeded). In all the large industrialized countries, millions of people lived below the poverty line, and it needed only the slightest encounter with misfortune to send them sliding toward complete destitution. If there was not enough work, they starved. If there was work, the wages given for it were so low that the worker spent all of his or her waking hours in an unceasing grind. Nearly all piece-work fell into this category.

Members of the more fortunate classes found it difficult to understand how people could be so poor if they were willing to work at all. The destitution of the unorganized piece-worker was all too often put down to fecklessness and idleness, and it needed a great campaign of reform before these attitudes could be changed. Often, as we have seen, the investigators had difficulty believing the evidence that they themselves had unearthed, and spent much effort and ingenuity in trying to avoid what to us are obvious conclusions.

One cannot be surprised, therefore, that the full horrors of sweated labor are not represented in the art of the time. Even so, the hints are there in some paintings. The carelessly patrician John Singer Sargent, in his picture of Venetian bead-stringers, cannot avoid giving us a glimpse of the toil to which these women were condemned. Max Liebermann's *Women working at a canned food factory* (Plate 27) and S. Melton Fisher's *Clerkenwell Flower-makers* (Plate 31) show scenes from which a sterner moral can be drawn than that which the artists intended—if, indeed, they meant to moralize at all.

Where the artists had a shrewd instinct for the realities of the situation was in their representation of human relationships. Experts on Van Gogh (who belongs precisely to the same generation as most of the artists represented here) often speak of the work of his early or "dark" period, when he painted the peasants of Nuenen, as if it amounted to a unique act of sympathy for the poor and oppressed. This is not quite the case. Van Gogh wrote to his brother Theo, concerning *The Potato Eaters* of 1885:

47

I intended to keep conscientiously in mind the suggestion to the spectator that these people eating their potatoes under the lamp and putting their hands in the plate, have also tilled the soil, so that my picture praises both manual labor and the food they have themselves so honestly procured. I intended that the painting should make people think of a way of life entirely different from our own civilized one. So I have no wish for anybody to consider the work beautiful or good.

It is only in the last sentence that Van Gogh exceeds the ambitions of many of the academic or Salon painters of his time. The rest of the passage could apply to their work almost as well as it does to his.

We may say, and rightly, that what the Salon painters produced was a far more superficial kind of art, the work of talent not genius. But it is too easy to dismiss the numerous sickbed and deathbed scenes, for example, as being due entirely to the sentimentality of the age. While scenes of this kind undoubtedly appealed to the narrative painter's instinct for the dramatic, and provided an efficient way of communicating with the public, the ideas he wanted to communicate were not unworthy, nor were they necessarily falsified in the process of embodiment.

A number of paintings convey with great vividness the terrible anxiety of the working-class family when the breadwinner fell sick. They mirror, too, the miserable conditions in which people were forced to live. Decent housing remained a problem, even for relatively skilled and prosperous members of the working class.

It is worth asking if these pictures were more or less effective as an instrument for social change than the photographs that were beginning to be taken at the same time, most notably by the pioneering reformer-journalist-photographer Jacob A. Riis. Riis's photographs of the New York tenements and the people who lived in them help to elucidate not only some of the important differences between photography and Naturalist painting, but some essential features of the narrative paintings reproduced in this book.

Even at this date, painting may be thought of as fighting a losing battle to retain its traditional function in Western society. Its opponent was the photograph, which seemed capable of usurping many of art's functions and performing them more efficiently. Photography could claim to be more accurate as a means of conveying information and to outdo painting in the sheer quantity of facts which the image could contain.

Riis' own work is an outstanding example, not only of the photograph's power

48

to convey information, but of its ability to impose conviction as well. It imposes a confrontation on the spectator. These images, unposed and unretouched, have the air of unvarnished truth. At the time they were made, trust in the camera's essential objectivity had still not been shaken, even to the extent that it has been now, and what they contained could not be discounted as distorted by the artist's own temperament and prejudices.

On the other hand, there is something extraordinarily alien and alienating about documentary photography of this type: the spectator feels acutely the gap between himself and what is shown. The Naturalist painters were skillful at bridging this gap. They sought for a general truth beneath the surface of what was represented; they endeavored to show that, while men's circumstances might differ, the basic human emotions remained unaltered; they tried to demonstrate, above all, that these were not brutes but suffering men. On the whole, we must admit that they succeeded, and that they preserved their honesty in the process.

It is therefore a mistake to say, with whatever nuance of meaning, that the paintings they produced are "just like photographs." From the compositional point of view, they are of course far more elaborately orchestrated than any photograph of the period could hope to be, even those that were composites of several negatives. But what really counts is an inner coherence, emotional as much as purely visual, which photography could rarely achieve. And the ability to achieve this coherence was put at the service of ideals which deserve our respect.

It is a strange irony that the painters themselves were in some respects in a corresponding position to the sweated laborers whose lot they occasionally attempted to depict. Like these workers, they were in competition with the machine, which could produce what they produced—a lifelike image—both more quickly and with greater efficiency. It was only the continuing prestige of art itself and the corresponding refusal to acknowledge photography as a fine art that preserved them from the economic consequences which the sweated laborers of the slums and tenements were forced to face. It was now the philosophical, not the social and economic position of the artist that threatened to become untenable.

X.

When we consider the paintings collected here, and the messages they convey we have to think not only of the audience for whom they were painted but of the

49

artist himself. His position in society certainly affected his attitude toward what he saw, and made him more sensitive to some issues than he was to others. The painters who produced these works were not Bohemians, but well-established professional men. During their period as students (almost invariably at official art schools) they may have sampled the *Vie de Boheme* so seductively described by Henri Murger in his novel of the same title (and now most familiar to us from Puccini's opera *La Boheme*), but for most of their careers they pursued a very different way of life.

Artists had achieved respectability long before the nineteenth century. Sir Peter Paul Rubens served as an ambassador between sovereigns, and was knighted by James I; Sir Joshua Reynolds was one of the dominating figures in the London society of his time. But by the late nineteenth century, this respectability had become a settled matter, scarcely to be questioned. So settled was it, indeed, that the moment had come for a new challenge. The old system of officially sponsored Salons was just beginning to break up and was soon to be replaced by what has been labeled the "dealer-critic" system, the loose but effective network of marketing and promotion with which we are familiar today. One motivating force in this change was the fever for speculation which possessed the middle class. Art became a commodity and, as with most commodities, there were fluctuations in the market. An important side effect was the release of the artist from his social strait-jacket. Picasso, though he achieved world renown, still managed to remain a Bohemian all his life.

It is tempting, however, to see these developments as happening earlier and more completely than they did. "Outcasts" such as Gauguin and Van Gogh were not typical of the art world of their time. This, indeed, was why they were made to suffer so acutely. Even though there was already speculation in taste, the survival of the official system provided an important check to it. The artists still thought it vital to be accepted at the Salon or the Royal Academy, to be praised for their exhibits, and eventually to be given some kind of official recognition—the Legion of Honor in France, perhaps a knighthood in England, or election to the National Academy of Arts in America.

One characteristic shared by many of the painters whose work is included here is that they were conformists within their own institutions. They made use of the opportunities which the official system gave them even more willingly than they did the approaches of the dealers. In their view success in the Salon was the main means of generating private sales elsewhere. Even the Impressionists would

50

have preferred success within the framework of the system rather than outside it.

It is perhaps not surprising, therefore, to find a bias toward institutional scenes in the subjects treated by these artists. We are shown schools, prisons, clinics and hospitals. Perhaps most numerous of all are the paintings that show institutions devoted to the care of the aged. At work in these paintings there are several apparently contradictory forces, some of them social and some of them aesthetic.

From the aesthetic point of view, the institutional framework provided the narrative painter with special advantages. The personages were immediately recognizable and played more-or-less fixed roles, which made it easy to give drama to the story and equally easy for the spectator to see what was going on. By dealing with a relatively large number of figures, arranged in complex patterns, the painter had an opportunity to impress the public with his skill. Scenes of this type were the modern equivalent of the large, complex historical paintings which were now beginning to lose favor because of their obvious artificiality. Finally, the old seem to have attracted attention because of the universal respect for Rembrandt: the faces of old men in pictures of this kind are often treated in a conspicuously Rembrandtesque way, so much so that such details may look out of place.

When we analyze the character of the institutions themselves, we find they fall into two categories. On the other hand, there are new organizations, forerunner of the elaborate system of state welfare that now exists in European democracies such as England, Holland and Scandinavia. On the other hand, there are charitable institutions with their roots in the Middle Ages. A good example of the latter is J. J. Geoffroy's *Convalescents in the 'Gran Chambre des Pôvres', Hospice de Beaune* (Plate 206) where the artist shows us something that has centuries of continuity behind it. Geoffroy was a specialist in hospital and medical scenes, especially those involving children, and one of the most faithful recorders of the charitable institutions of his time. This very fidelity makes us aware of the failure of the institutions themselves, and this awareness is sharpened when we confront these paintings with the statistics which are available in the social surveys carried out at the same period.

One wonders if the contemporary audience was aware of this inadequacy. The paintings make one suspect that it was not. What is modern is recorded in a spirit of complacency, what is ancient is clothed in nostalgic indulgence. Yet, taken together, the pictures amount to an indictment of late nineteenth-century society; and, seeing them *en masse* at the various official exhibitions, contemporaries must have been at least subliminally aware of the defects being exposed. The compulsive

truth that was the creed of Naturalism made the painter a dangerous witness, even when he was himself apparently unaware of the implications of what he recorded.

XI.

How, then, did art and artists function in late nineteenth-century society? In order to answer this question we must look at the painters included here from several different points of view. National origins, national sentiment, social class and method of professional training are all relevant. The Register of Artists which we have included as an appendix to the main text shows that the national origins of the artists concerned were in fact extremely diverse. Almost all the major European nations are included, in addition to the United States, Canada and Australia. Nevertheless, the illustrations demonstrate a considerable uniformity of style.

The wide geographical spread and accompanying stylistic unity can be accounted for in several different ways. Naturalism was one of the best-disseminated of European art-styles, acceptable everywhere because it communicated facts people knew in a visual language they found easy to assimilate. The diverse national origins of the artists did not mean that aspiring artists were trained by very different methods, according to their place of origin. The basic process of art instruction, based upon methods first devised by the Carracci and by other Bolognese academics at the end of the sixteenth and beginning of the seventeenth century, tended to be the same everywhere. The situation is very different today, when people no longer have any feeling of certainty that "art" can be taught at all.

In addition to this, it will be seen from the Register that nearly all artists, wherever they were born, tried to complete their artistic education in Paris, preferably at the Ecole des Beaux-Arts, and preferably under some celebrated teacher such as Bonnat, Bouguereau or Gérome. The attraction of Paris was such that many young foreigners, having gone there to complete their education, were never able to bring themselves to leave it entirely. It was a common pattern with successful Scandinavian artists, for example, to base themselves in France while continuing to pay long summer visits to their northern homelands.

Even for those artists who remained firmly rooted in their countries of origin,

a well-developed system of international exhibitions allowed opportunities to see what was being done elsewhere and measure themselves against their rivals. These exhibitions also kept the public in touch with the international progress of art, and helped to confirm the belief that Naturalism was the stylistic norm from which everything else was a mere deviation.

Yet if Naturalism was *par excellence* an international phenomenon, the content of the paintings is often paradoxically nationalistic. Like the writers and musicians of the period, the artists could not remain unaffected by the search for national origins that was everywhere going on around them. This was one of the artistic as well as political themes of the period leading up to the First World War, and accompanying it was a vigorous assertion of national loyalties. For the history painter, this meant treating incidents that seemed to be of key importance in the story of his own country's development. For the artist who preferred to show the everyday life around him, it meant a search for whatever seemed most "typical," whatever best expressed the character of the nation to which his loyalty was given.

Naturally enough, the search for national identity was pursued most vigorously in those nations which were either genuinely new, such as the United States, or which were undergoing a traumatic period of renewal, such as Russia. In this context it is often forgotten that the freeing of the serfs in Russia in 1861 marked a change almost as important as the final overthrow of the tsarist autocracy in 1917. The feeling of change was reinforced in Russia, just as it was in America, by rapid industrialization and particularly by the building of the railroads, which completely altered the economic life of the nation.

It is not surprising, therefore, to find distinct resemblances between the American and Russian realists of this period. There is a spiritual kinship between the artists of the American "Ashcan" school—among them John Sloane, Everett Shinn and George Bellows—and the members of the group called the "Wanderers" in Russia, one of the most prominent of whom was Ilya Repin.

One thing which the "Ashcan" painters and the "Wanderers" have in common is that they were considered socially disruptive in their own time, and in this they form a distinct contrast to most of the other artists whose work is included in this book. The "Ashcan" painters, though not stylistically innovative, did tackle subjects that the American public had, up till then, considered unacceptable in art. By doing so they made available a whole new area of the American experience, something which the public found as painful as it was stimulating. It was for this reason that they were rightly represented in the epoch-making New

53

York Armory Show of 1913, which brought modernism to the American continent.

If the work of the "Wanderers," and particularly of Repin, seems to have a more sharply political focus than anything painted in America at the same period, this is due to a difference of circumstances. The "Wanderers," who came together under the patronage of the Russian railway tycoon Savva Mamontov, were faced by a rigid political situation, and this rigidity extended to the administration of art. American art-institutions were decentralized and weak; in Russia everything was controlled by the Petersburg Academy of Art, which had ruled the artistic life of the country since its foundation by Catherine the Great in 1754. It was from this institution that the group which was to become the "Wanderers" seceded in 1863. Mamontov's protection enabled them to survive the consequences of their action, and this meant immediate ostracism from the official hierarchy.

One reason that the "Wanderers" seceded was dissatisfaction with the official attitude toward the social function of art. Chernishevsky, an aesthetic propagandist of the period who influenced the Mamontov group, proclaimed that "The true function of art is to explain life and comment on it." He also declared that "Only the content is able to refute the accusation that art is an empty diversion." It was perhaps only in backward Russia, at this period, that such notions could come as a shock.

Repin, who was somewhat younger than the original nationalist painters in Russia, was the most successful in carrying out their ideals. In paintings such as *They did not expect him* and the famous *Volga Boatmen* he created images that everyone recognized as having a significance well beyond what the incident depicted. In tsarist times, as in Soviet Russia today, the arts had an intensity of social and political significance which reflected the lack of other channels through which ideas about society and government could express themselves.

Because he seems to foreshadow the October Revolution and its consequences, Repin is reverenced in Russia today, and is regarded as the begetter of the Socialist Realism which is officially approved and supported by the Soviet authorities. Does this mean that he is in any sense to be regarded as a Marxist painter? When Engels spoke at Marx's funeral in 1883, he tried to sum up in a few words the life-work of his friend and collaborator. "Marx," he said, "was above all a revolutionary."

To co-operate in one way or another in the work of bringing about the downfall of capitalist society and the state institutions which are its creations, to co-operate in the liberation of the modern proletariat, to make it conscious

of its situation and its needs, and conscious of the conditions for its own emancipation—that was his real life-work.[19]

Even Repin, who is perhaps the most politically revolutionary of the artists included in this book, seems to fall far short of this description. The "Wanderers," it is true, received their name because they believed in bringing art to the people, and put their beliefs into practice by taking traveling exhibitions to the Russian countryside. But the content of these exhibitions would not have fit the Marxist requirements. There is a wide difference, here, from the *Agitprop* trains devised by the Constructivists at the height of their revolutionary fervor in the early twenties.

The painters represented in this book accepted, though in rather varying degrees, the essential framework of the society in which they lived. The schools where they received their professional training were often organized and run by the state. The exhibitions where they showed their work often had, as we have noted, an "official" character, even when they were in fact the responsibility of self-governing and self-perpetuating corporations of artists. Artists were more than happy to accept, not only the medals and diplomas which were so lavishly handed out on the occasion of any international exhibition, but the honors offered by the state. Those painters who began in humble circumstances were more than happy to be translated by success into the bosom of the professional class. In all these respects they thoroughly identified themselves with the *status quo*.

If anything is certain, therefore, it is that the images collected here do not amount to a cry of rage against a hopelessly corrupt society. Nor were they intended as a denunciation of capitalism. So far as the artists were concerned, the society they lived in was far from irredeemable; and everything indicates that they not only accepted capitalism but were often themselves capitalists on a small scale. However, they were too intelligent and too perceptive not to be aware of specific evils, though we may feel that their attitude toward these evils was sometimes exploitative. The public for which they worked enjoyed having its feelings harrowed—in this respect resembling almost any public. There are some paintings here whose essential truthfulness we can recognize, while acknowledging at the same time that the artist is inclined to turn the sentimental screw.

A more conspicuous feature of these works, however, is that the artist, though on the one hand trying to report objectively what he has seen, also feels free to react in his character as a moralist. What was new about these Naturalist works at the time they were painted was that the moral commentary which the public

expected was less obvious than it had been before. Contemporaries were some-times inclined to denounce the Naturalist school for what they called its "im-morality," and the absence of overt comment was exactly what they objected to. They made the same objections to Zola's novels. We should be too wise to fall into the same trap. What makes many of these paintings so moving, and in the long run so effective, is the artist's ability to give them a moral centre without falsifying what he has seen.

This morality, in turn, with its fixed polarities of "good" and "evil," is hateful to the Marxist. Marxism preaches that capitalism must be destroyed root and branch, and bourgeois moral value with it, because they are inextricably bound up with the rest of the system.

The distortion inherent in a collection of this kind is that it brings into sharp focus a particular aspect of late nineteenth-century experience, and makes us concentrate on things which the men of the time perceived in a more diffuse and subliminal way. If the most diligent social researchers found difficulty in accepting the real meaning of what they had discovered, can we blame the artists for being blind to the wider implications of much that they painted?

Nevertheless, we ought to do these painters, who have been until recently so systematically neglected, the justice of recognizing that theirs was, both morally and socially, a more complex and a more sophisticated art than what has suc-ceeded it. It is not merely that the Soviet "Tractor School" is a caricature of Repin. It is also that the Modernism now ascendant in the West is morally inert and unable to deal with the simplest social, political or moral issues without becoming crudely propagandistic. The Naturalism represented here was in certain respects inadequate to its time, as all art since the Industrial Revolution has been. But it was nearer to providing a satisfactory response to the terrible problems of the late nineteenth century than art since 1945 has been in relation to those of post-atomic and late capitalist society.

1. Victor Cherbuliez, *Etudes de litterature et d'art* (Paris, 1873), pp. 235-6.
2. ibid., pp. 290-1.
3. Jules Claretie, *L'art et les artistes francais contemporains* (Paris, 1876), p. 5.
4. ibid., p. 123.
5. ibid., p. 225
6. J. K. Huysmans, *L'art moderne* (Paris, 1883), p. 5.
7. ibid., p. 49.
8. ibid., p. 132.
9. ibid., pp. 153-4.
10. Gustave Geffroy, *La vie artistique*, 7me serie (Paris, 1901), p. 190.
11. Gustave Geffroy, *La vie artistique*, 4me serie (Paris, 1896), p. 255.
12. ibid., pp. 320-1.
13. Beatrice Webb, *My Apprenticeship* (London, 1926), pp. 173-4.
14. Maurice Malingue, editor, *Paul Gauguin: Letters to his wife and friends* (London, 1948), p. 70.
15. Louis Paulian, *The Beggars of Paris* (London and New York, 1897), p. 116.
16. ibid., pp. 180-1.
17. Quoted by Gillian Naylor, *The Arts and Crafts Movement* (London, 1971), p. 171.
18. Clementina Black, *Sweated Industry* (London, 1907), pp. x-xi.
19. Quoted by Boris Nicolaievsky and Otto Manchen-Helfen, *Karl Marx: Man and Fighter* (London, 1973), p. x.

1. GEORGE SMITH *Sleeping Boot Boy*. c. 1880.
Boot boys, like chimney sweeps, were examples of the kind of child labor that appealed to public
sentimentality. Children in factories were out of sight, therefore out of mind.

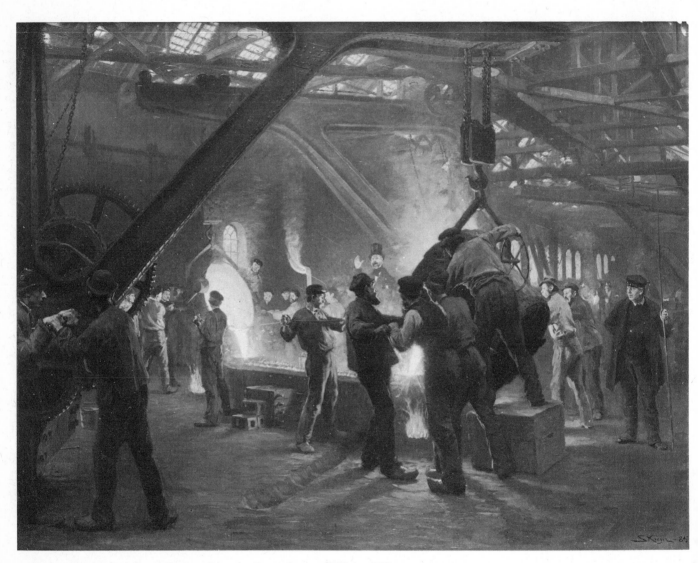

2. PETER SEVERIN KRØYER *The Iron Foundry Burmeister and Wain.* 1885.
Krøyer is one of the ablest late nineteenth century painters of industrial scenes.

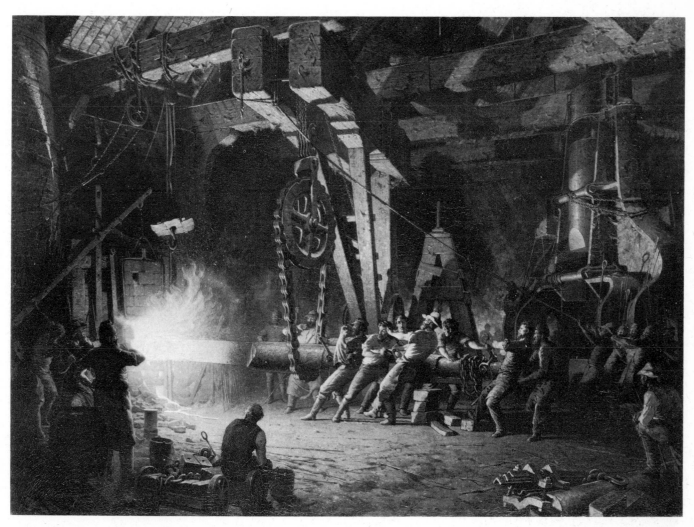

3. JOHN FERGUSON WEIR *Forging the Shaft*. 1877.
This scene was painted at the West Point Foundry in Cold Spring on Hudson.

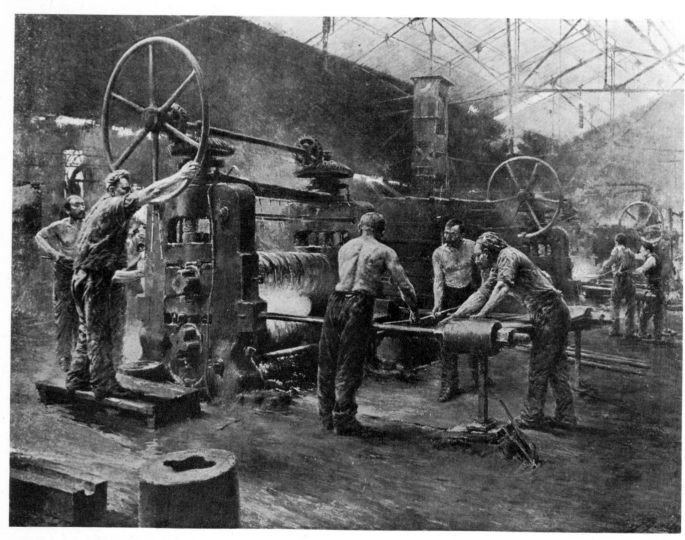

4. FERDINAND-JOSEPH GUELDRY *The Rolling Mill.* c. 1901.

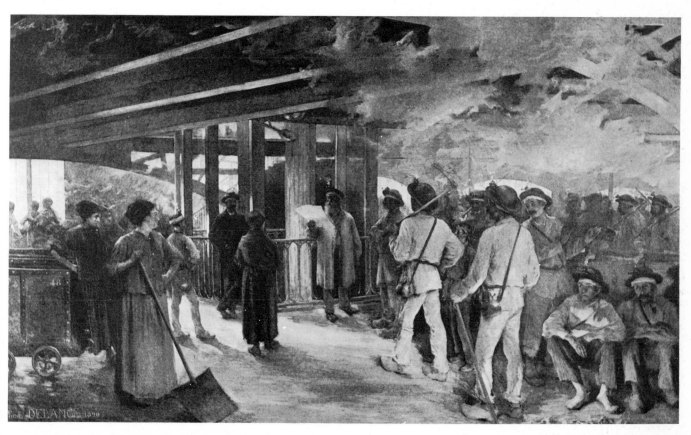

5. PAUL DELANGE *The Miners' Roll Call*. 1890.
The presence of above-ground women workers can be noted on the left.

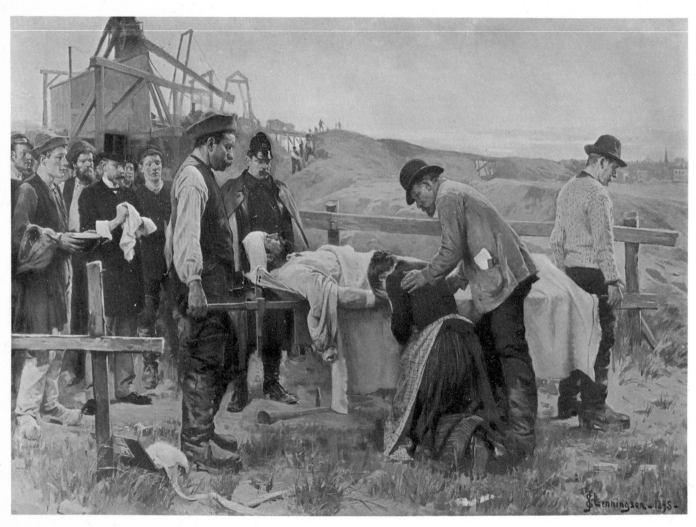

6. Erik Henningsen *A Wounded Workman.* 1895
Industrial safety codes had not yet been developed.

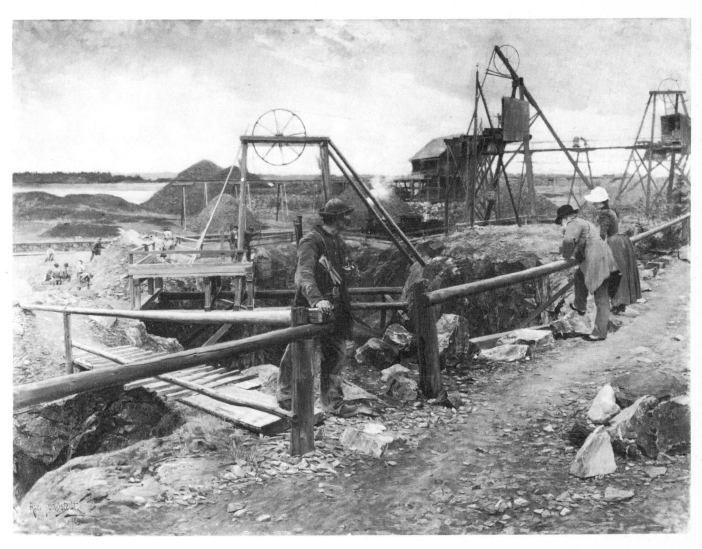

7. AXEL JUNGSTEDT *The Mines at Dannemora*. 1890.
Another example of the unromantic clear-sighted vision of industrialism possessed by Scandinavian artists.

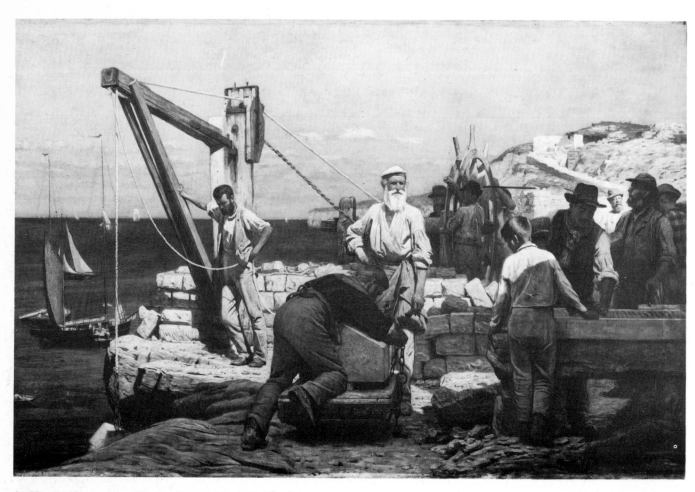

8. HENRY TAMWORTH-WELLS *Quarry Men at Purbeck*. c. 1885.
Purbeck marble is used for column shafts in many English cathedrals and the industry shown is a
traditional one.

64

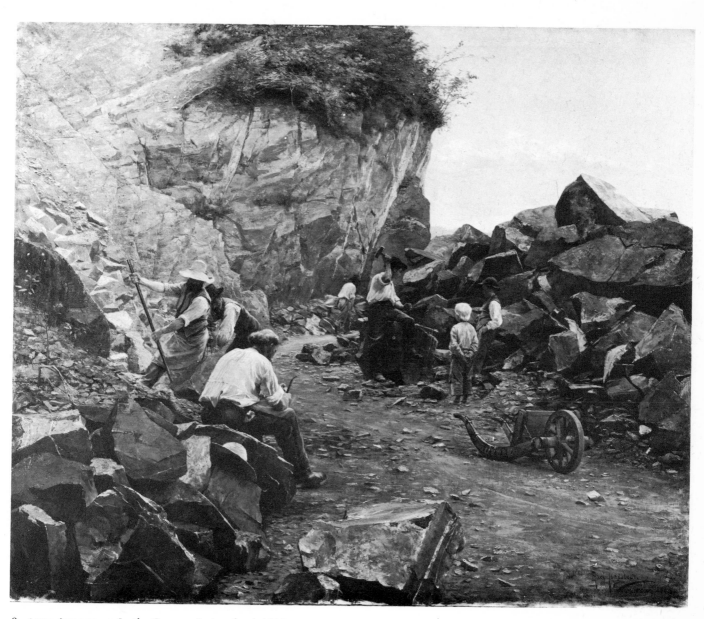

9. AXEL JUNGSTEDT *In the Quarry, Switzerland.* 1886.

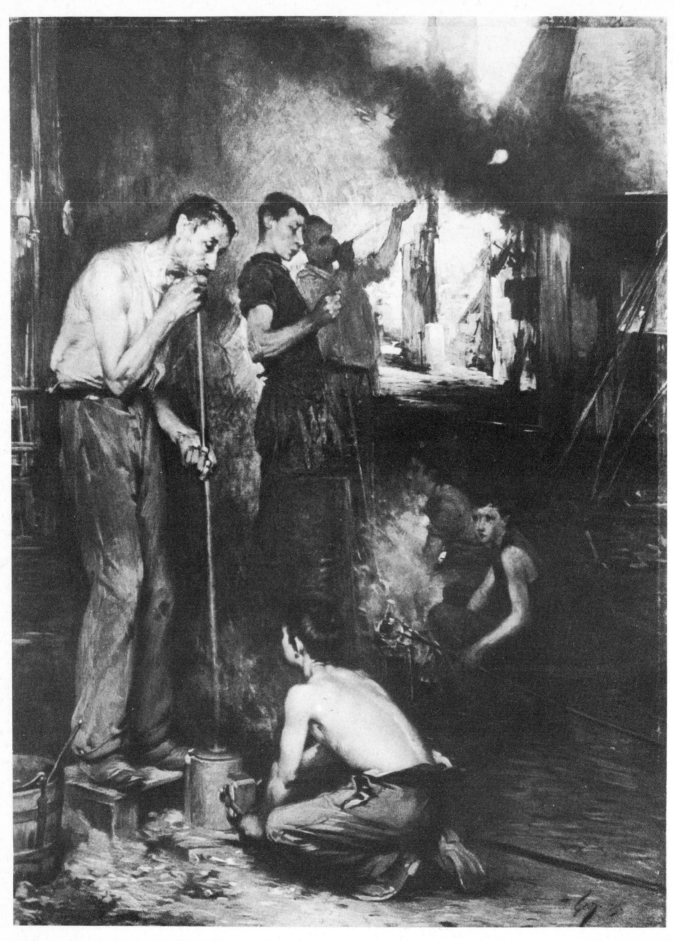

10. JULES JEAN GEOFFROY *The Glass Blowers*. 1905.
Glass-blowing techniques have changed very little—a similar scene appears in a medieval manuscript.

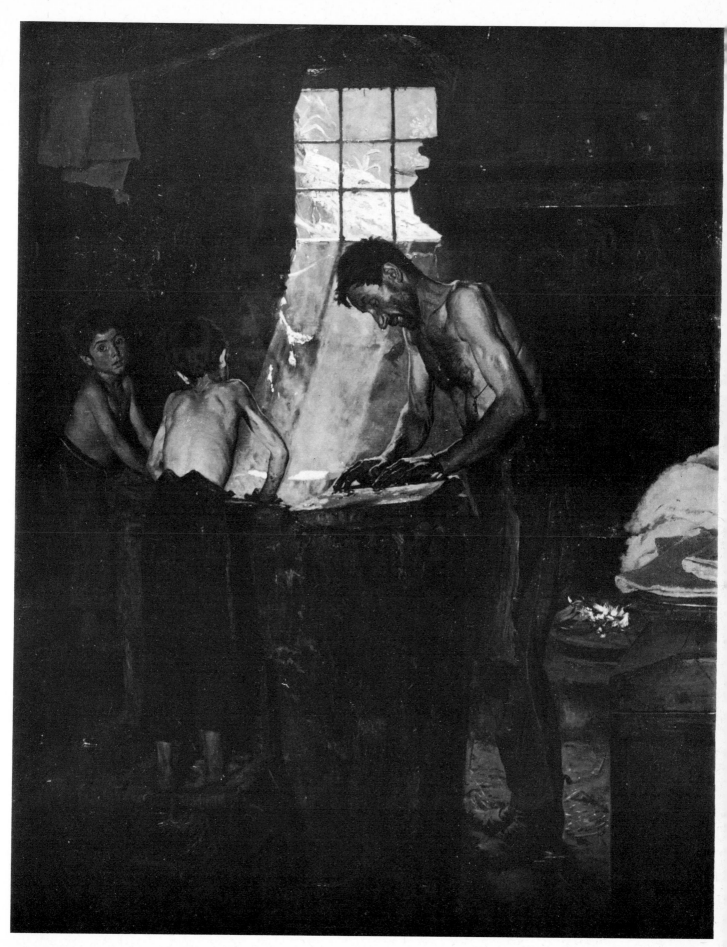

11. PETER SEVERIN KRØYER *The Italian Smith, Sora*. 1880.
This picture caused offense when first shown because it was considered too realistic. The drop of sweat on the smith's nose was especially objectionable.

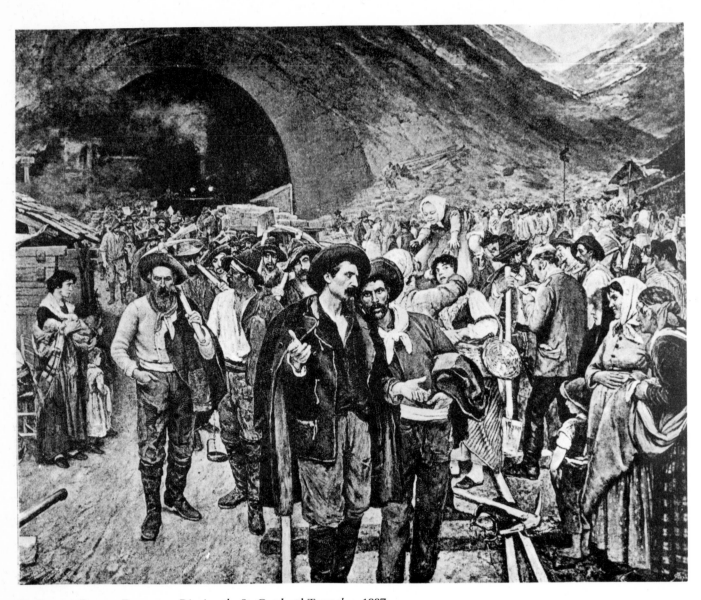

12. ERNEST PHILIPP FLEISCHER *Digging the St. Gotthard Tunnel.* c. 1887.

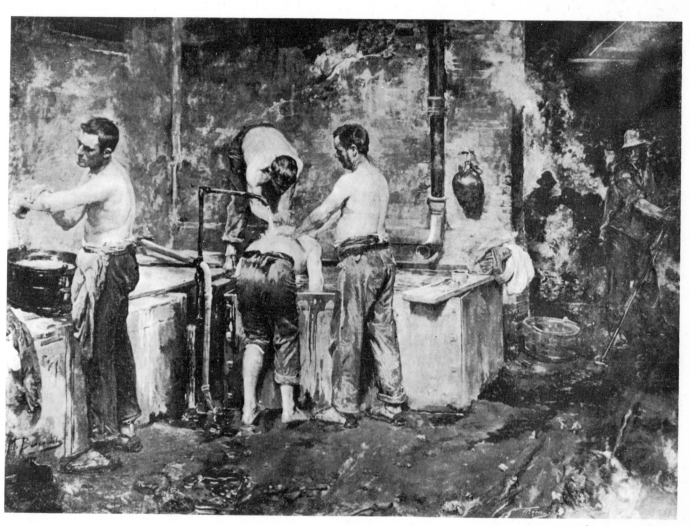

13. MANUEL BENEDITO *Washing after work*. 1897.

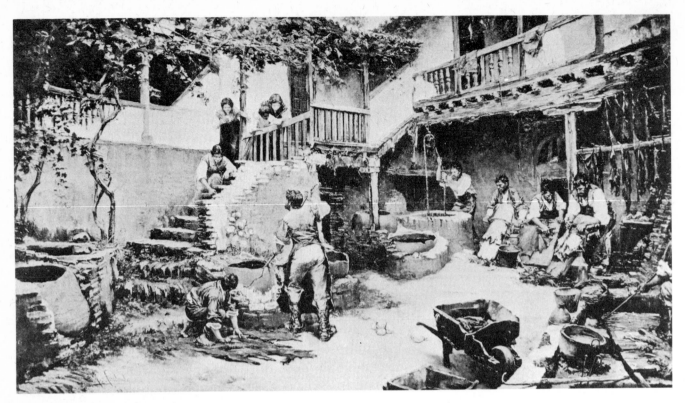

14. RICARDO ARREDONDO *The Tannery*. c. 1897.

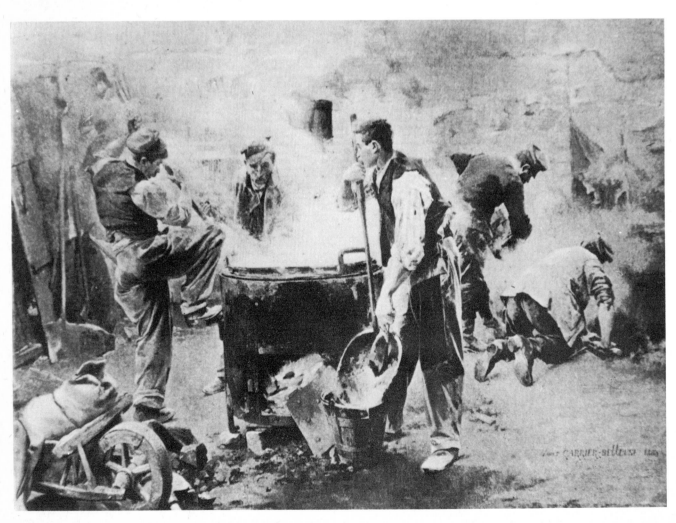

15. PIERRE CARRIER-BELLEUSE *Road Menders in Paris*. 1883

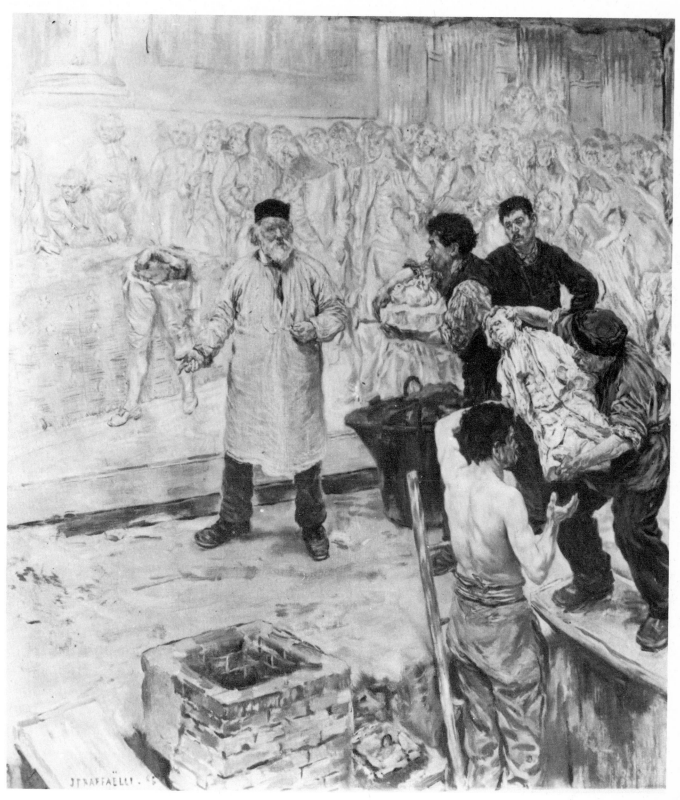

16. JEAN FRANCOIS RAFFAELI *At the Bronze Foundry*. 1886.
An example of the small "craft" industry which continues to flourish in Paris.

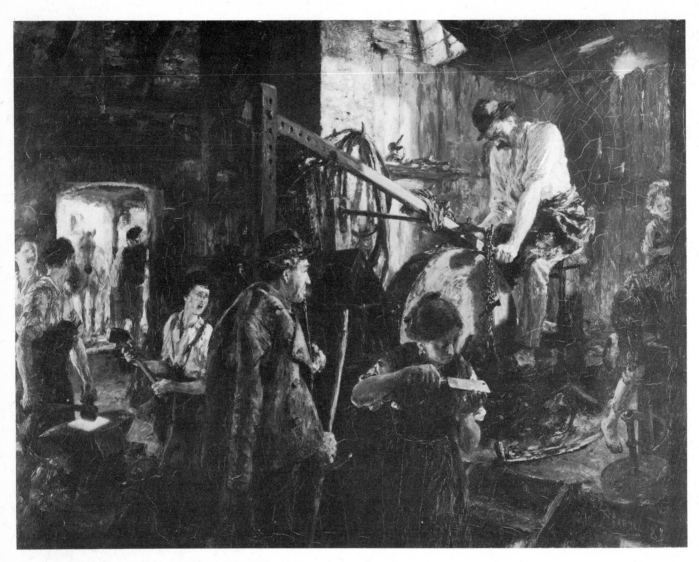

17. ADOLF VON MENZEL *The Knife Grinder.* 1881.

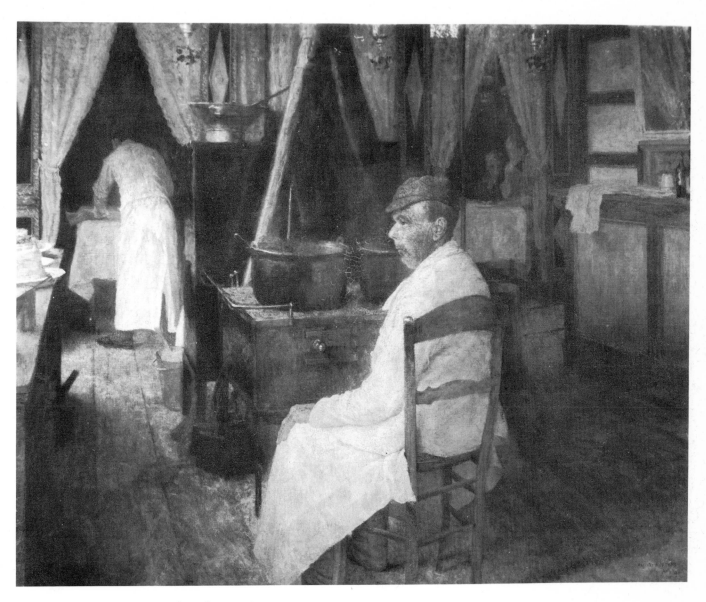

18. CHARLES MERTEN *The Wafer Seller*. 1880's.

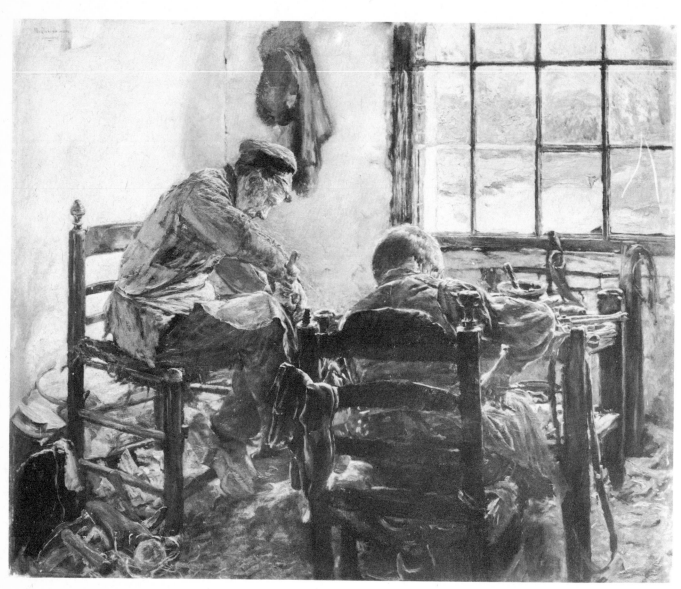

19. MAX LIEBERMANN *The Cobbler's Shop*. 1881.

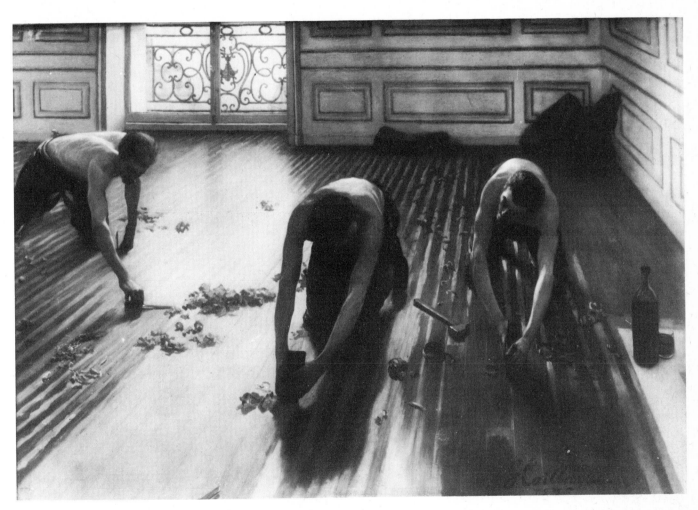

20. GUSTAVE CAILLEBOTTE *Finishing the Floorboards*. 1875.
Note the traditional litre of red wine to the right.

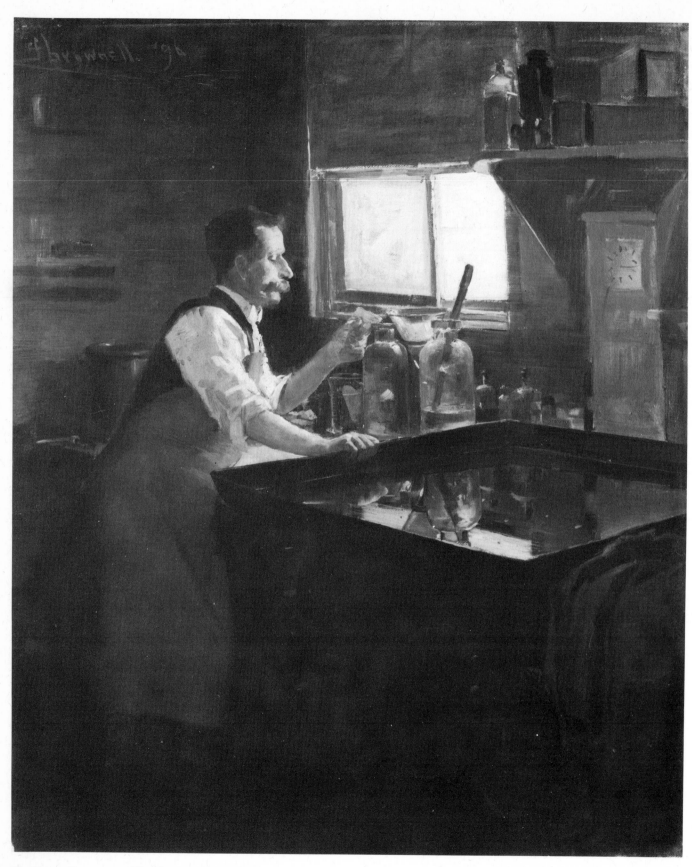

21. FRANK BROWNELL *The Photographer*. 1896.
Photography was a new craft, and it is appropriate that it should have been recorded by a painter in one of the "developing" countries.

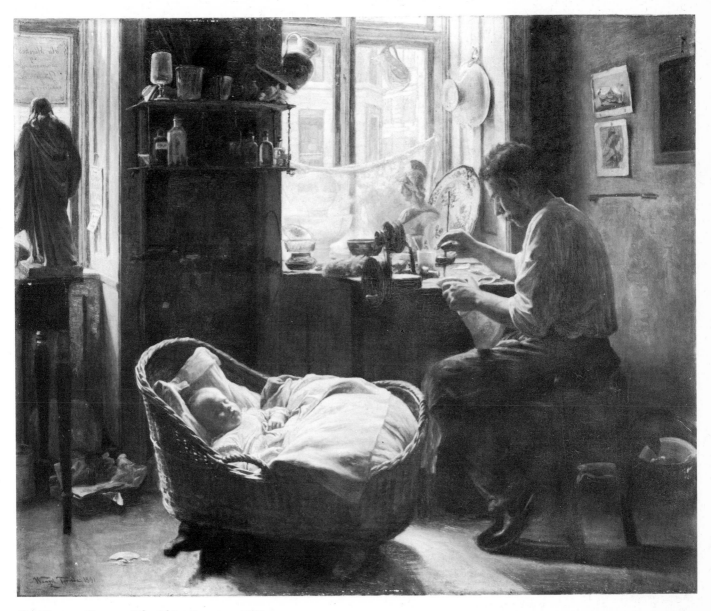

22. Wenzel Tornoe *The China Repairer*. 1891.

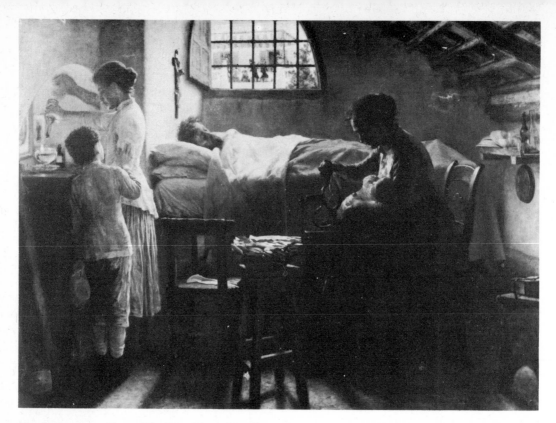

23. GIOACCHINO TOMA *The Poor Man's Family*.
This picture shows some of the realities of sweated labor. The wife must continue to work as she watches by the bedside of the principal breadwinner.

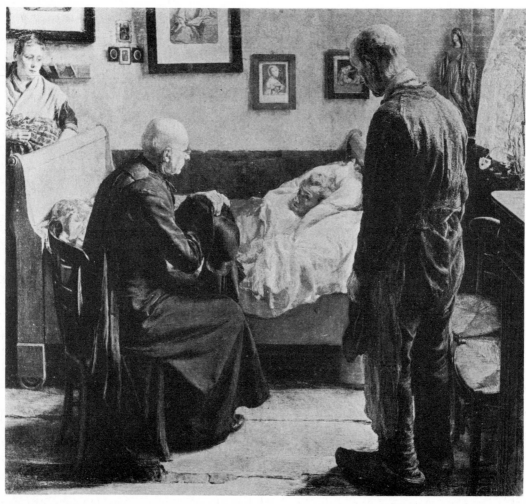

24. ALEXANDRE STRUYS *Visiting the sick*. c. 1895.
A household of reasonably prosperous peasants. The bed—elegant but then unfashionable—dates from sixty years before the picture was painted.

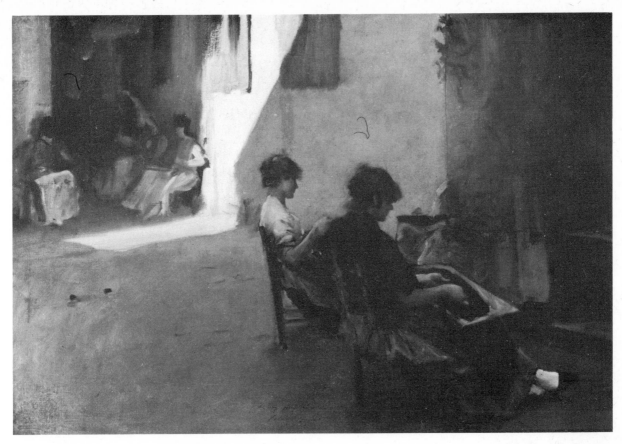

25. JOHN SINGER SARGENT *The Bead Stringers of Venice.*

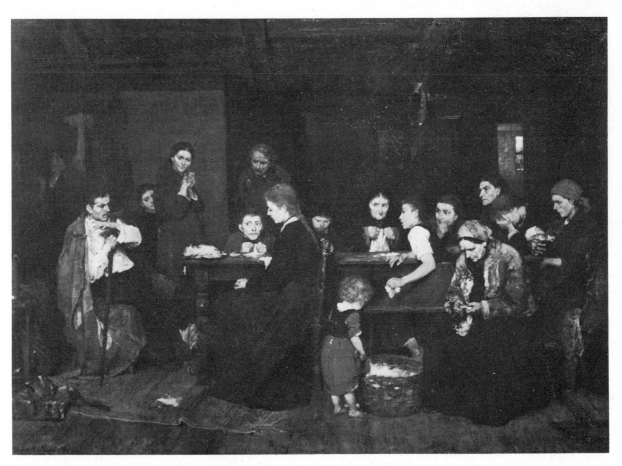

26. MIHALY VON MUNKACZY *Charpie Makers.* 1871.
The women and children are making pads for wounds.

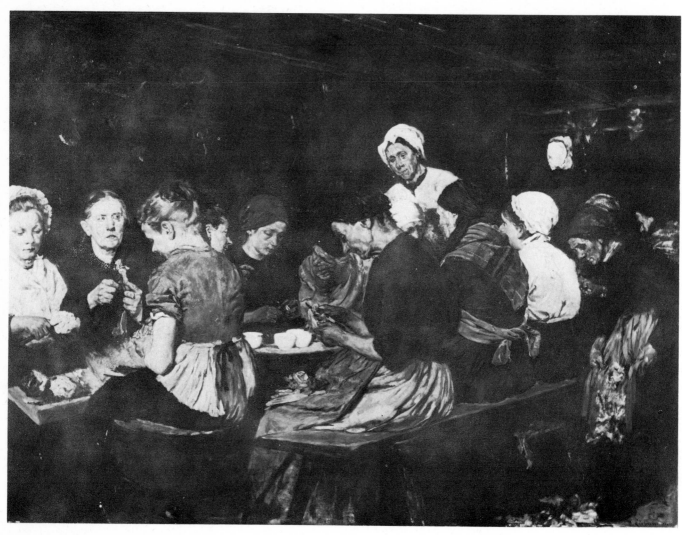

27. MAX LIEBERMANN *Women working at a canned food factory.* 1879.
Painted in Holland.

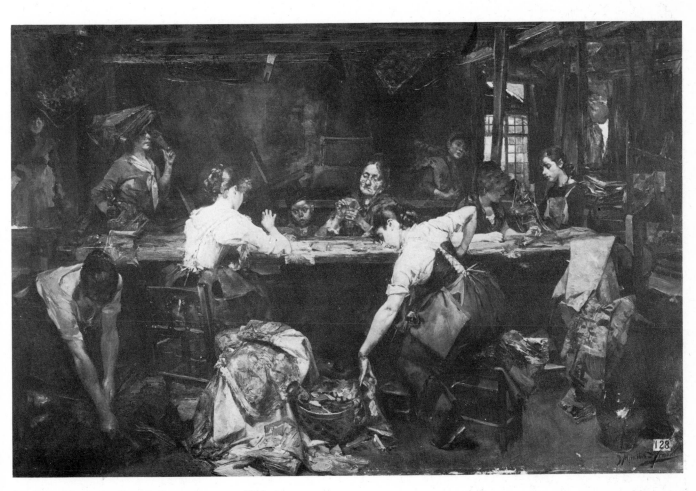

28. JOSE MIRALLES *Curtain Seamstresses*. c. 1891.

29. ANDERS ZORN *The Large Brewery*. 1890.

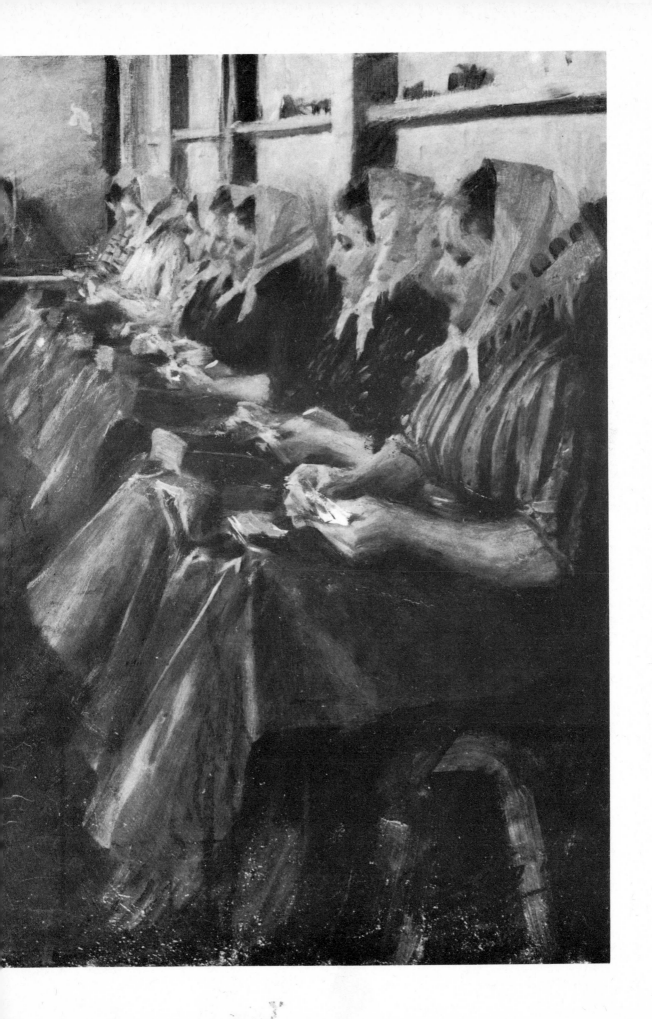

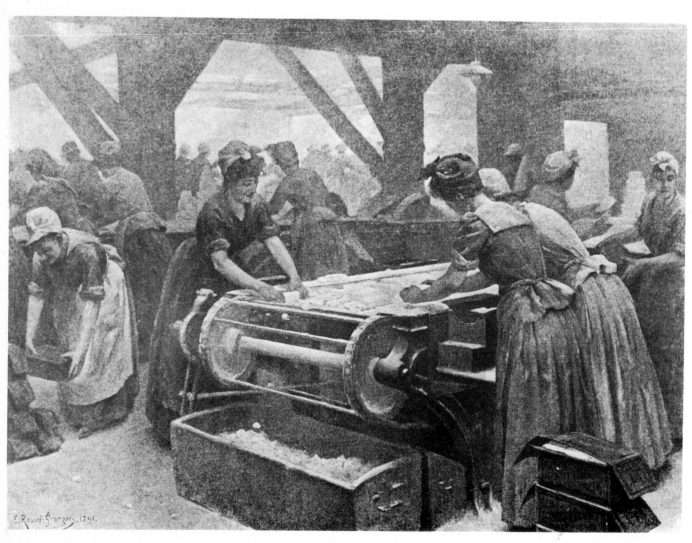

30. EDOUARD ROSSET-GRANGER *The Sugar Crushing Machine*. 1891.
A sugar refinery staffed by women workers.

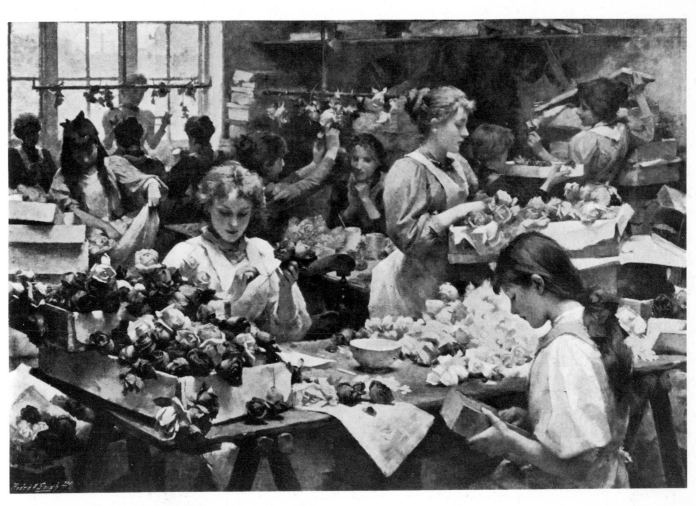

31. S. MELTON-FISHER *Clerkenwell Flower-makers*. c. 1902.
A good example of female sweated labor in the East End of London.

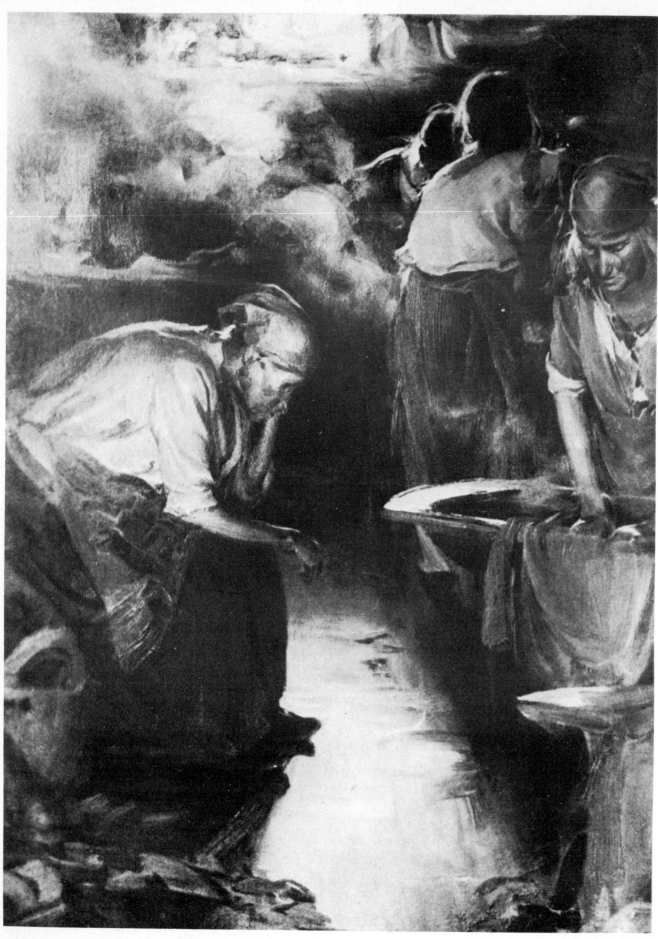

32. ABRAHAM ARCHIPOV *Laundry Women*. 1901.
Laundry work was among the heaviest work done by women.

33. EDMUND HARBURGER *The Seamstress*. 1887.

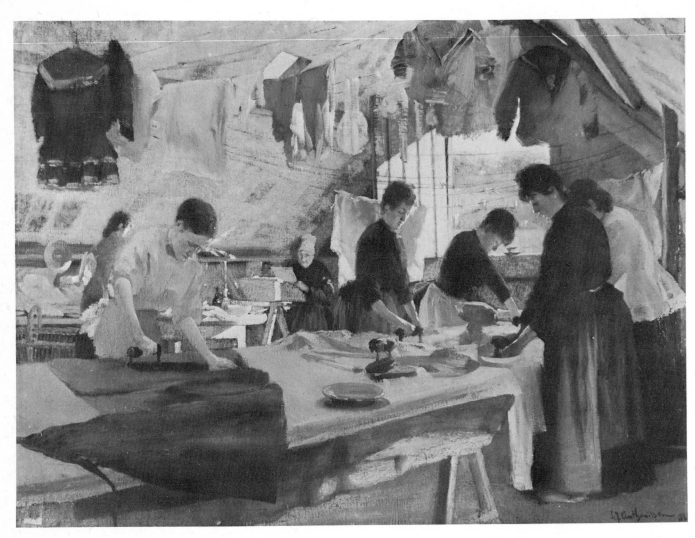

34. LOUIS JOSEPH ANTHONISSEN: *Ironing at Trouville.* 1888.
Note the old-fashioned bathing dress hanging on the left.

35. RENE GÉRIN *The Manicure.* c. 1896.
A scene from the demimonde. The man at the right is the protector of the beauty who reclines on the chaise-longue.

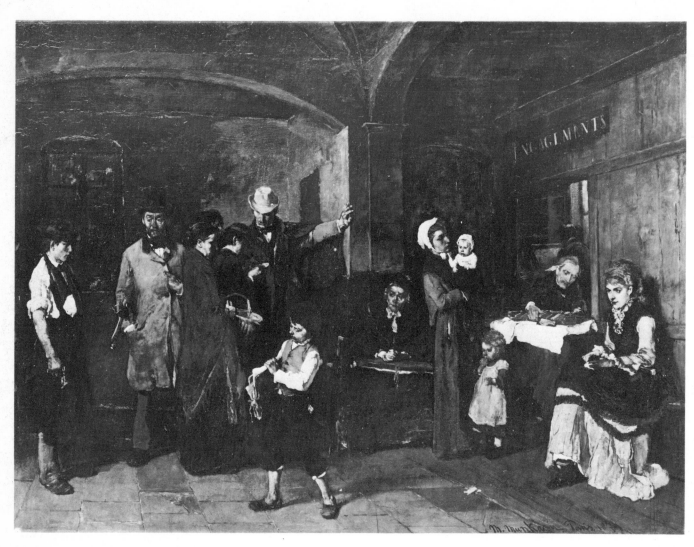

36. MIHALY VON MUNKACZY *The Pawnbroker.* c. 1891.

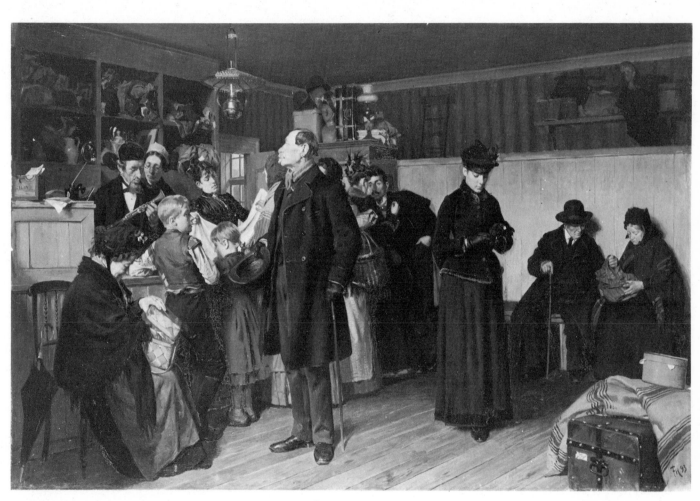

37. FRANS HENNINGSEN *The Pawnshop*. 1893.
Here the pawnbroker wears a skullcap, and seems to be Jewish.

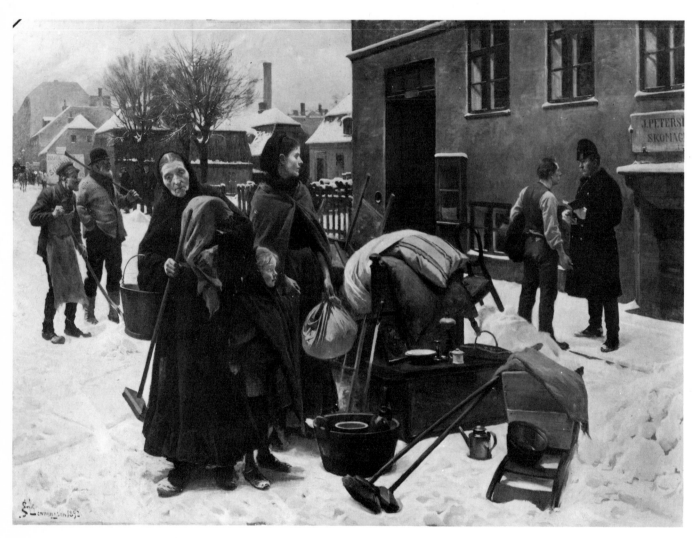

38. FRANS HENNINGSEN *Evicted Tenants*. 1892.
Tenants summarily evicted for failure to pay their rent.

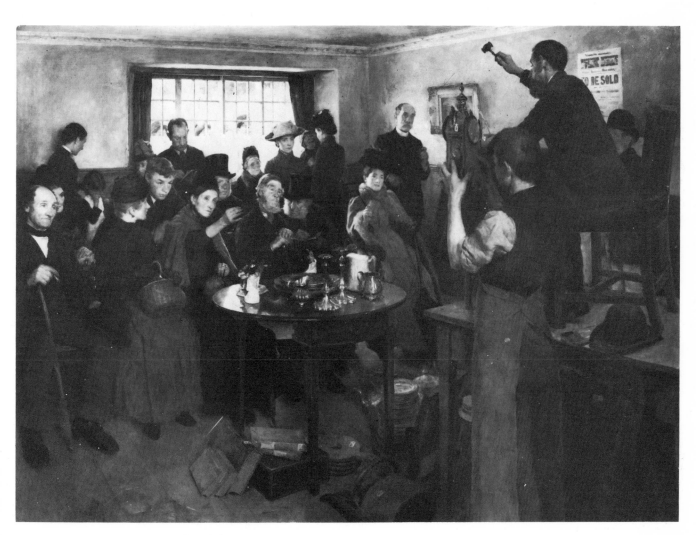

39. Stanhope A. Forbes *By Order of the Court*.
A debtor's goods are being auctioned.

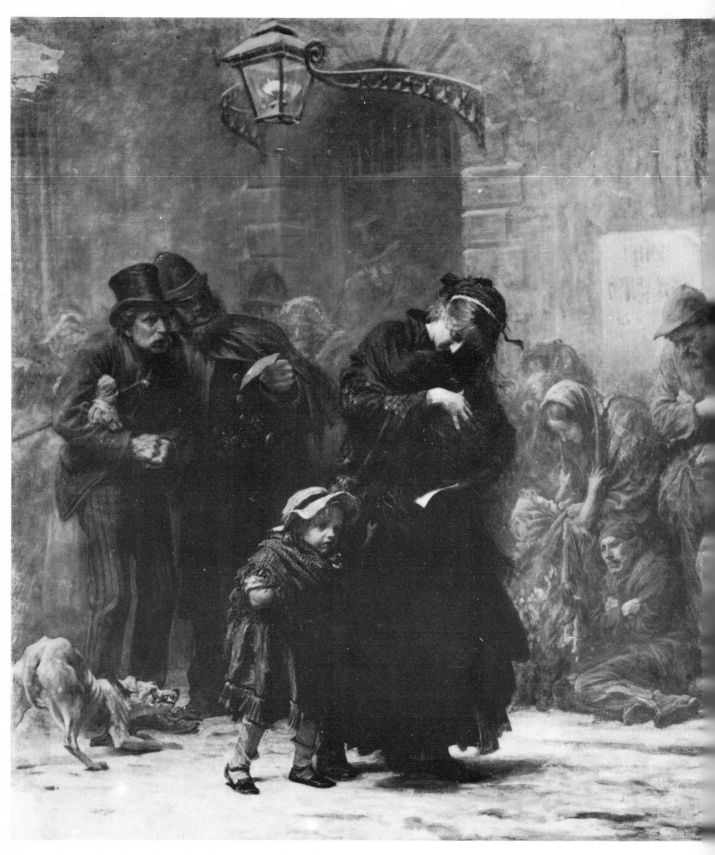

40. LUKE FIELDS *Applicants for admission to a Casual Ward*. 1874.
This picture caused a sensation when first exhibited. The Casual Ward was that part of the workhouse
where the homeless could seek a night's shelter.

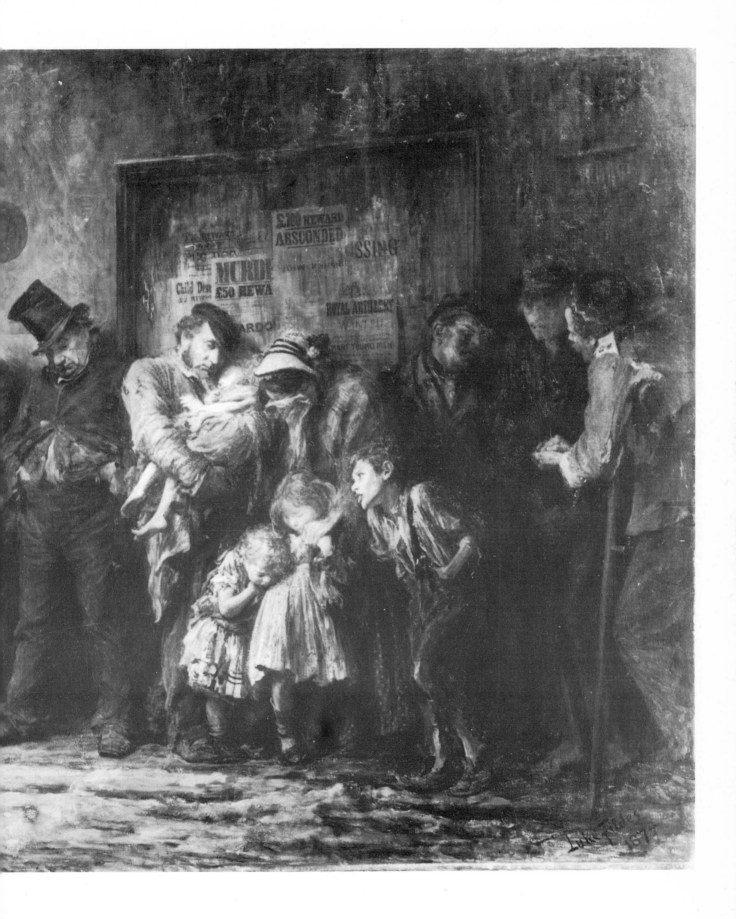

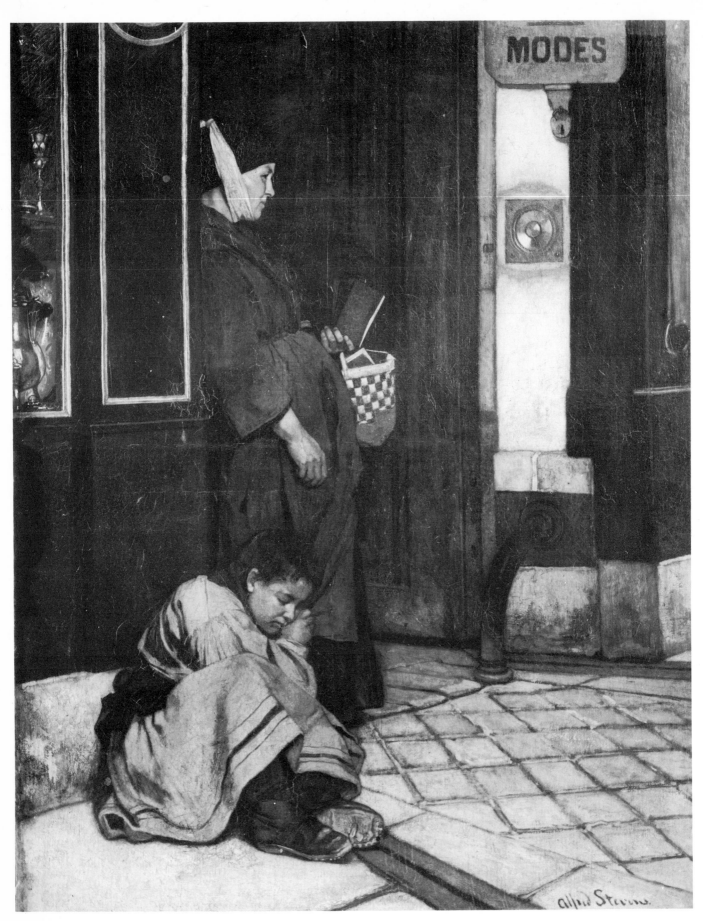

41. ALFRED STEVENS *Licensed Begging*.
The title is ironic. The woman is selling almanacs in order to keep on the right side of the law.

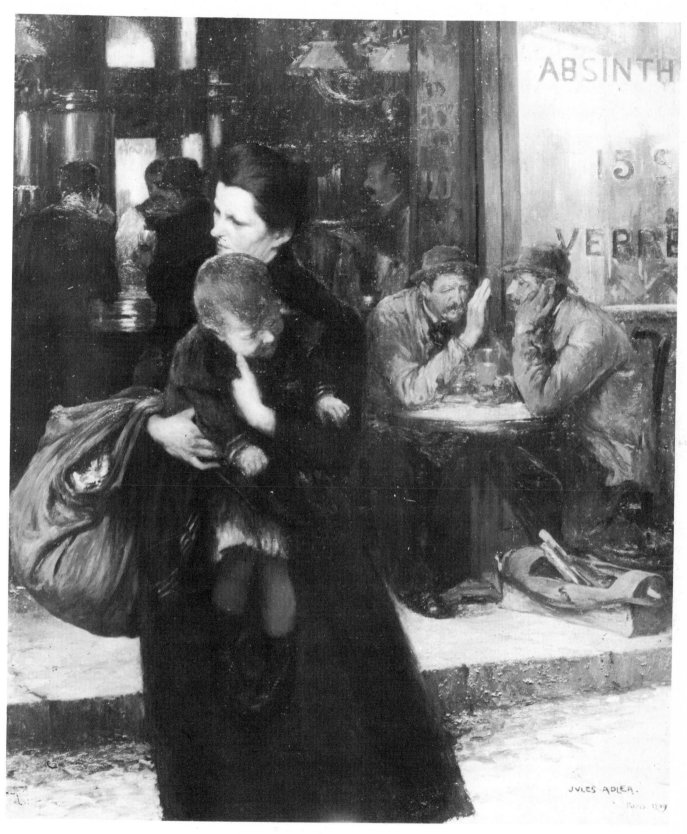

42. JULES ADLER *The Mother*. 1899.
Note the advertisement for absinthe, which is meant to relate the plight of the mother and her sickly child.

43. JOSE SORIANO FORT *Hopeless*. c. 1897.
A dying woman in a charity ward.

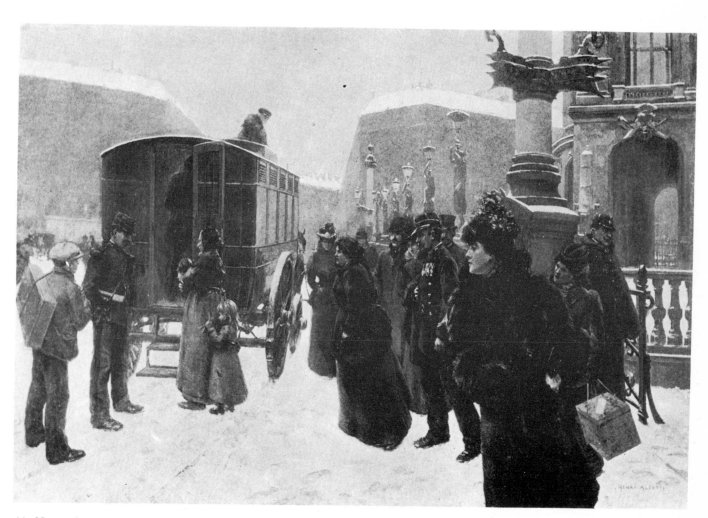

44. Henri Alberti *Winter morning, collecting the homeless.* c. 1898.

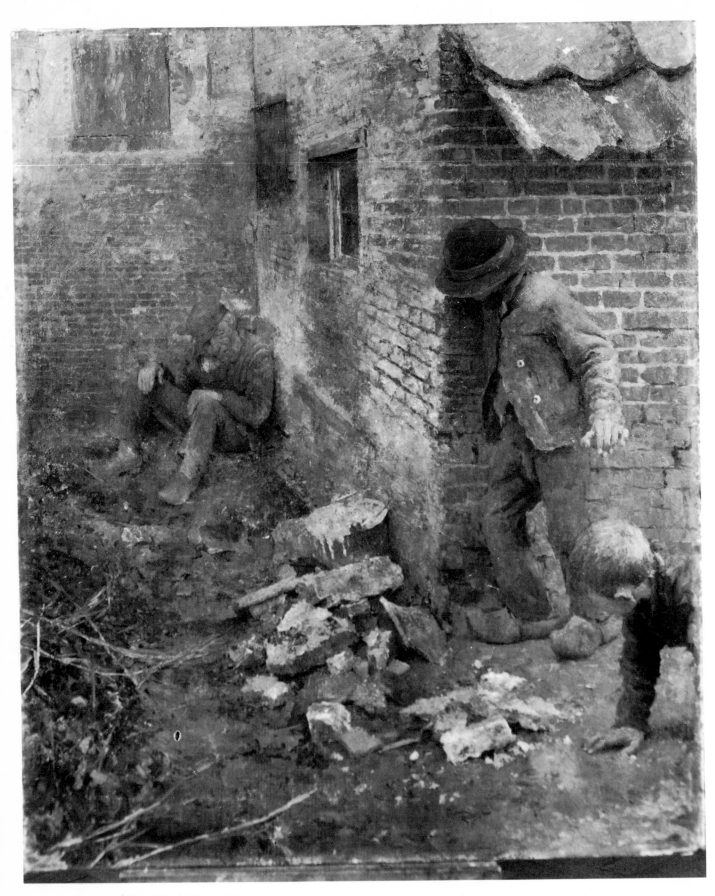

45. EVERT LAROCK *The Village Idiot*. 1892.

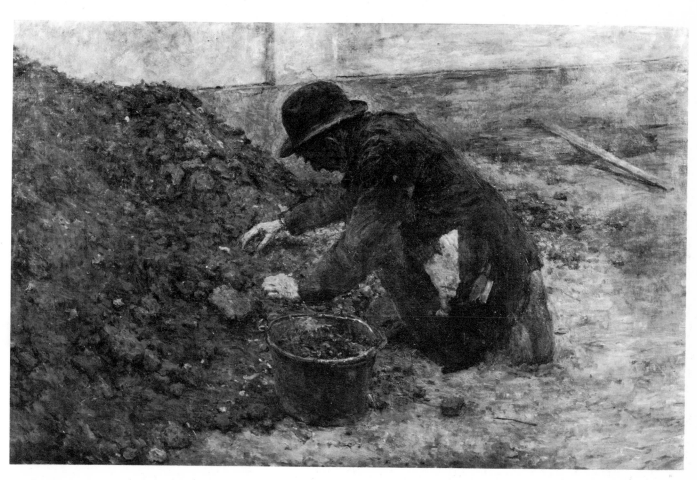

46. EVERT LAROCK *Picking coal from the tip*.
In mining districts, the poor could warm themselves with what the mineowners discarded.

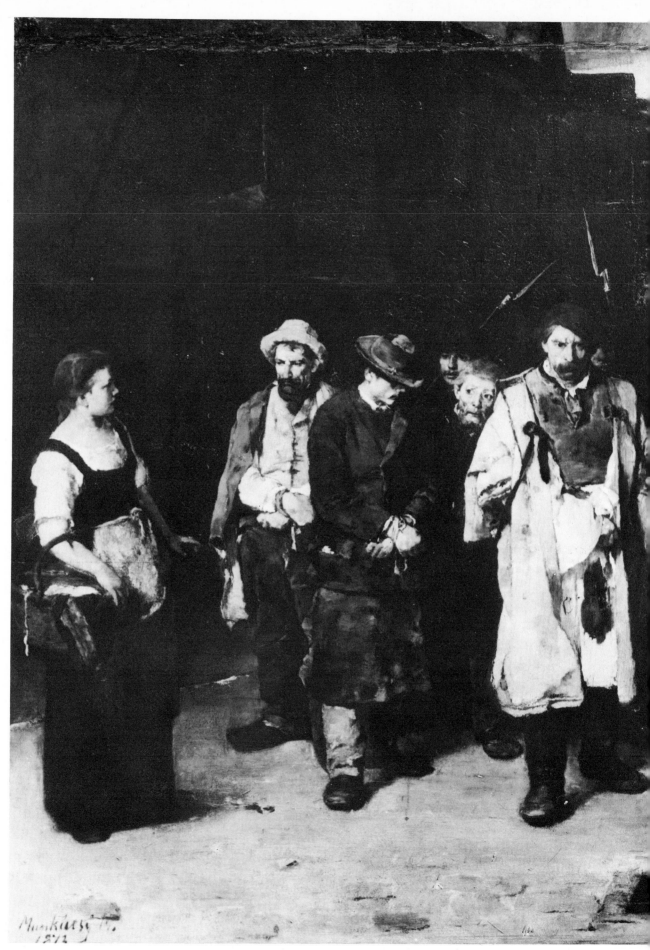

47. MIHALY VON MUNKACZY *Arrest of the Night Tramps*. 1872.
Those in custody are men of no fixed address, whom the Gendarmes suspect of planning to rob passers-by.

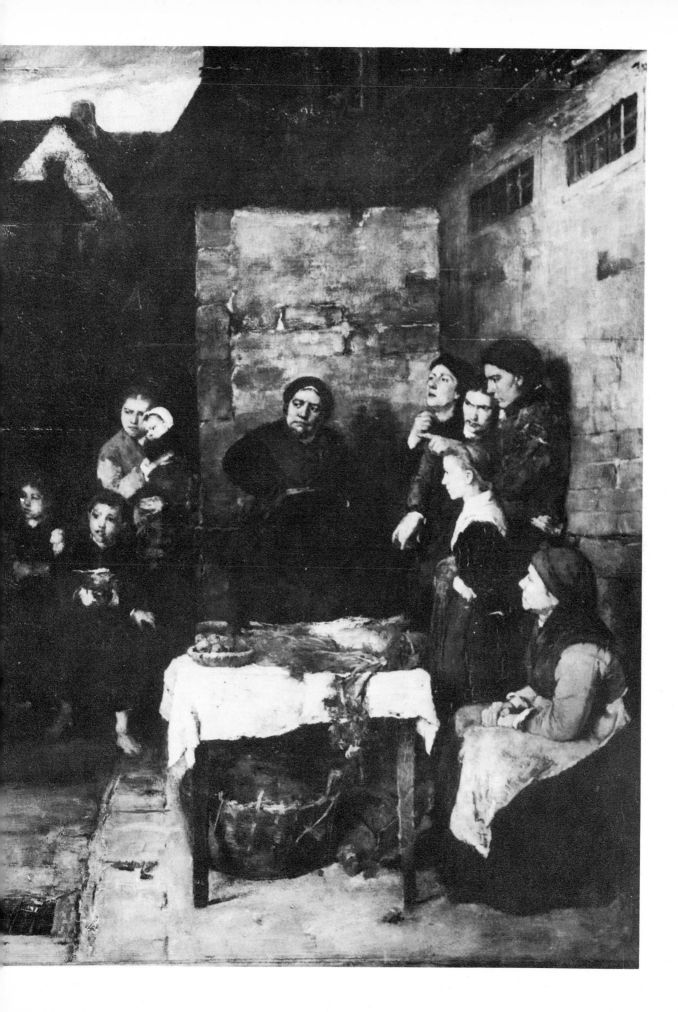

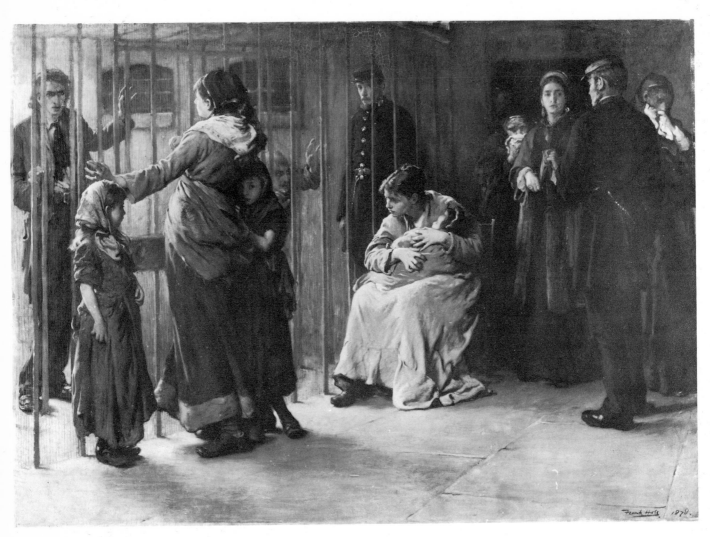

48. FRANK HOLL *Newgate, Committed by Trial*. 1878.
The imprisoned men are visited by their wives.

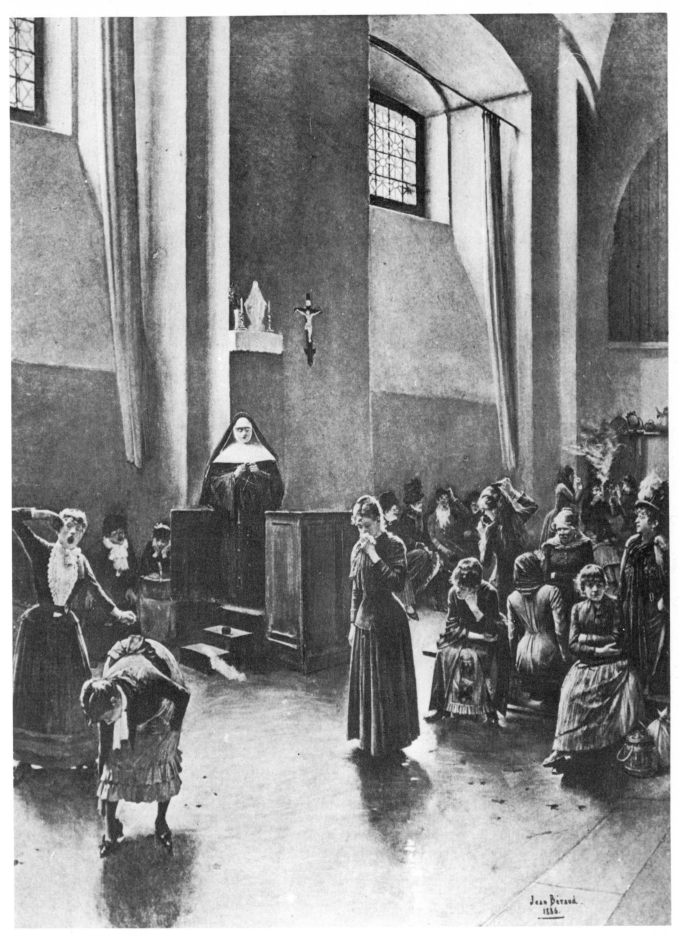

49. JEAN BÉRAUD *St. Lazare prison, the girl's room.* 1886.
The women are prostitutes.

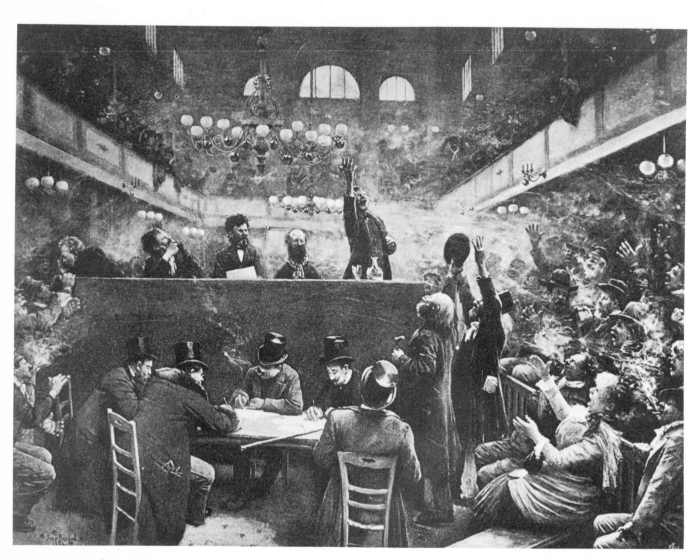

50. JEAN BÉRAUD *The Public Meeting.* 1884.

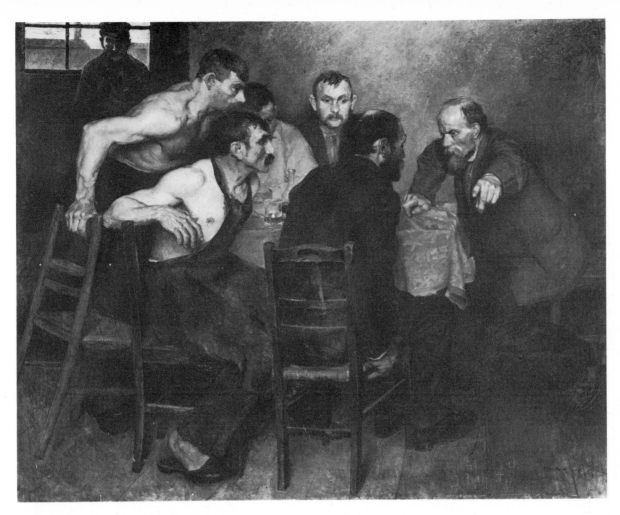

51. KAROLY KERNSTOK *The Agitator*. 1897.
The men are factory workers, as we can tell both from their clothes and the view through the window.

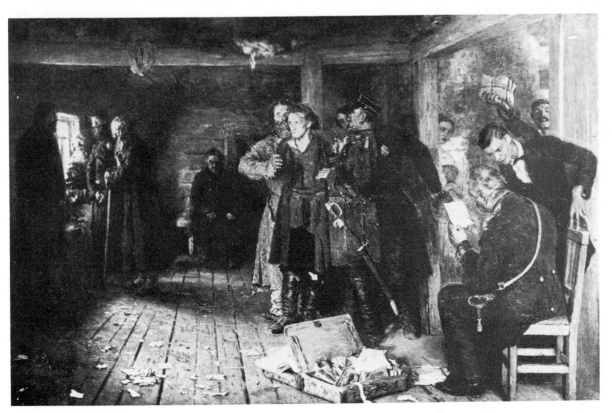

52. ILYA REPIN: *Arrest of the Revolutionary*. 1880.
One of Repin's outspoken criticisms of tsarist autocracy.

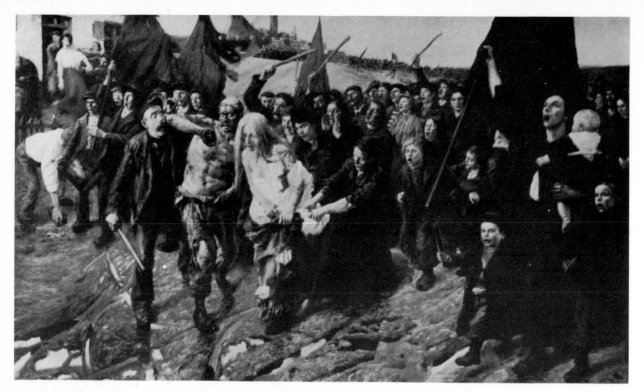

53. LUCIEN HECTOR JONAS: *The "Roufions"—a strike at Anzin.* c. 1907.
This reflects the frequent violence of strikes at the time.

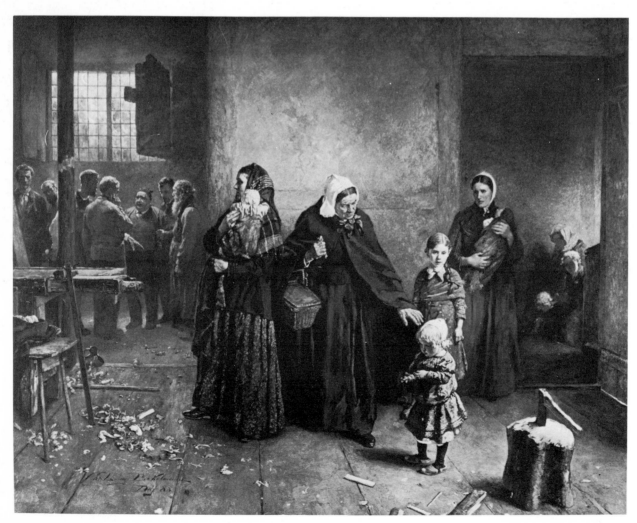

54. LUDWIG BOKELMANN *Strike.* 1888.
This concentrates on the anxiety of the men's wives when a strike was called. The scene is a small wood-working shop.

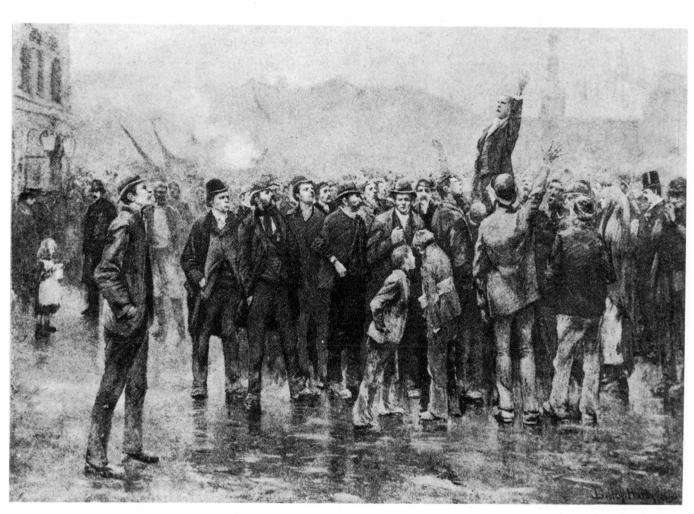

55. DUDLEY HARDY *The Dock Strike, London 1889*. 1890.

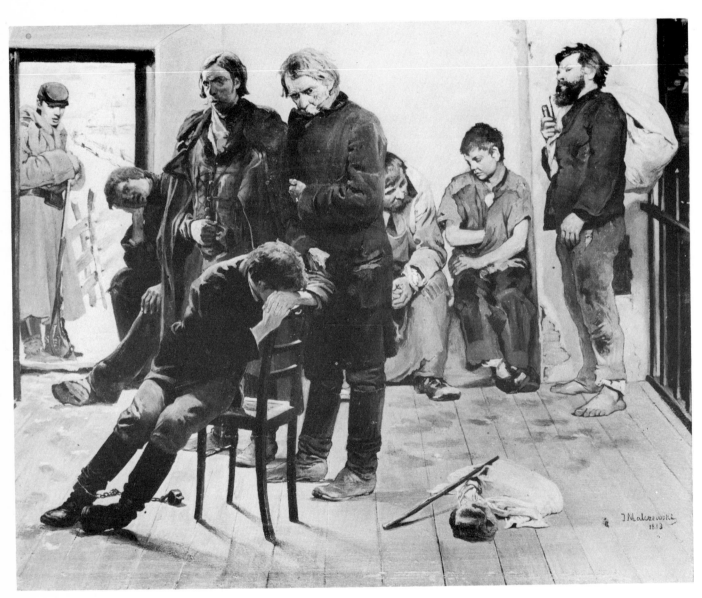

56. JAN MALCZEWSKI *A Step Nearer Siberia*. 1883.
The prisoners are probably Polish Nationalists.

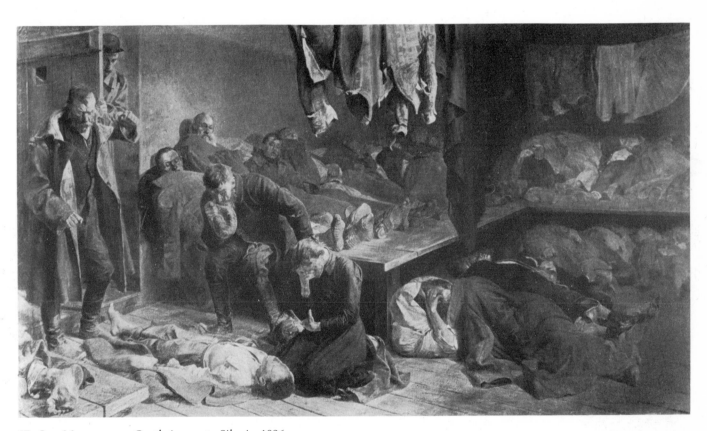

57. Jan Malczewski *On their way to Siberia*. 1896.

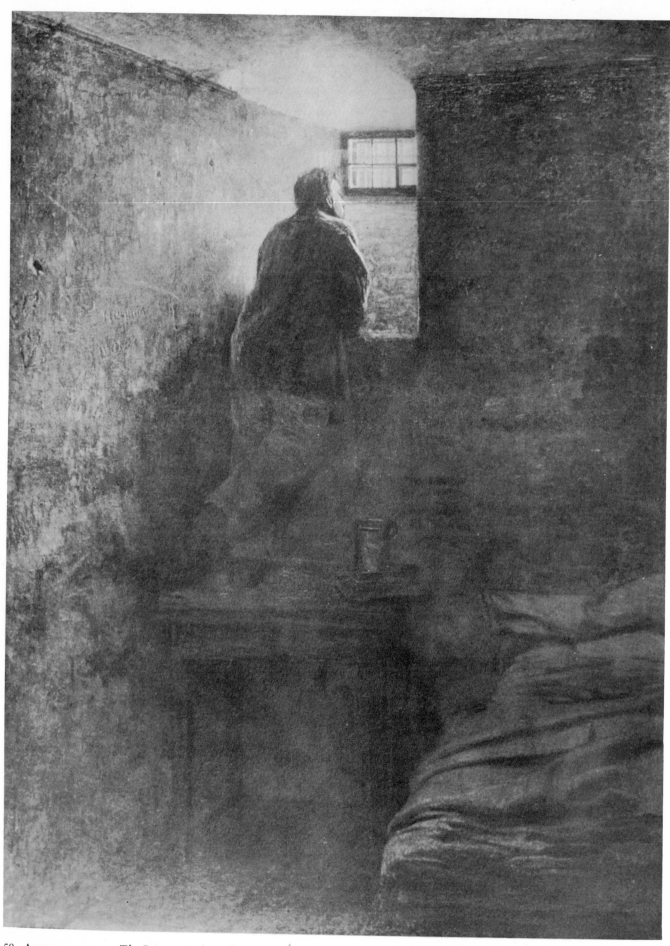

58. ARTIST UNKNOWN *The Prisoner in his cell.*

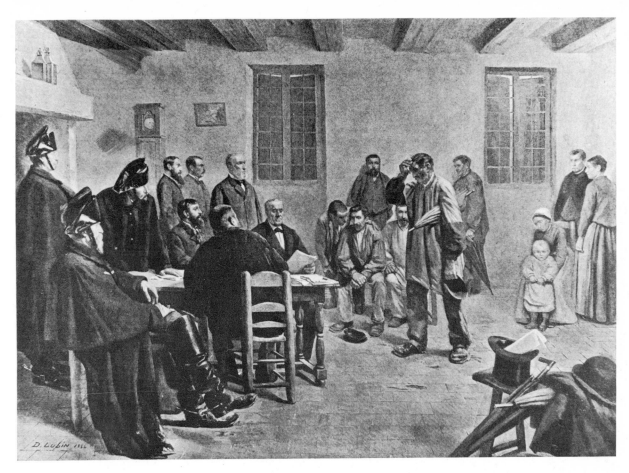

59. DESIRE LUBIN *Judicial Inquest at the Village*. 1886.

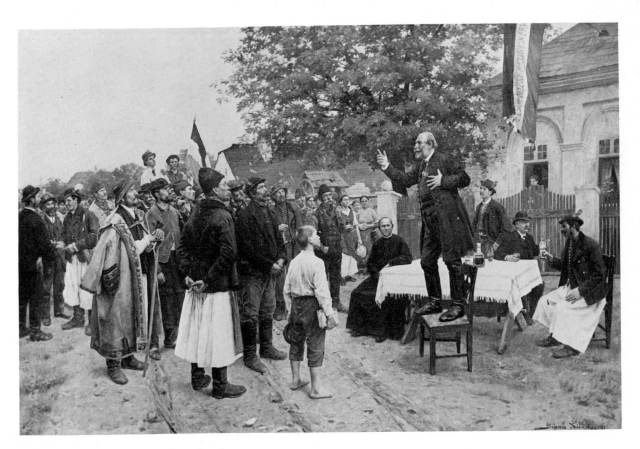

60. SANCLAR BIHARI *A Speech to the Electors*.
There is a mildly ironic contrast between the candidate in his town clothes and the Magyar peasants who
listen to him.

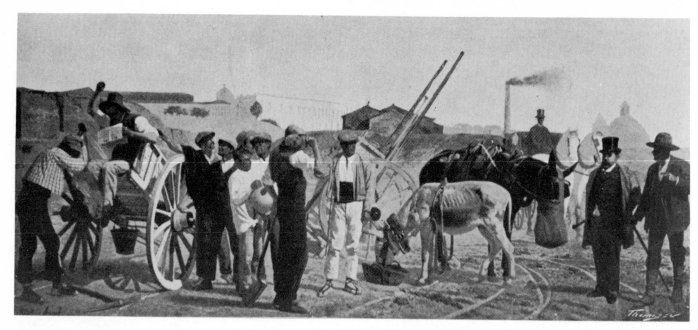

61. M. ANGEL: *The Contractor's Inspection.* c. 1897.

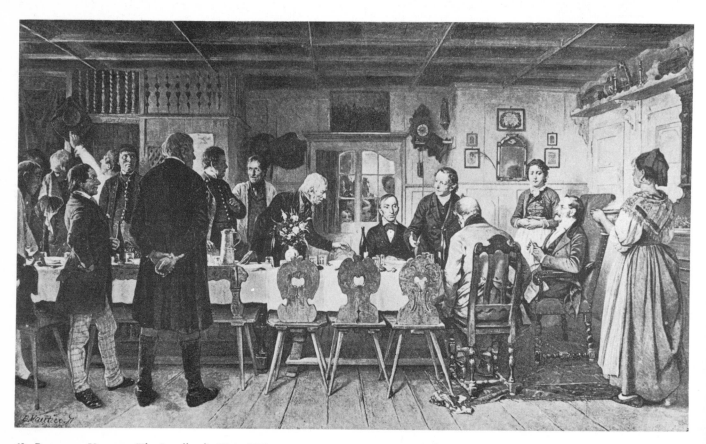

62. BENJAMIN VAUTIER *The Landlord's Visit.* 1871.

114

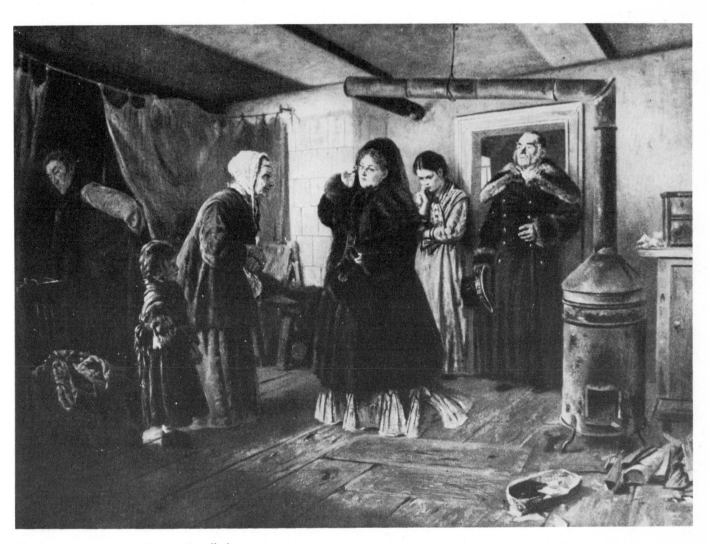

63. ARTIST UNKNOWN *A Russian Landlady.*
A sharply etched confrontation between the classes in Russia. The old peasant woman would have been born a serf.

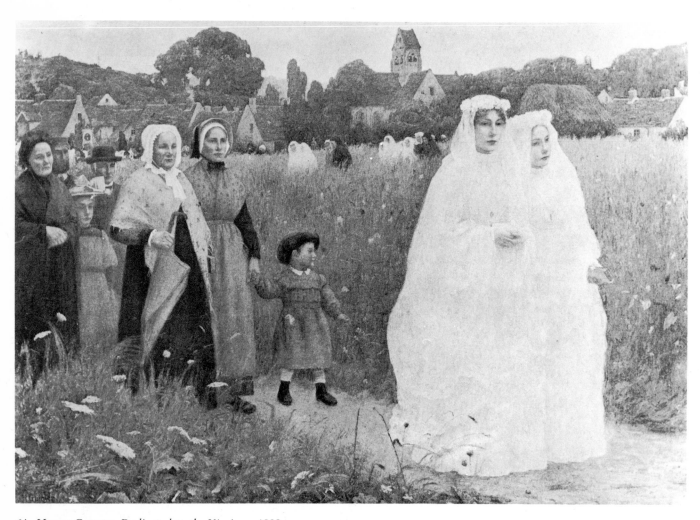

64. HENRI GUINIER *Dedicated to the Virgin.* c. 1898.
The girls are "Children of Mary," making their way to church to pledge their vows, and followed by their family.

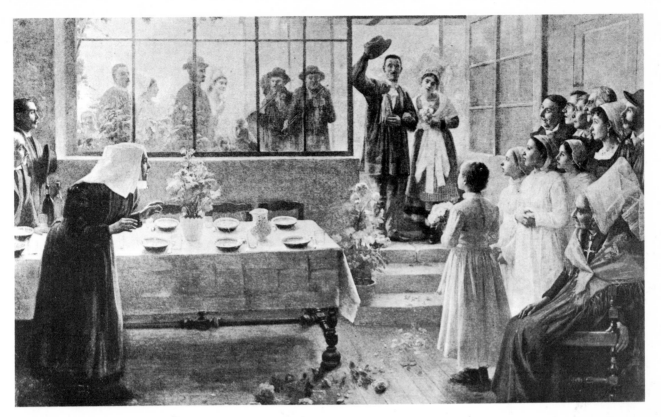

65. JEAN BRUNET *The Newlyweds return home.* c. 1892.
The ceremony has taken place, and two newly married peasants come home for the reception.

66. ALBERT AUGUSTE FOURIÉ *A wedding lunch at Yport.* 1886.

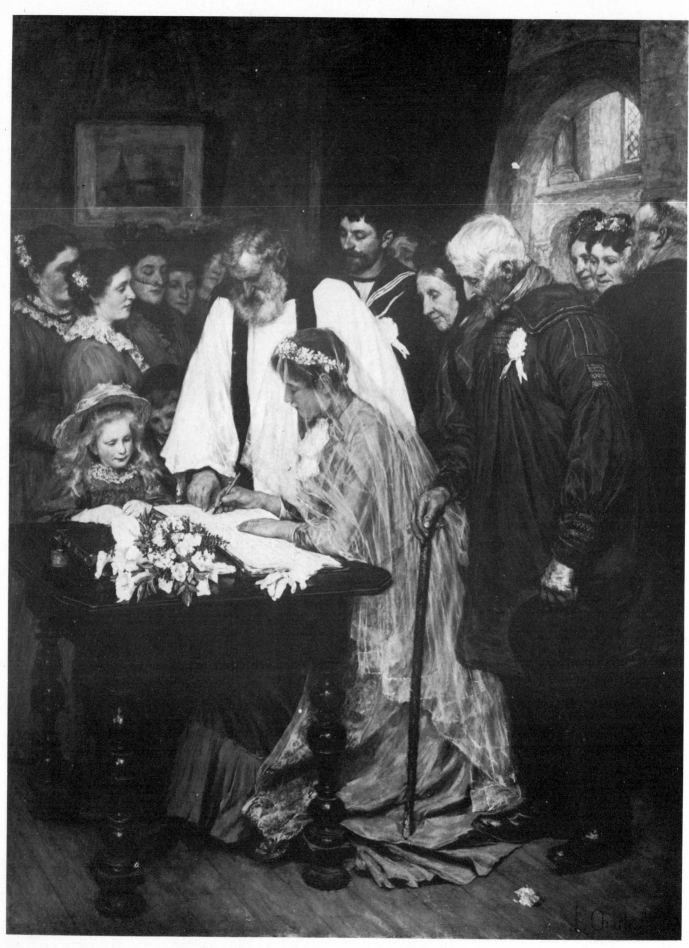

67. JAMES CHARLES *Signing the marriage register.* c. 1895.
The bridegroom is a sailor, and the bride's father wears an elaborate traditional farmworker's smock.

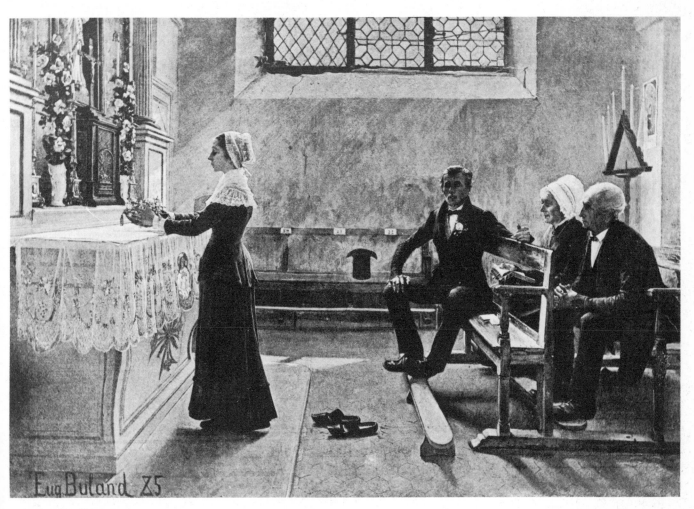

68. EUGENE BULAND *Homage to the Virgin, the day after the wedding.* 1885.
The newly married girl dedicates her lost virginity at the altar.

119

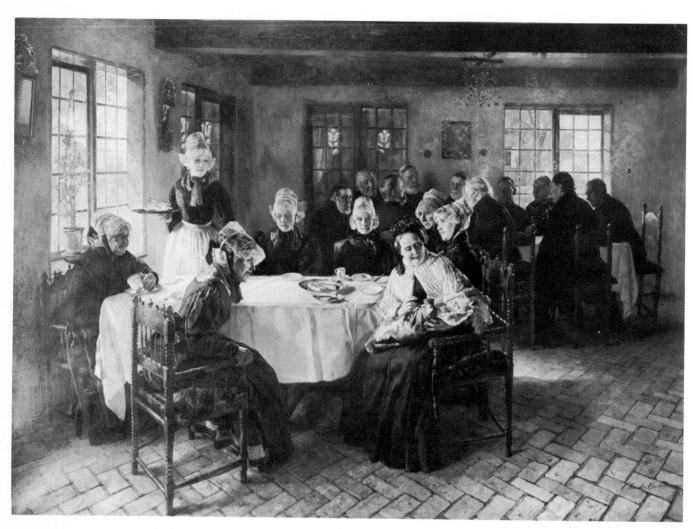

69. CHRISTIAN BOKELMANN *The Christening*. c. 1892.
The women's costumes are Frisian.

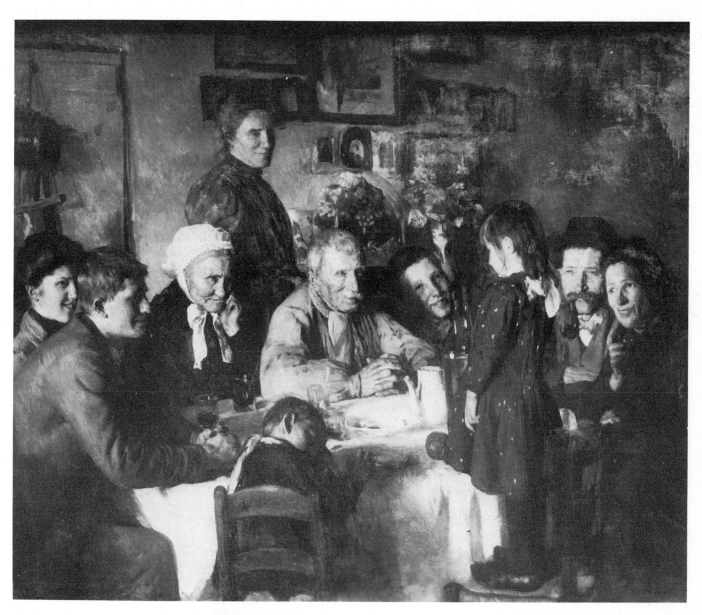

70. Louis Adolphe Déchenaud *The Golden Wedding*. 1909.

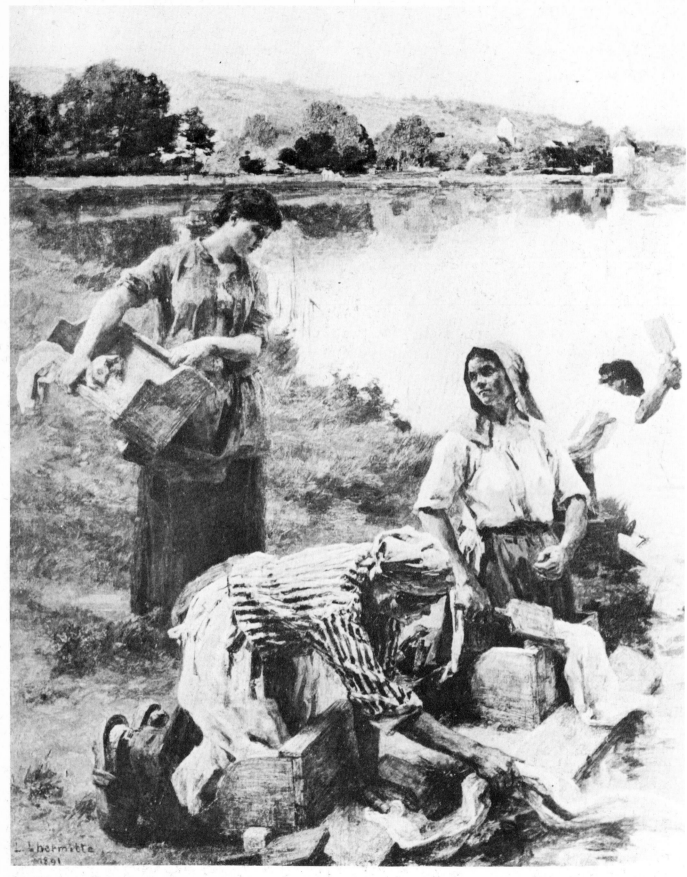

71. Leon Lhermitte *Washerwoman*. 1891.

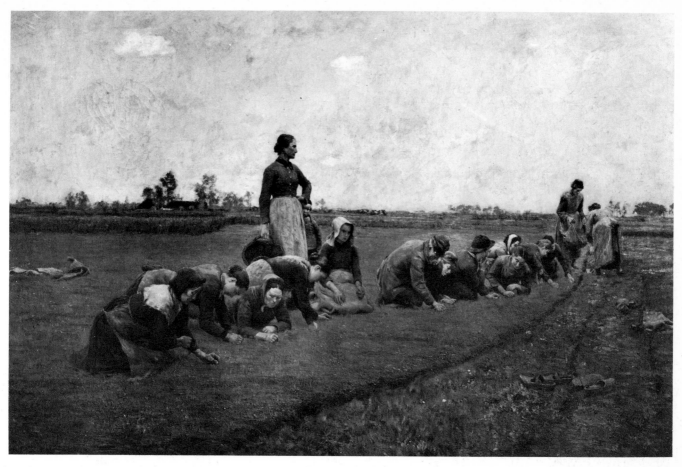

72. EMILE CLAUS *The Flax Field*. 1887.

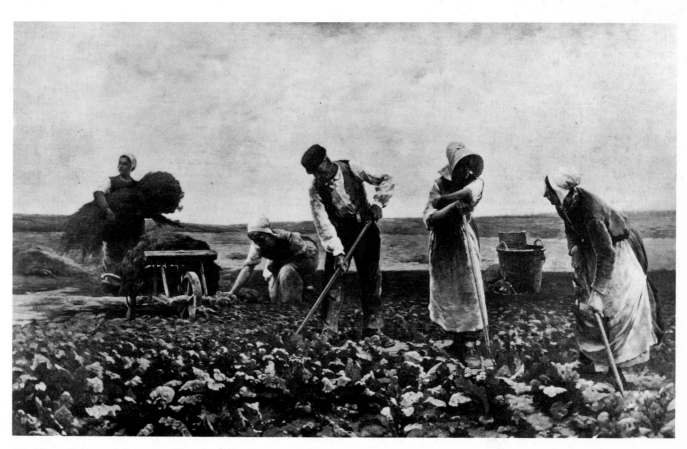

73. HUGO FREDERIK SALMSON *Picardy—The Beetroot Field*. 1879.

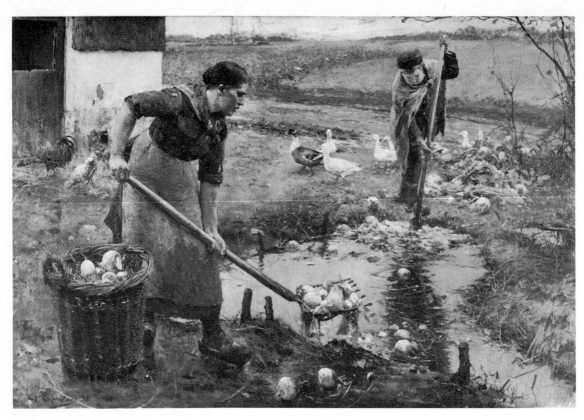

74. EVARISTE CARPENTIER: *Washing the turnips.*

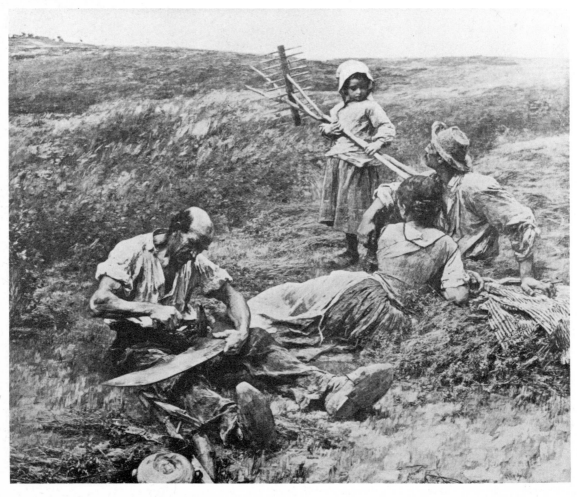

75. LEON LHERMITTE *The Gleaners.* 1877.

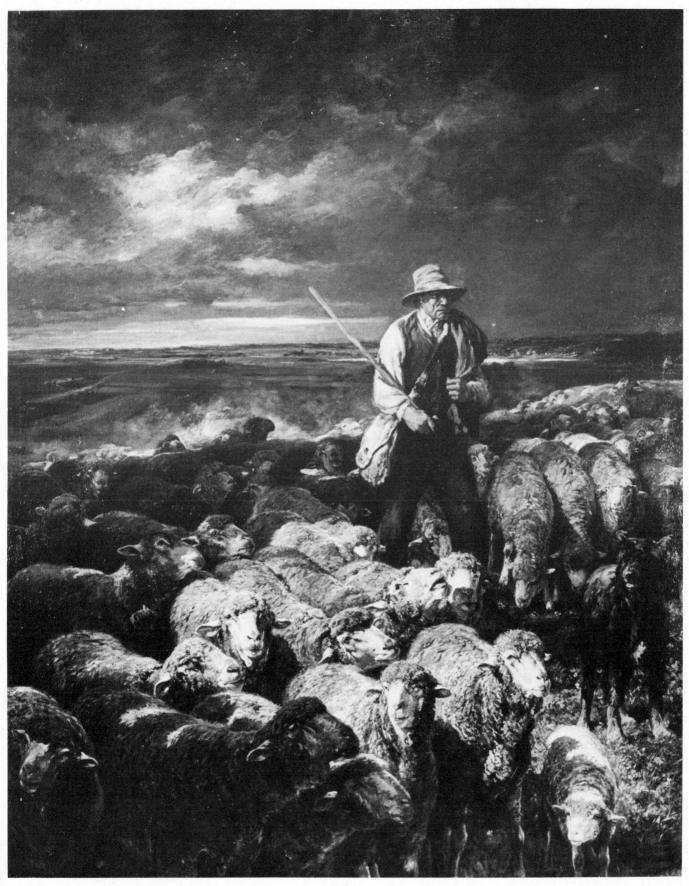

76. CHARLES EMILE JACQUE *The Large Flock*. 1880.
This picture marked the painter's triumphant return to the French Salon, after a long absence.

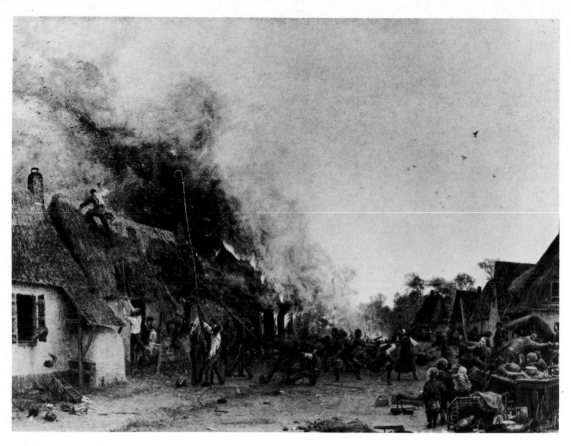

77. F. TATTEGRAIN: *Artois—The Burning Farm*. c. 1893.

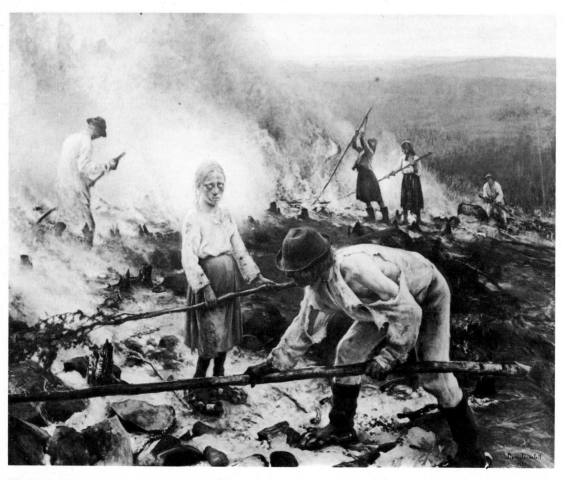

78. EARO JÄRNEFELT *Fighting the forest fire*. 1893.
The scene is Finland.

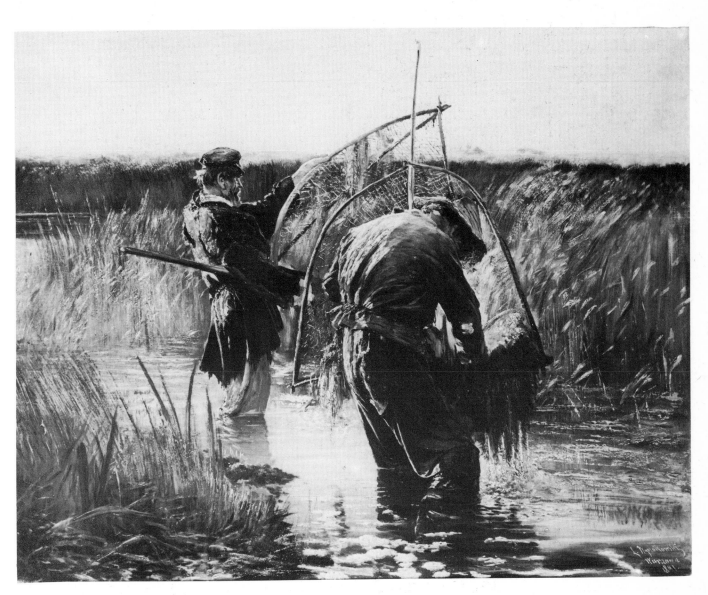

79. LEON WYCZOTKOWSKI *Fishermen*. 1891.

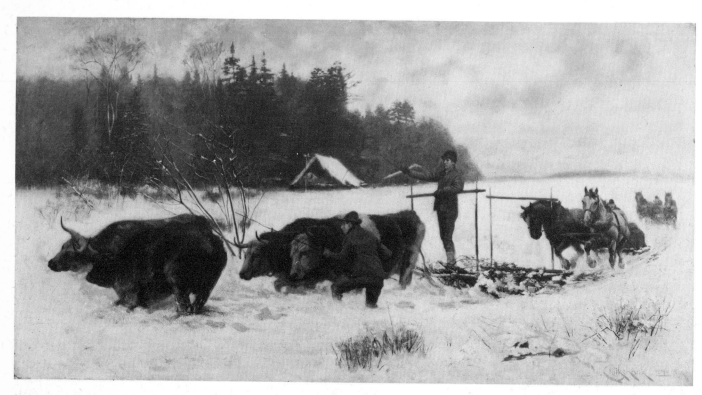

80. WILLIAM CRUIKSHANK *Breaking a Road*. 1894.
Life in the Canadian outback.

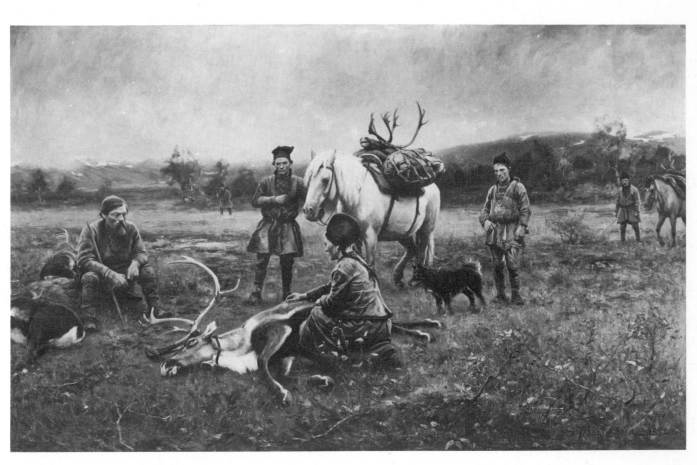

81. JOHANN TIRÉN *Lapps collecting a shot reindeer*. 1892.

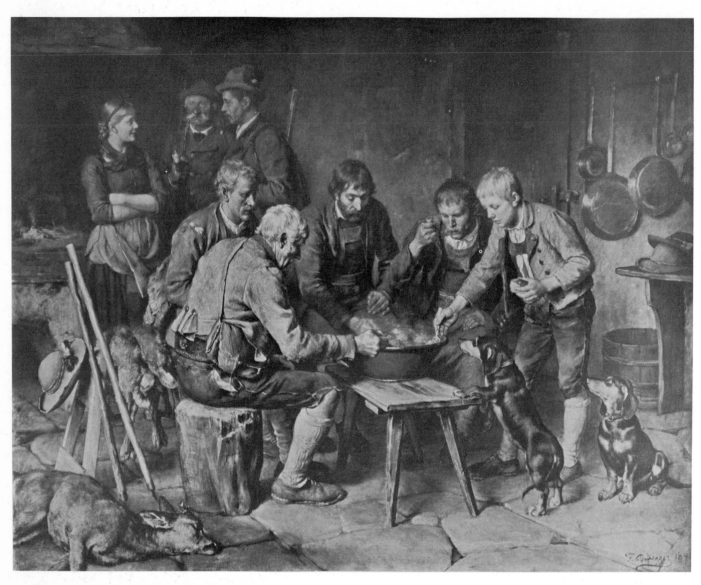

82. FRANTZ VON DEFREGGER *Sharing the soup*. 1891.
The hunters return to eat out of a communal bowl.

83. WINSLOW HOMER *Hound and Hunter*.
The deer has vainly tried to escape swimming.

84. K. D. SAVITSKY *Brigands of the Volga* 1874.
For rebels against society, the game to be hunted is human.

85. THOMAS POLLOCK ANSCHUTZ *The Cabbage Patch*. 1879.
The post-Civil War South, treated in a manner which is surprisingly idealized.

86. Louis de Schryver *Gardener preparing for market*. 1896.
Agricultural depression in Europe meant both diversification and more intensive cultivation. Here pot plants are the crop.

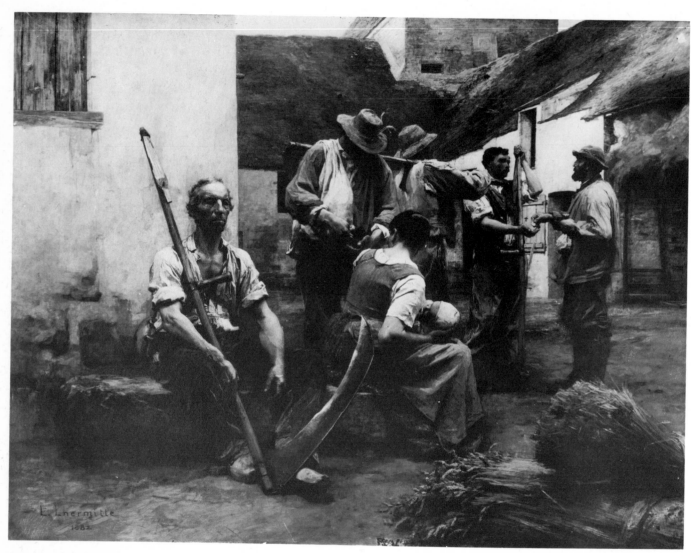

87. LEON LHERMITTE *The Harvesters' Payday.* 1882.

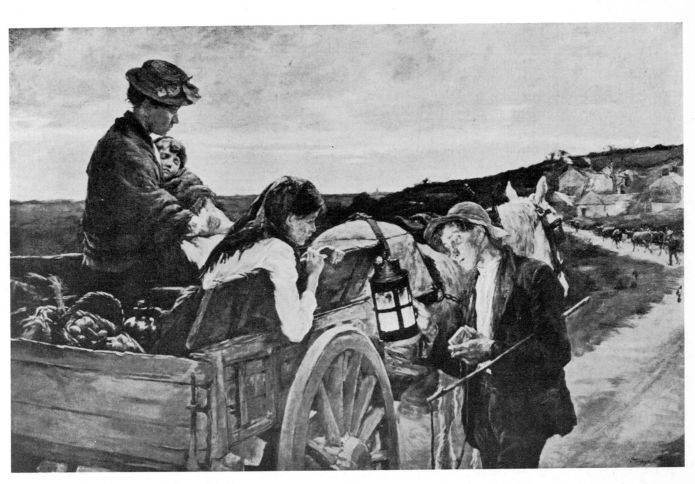

88. STANHOPE A. FORBES *Lighting-up Time*. c. 1901.

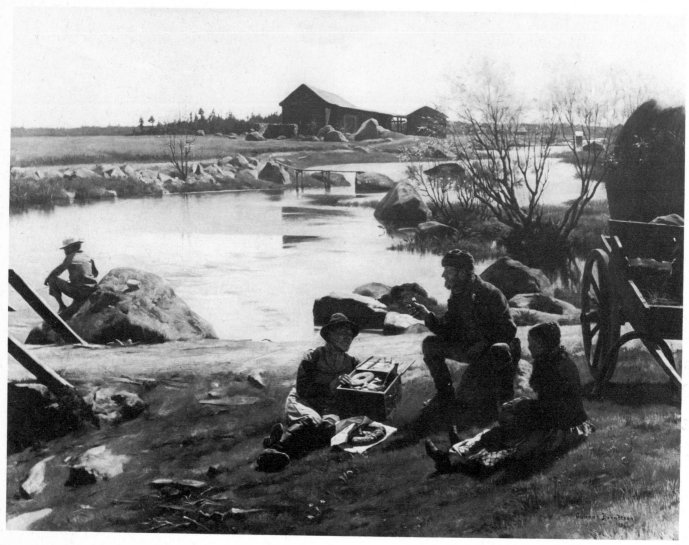

89. GUNNAR BERNDTSON *A rest on the way to the fair*. 1886.

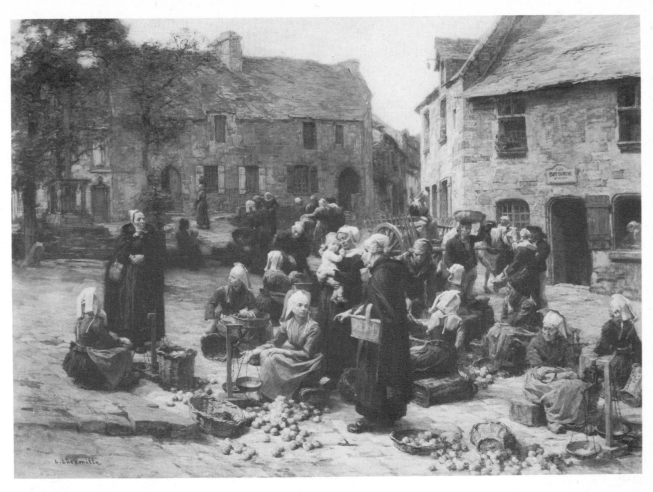

90. LEON LHERMITTE *The Apple Market, Landerneau*. c. 1878.
A good example of the Breton peasant scenes which fascinated painters of the period.

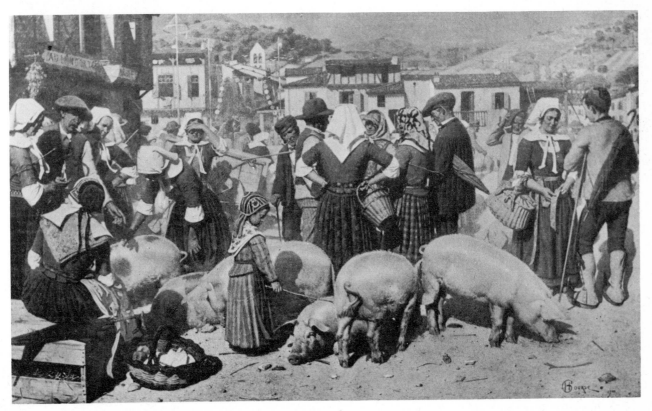

91. HIPPOLYTE CASMIR GOURSE *Pig Market in the Pyrenees*. 1900.
Note the artist's fascination with peasant costume.

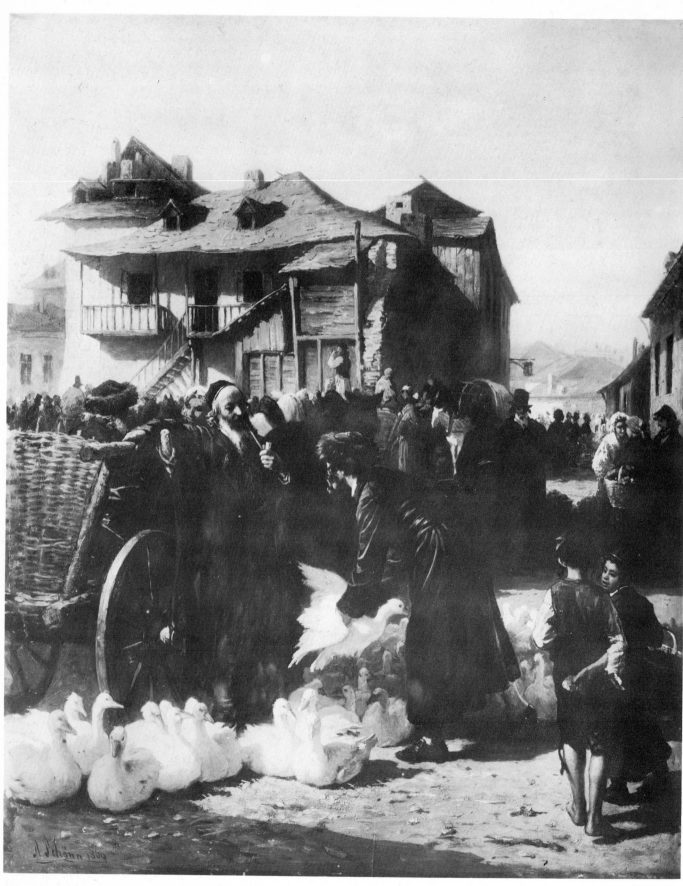

92. ALOIS SCHÖNN *Market in Cracow*. 1869.
One of the few scenes featuring Jews.

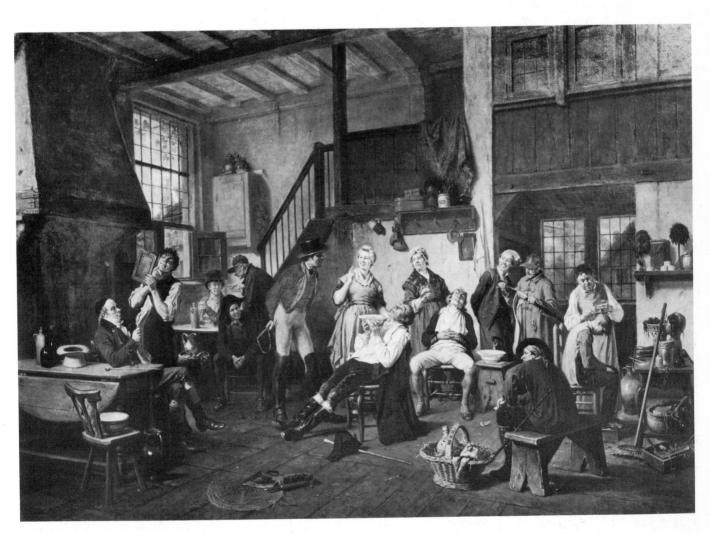

93. JAN DAVID COL *Barber's Day*. 1873.

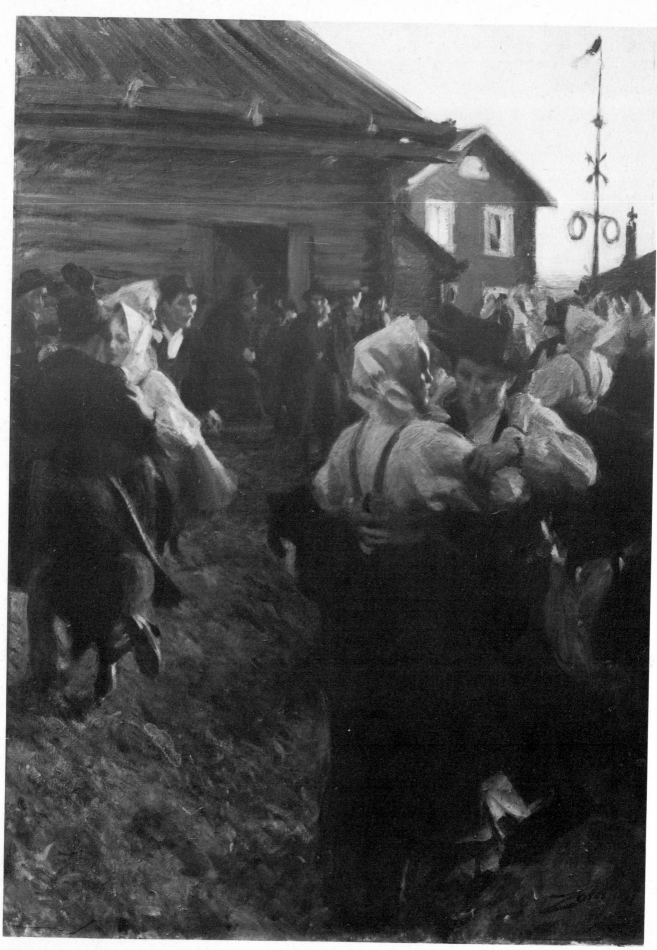

94. ANDERS ZORN *Midsummer Dance*. 1897.
In the Northern regions the "white nights" of summer were a traditional period of sexual license.

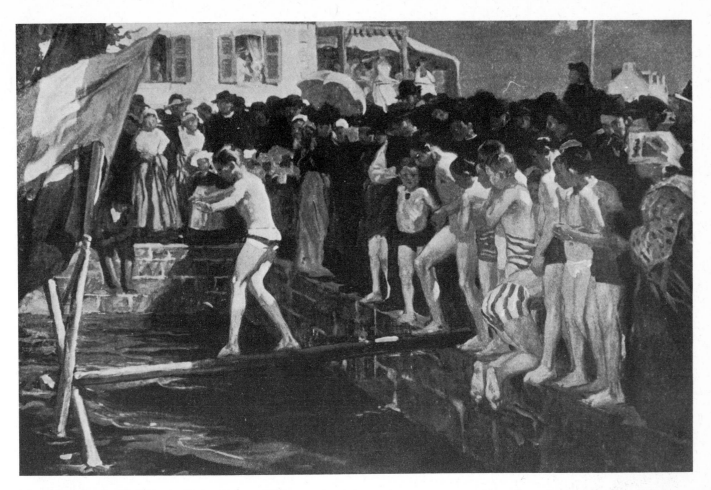

95. LUCIEN SIMON *Walking the Greasy Pole*. c. 1902.

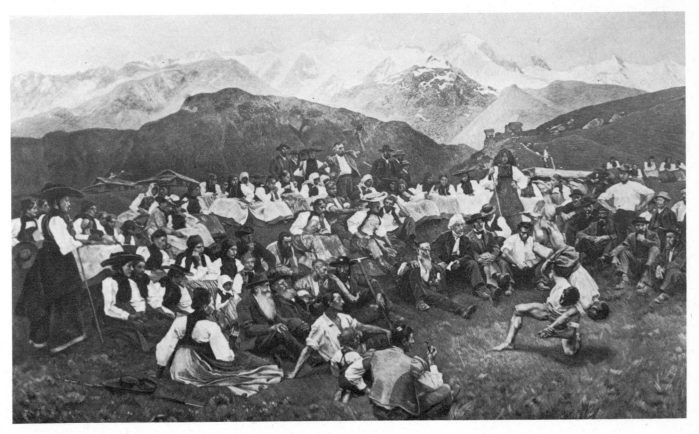

96. CHARLES GIRON *Wrestler's Festival in the Swiss Alps*. c. 1906.
Yet another instance of the academic painter's fascination with "folklore."

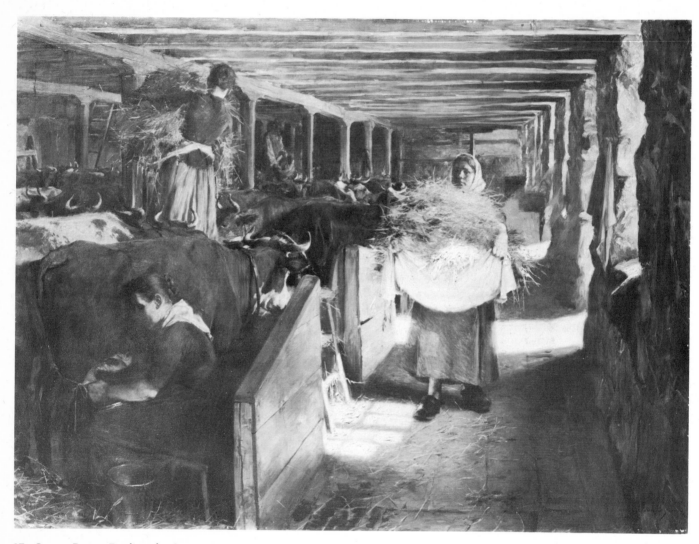

97. Oscar Björk *Feeding the Cows*. 1890.

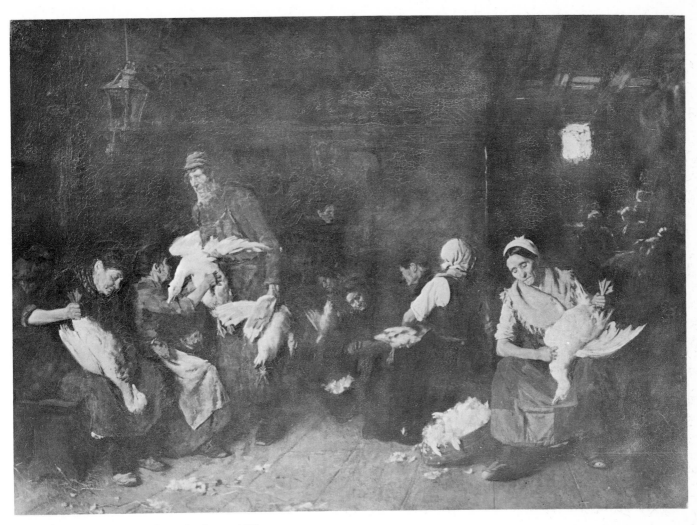

98. MAX LIEBERMANN *Plucking the Geese*. 1872.
The picture with which the artist caused a sensation as a young man—its realism was considered offensive.

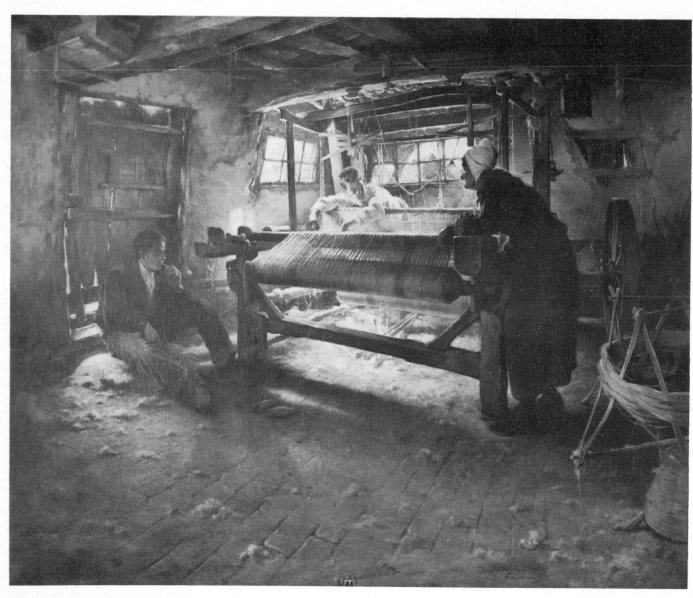

99. ALBERT DECAMPS *The Apprentice Weaver.* c. 1890.
Looms of this type are still used today by craft weavers.

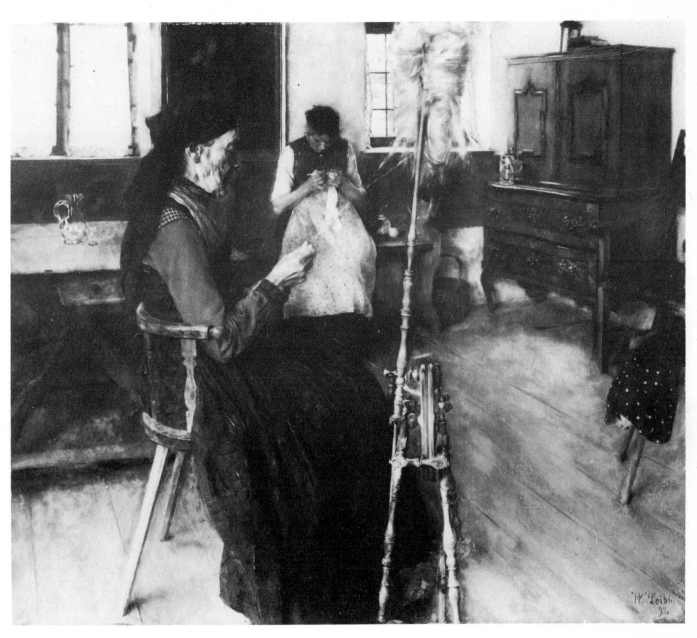

100. WILHELM LEIBL *The Spinner*. 1892.
The woman in the background is crocheting.

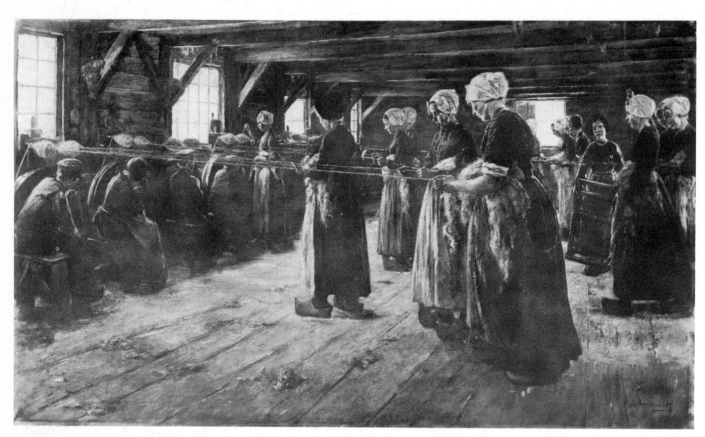

101. MAX LIEBERMANN *The Flax Barn at Laren*.
Typical of the Dutch subjects Liebermann liked. The flax is being spun on a semi-industrial scale.

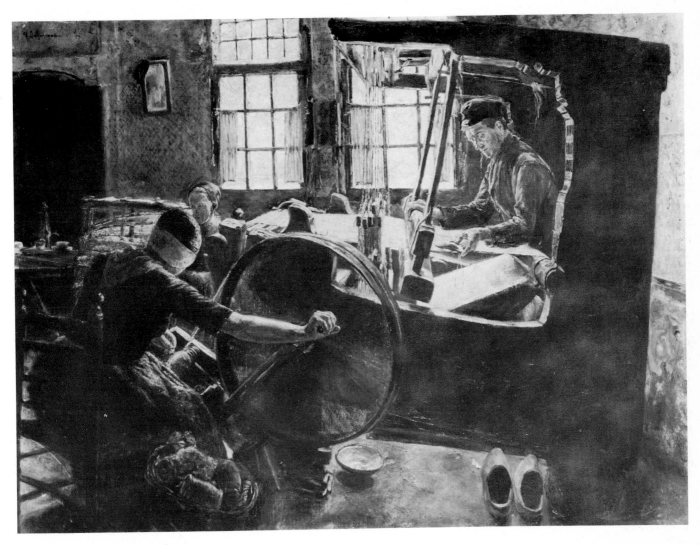

102. MAX LIEBERMANN *Weavers*.
Here spinning and weaving are a family enterprise, carried on in the home.

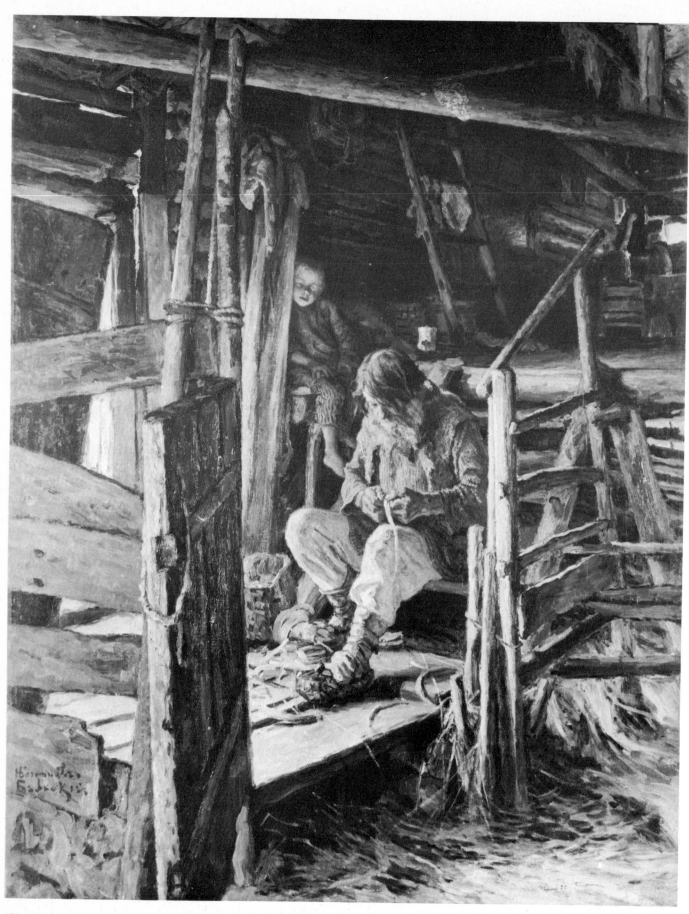

103. Nikolai Bogdanov-Nelski *Home*.
A denunciation of the wretched condition of the Russian peasantry. The old man is basket-making.

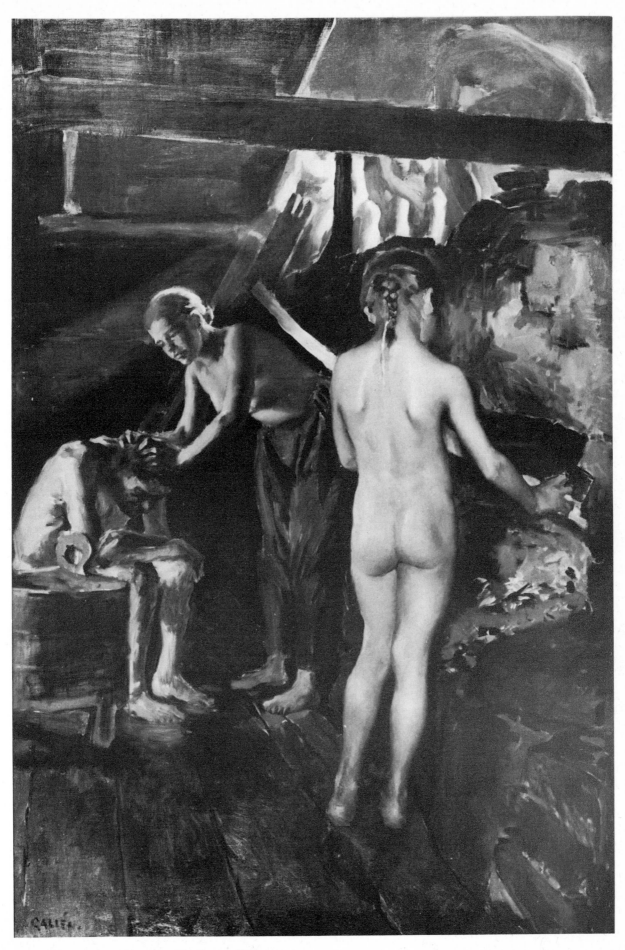

104. Akseli Gallen-Kallela *The Sauna*. 1889.
A typical Finnish peasant subject. Note the lack of sexual segregation.

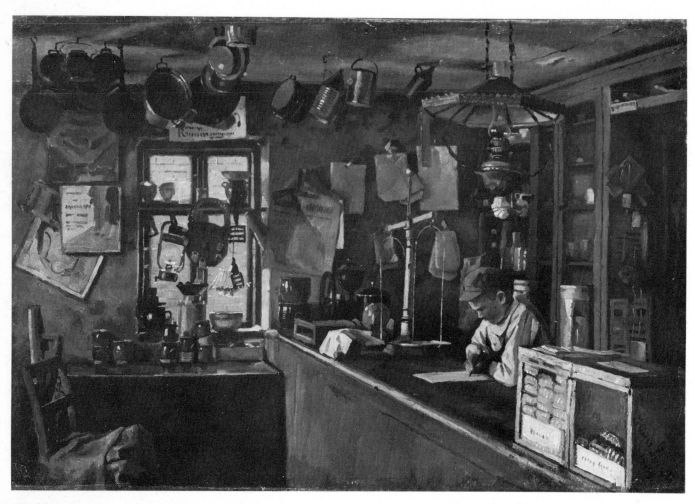

105. HANS SCHMIDT: *A Country Grocer*. 1909.
Sentimentality about the country store was not confined to the United States.

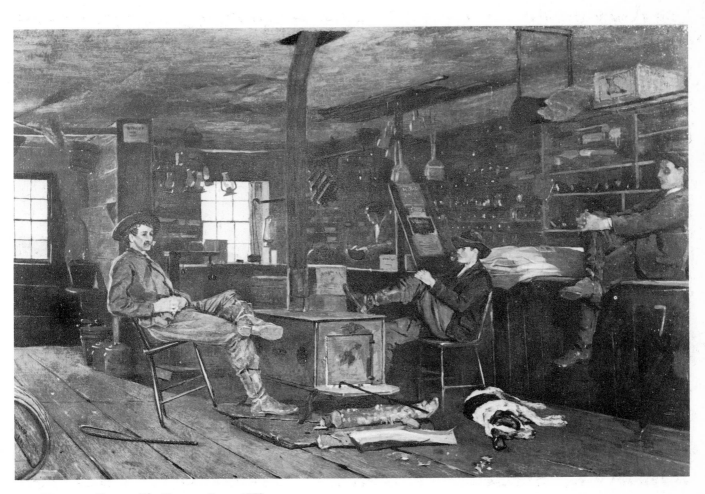

106. WINSLOW HOMER *The Country Store*. 1872.

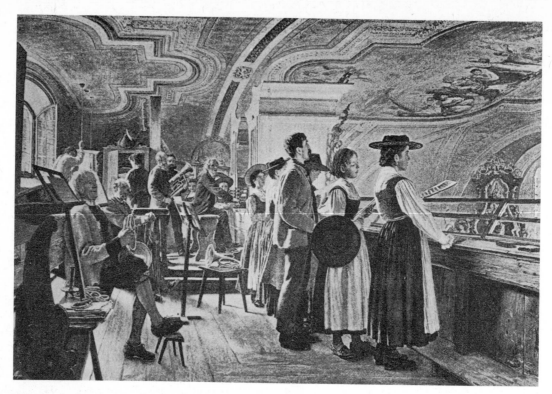

107. ADOLF SCHLABITZ *Church Choir in the Tyrol*. c. 1890.
The band of instrumentalists takes the place of an organ.

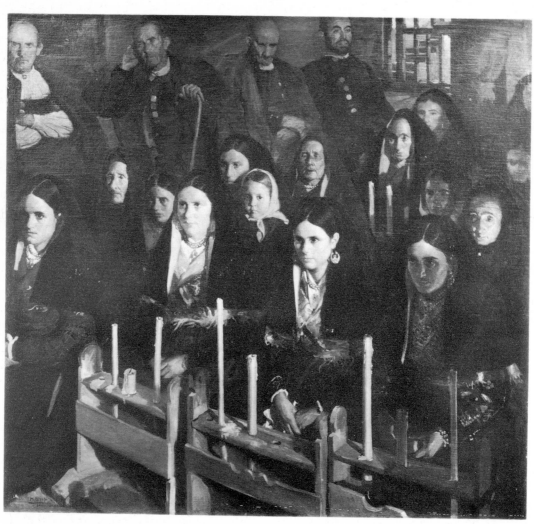

108. MANUEL BENEDITO VIVES *The Sermon*. 1907.
Religion was increasingly the business of women, even in Catholic Spain.

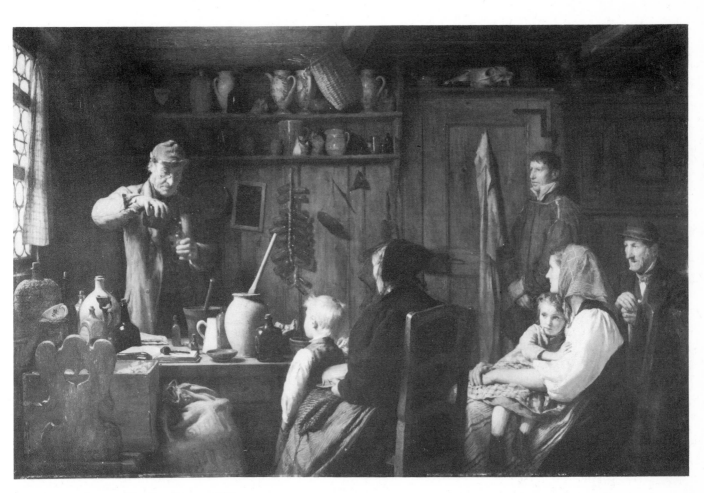

109. ALBERT ANKER *The Apothecary*. 1879.

153

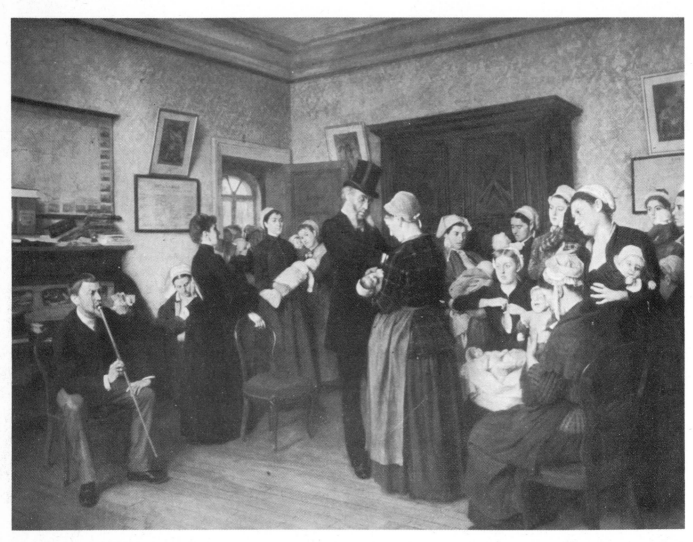

110. JULES JEAN GEOFFROY *The Doctor's Round—Infant's Clinic.*
This shows the "new" medicine, in contrast to the preceding picture.

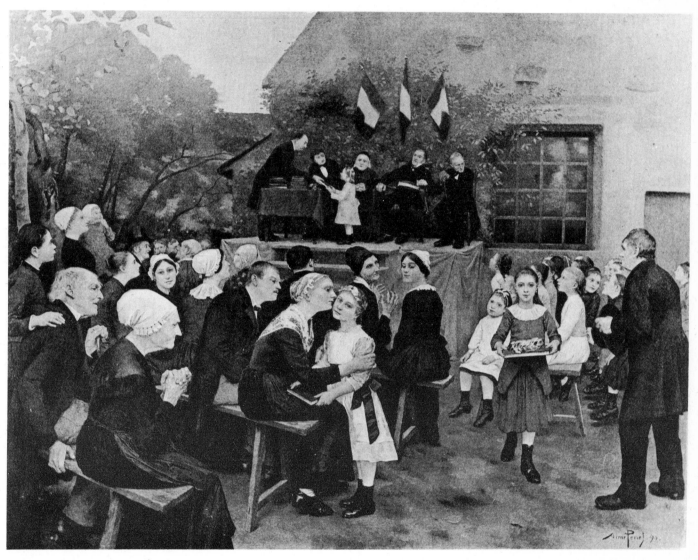

111. ANNE PERRET *The Prizes.* 1890.
The women are in peasant costume and, even in republican France, the village *curé* sits on the platform.

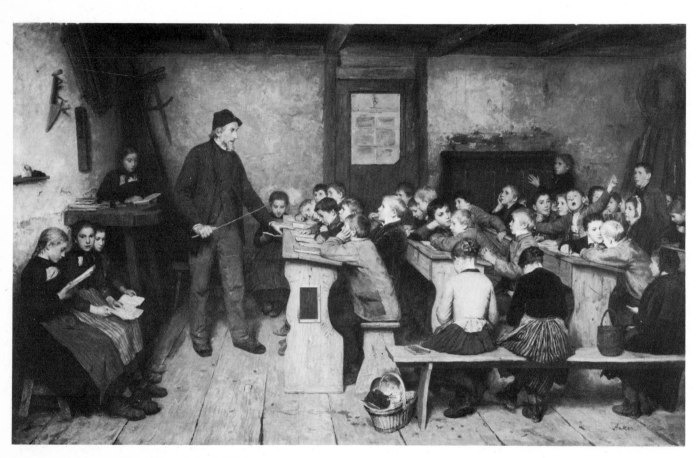

112. ALBERT ANKER *The Village School*. 1896.
The girl in the background at the left may be a student teacher.

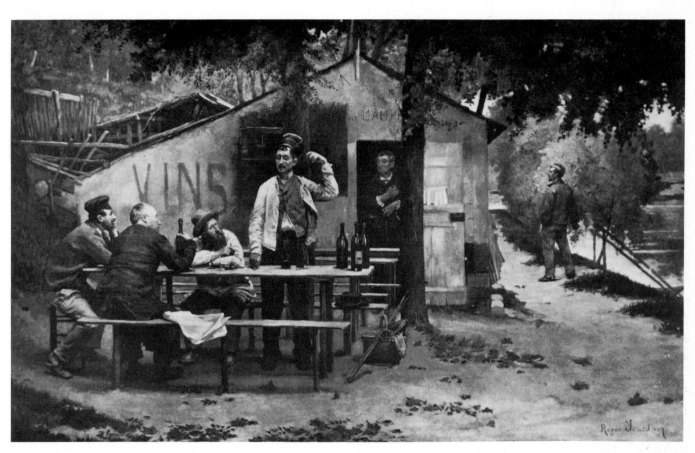

113. ROGER JOURDAIN *Monday.* c. 1878.
The men return to secular occupations after the restrictions of Sunday.

157

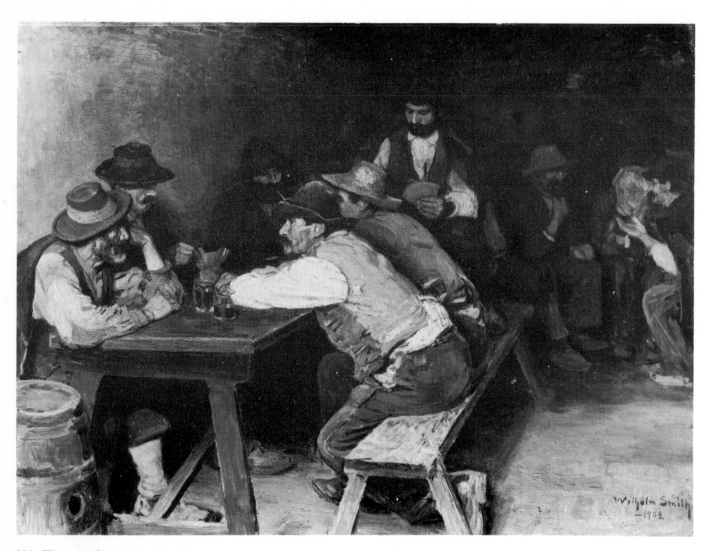

114. WILHELM SMITH *Osteria*. 1902.
A primitive Italian inn.

115. Remy Cogghe *Flemish Bowls*. 1897.

116. Leo van Aken *Archers*. c. 1901.
Archery clubs and guilds are typical of Flanders.

117. ANTOINE JEAN BAIL *The Wind Band*. 1881.
Another typical form of village club.

118. CARL WILHELMSON *Church-goers in a boat*. 1909.
The scene is one of the Swedish islands in the Baltic.

162

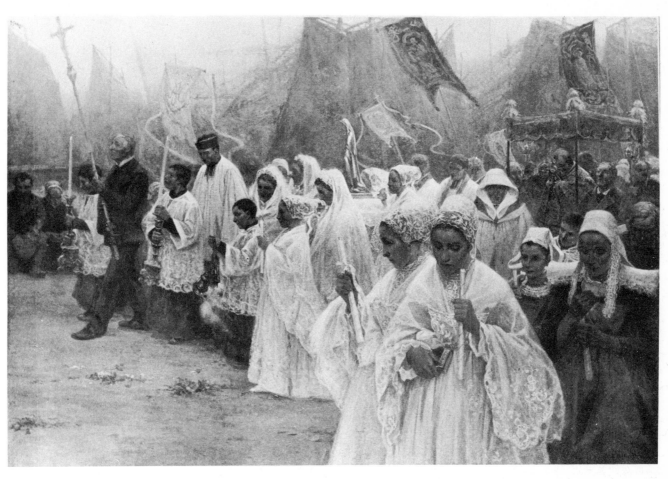

119. EMIL HIRSCHFIELD *Procession of Our Lady of the Sea.* c. 1900.
Characteristic of the Breton customs which fascinated painters.

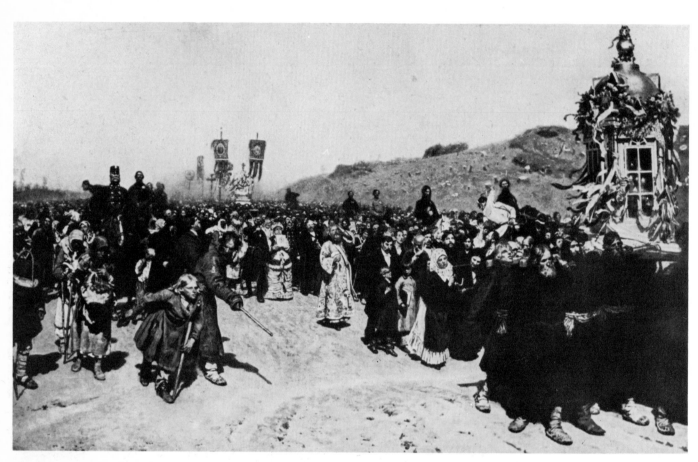

120. ILYA REPIN *Procession*.

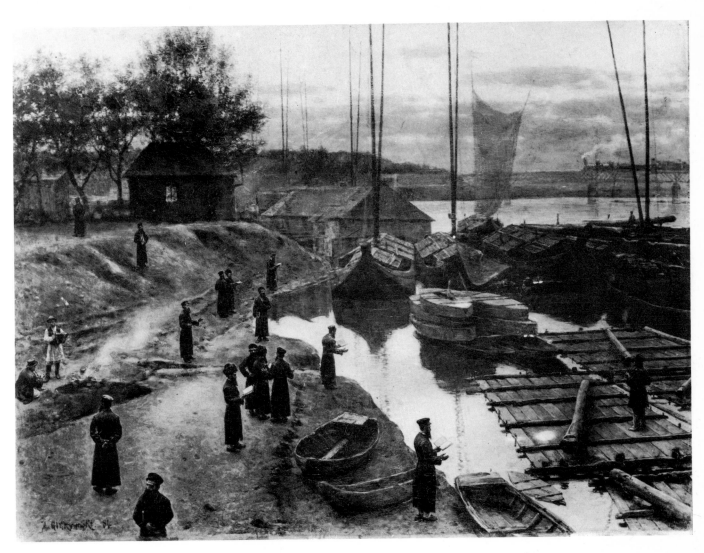

121. ALEKSANDER GIERYMSKI *Jewish Religious Celebration, Warsaw.* 1888.

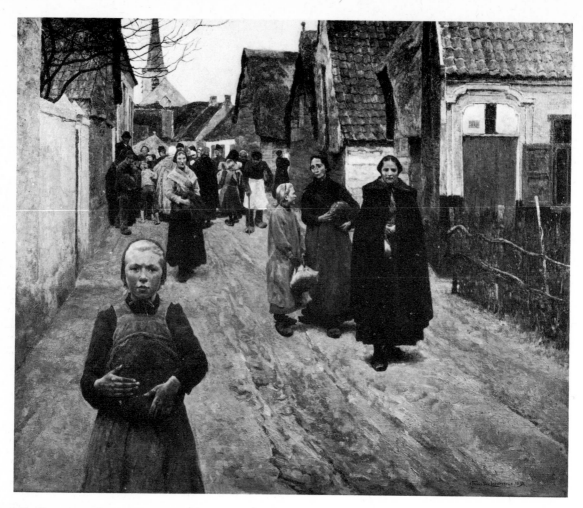

122. Frans van Leemputten *Distribution of Bread at the Village.* 1892.

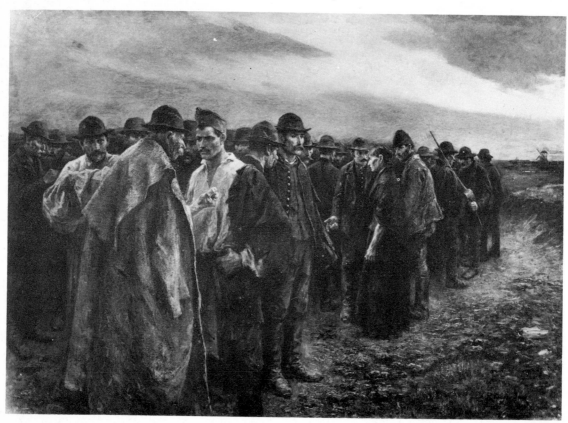

123. Istivan Rívéz *Panem.* 1899.
Dispossessed Hungarian peasants.

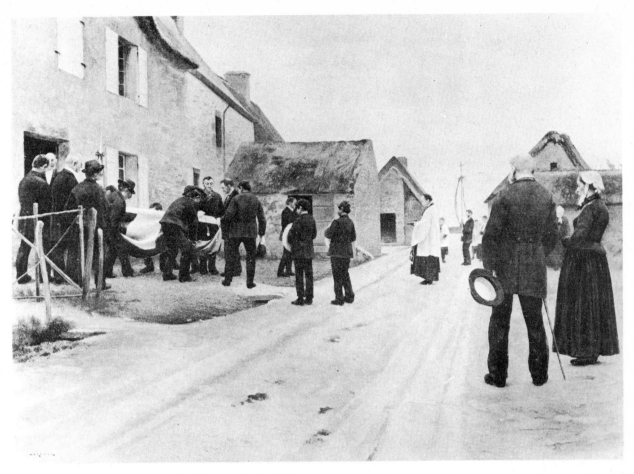

124. AUGUST HAGBORG *Funeral in Normandy.* c. 1893.

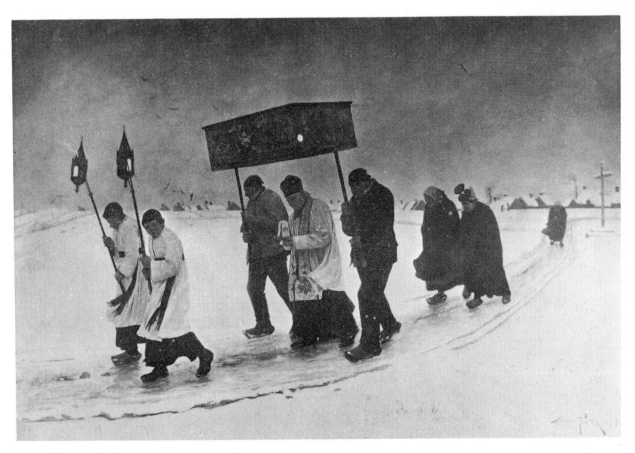

125. AIME PERRET *The Viaticum, Burgundy.* 1879.

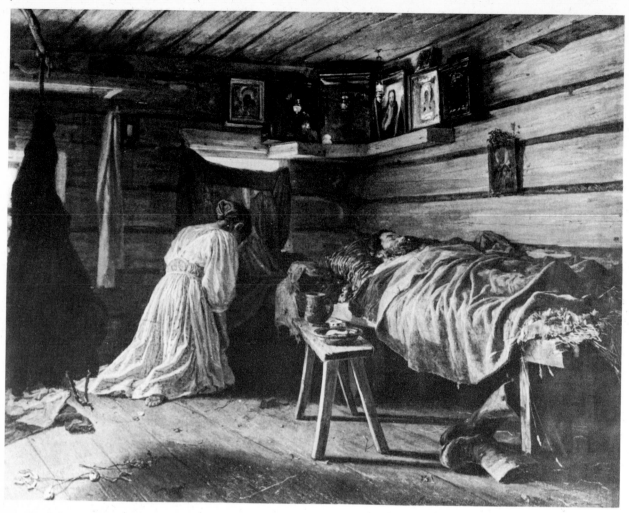

126. VASSILY MAXIMOV *The Death Bed*. 1881.
Note the "icon corner" above the bed—a sign that this is a Russian dwelling.

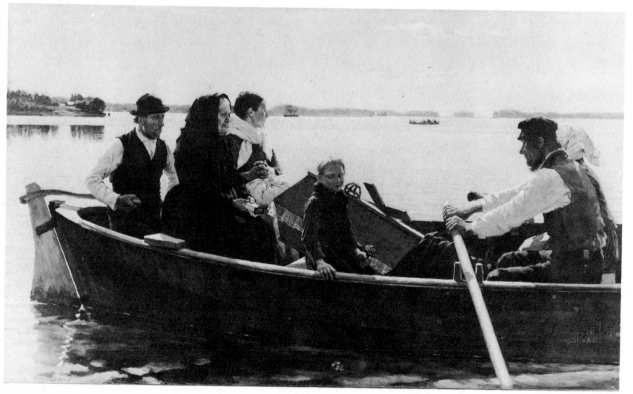

127. ALBERT EDELFELT *The Child's Funeral*. 1879.
The scene is the Finnish archipelago.

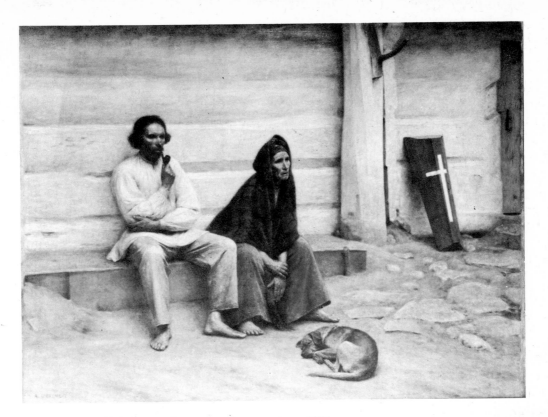

128. CHRISTIAN DALSGAARD *Inspecting the gravestone*. 1873.
The memorial is of typical "peasant" type.

129. ALEKSANDER GIERYMSKI *The Child is dead*. 1894.
This, like the preceding picture by Edelfelt, is a reminder of the continuing high rate of infant mortality.

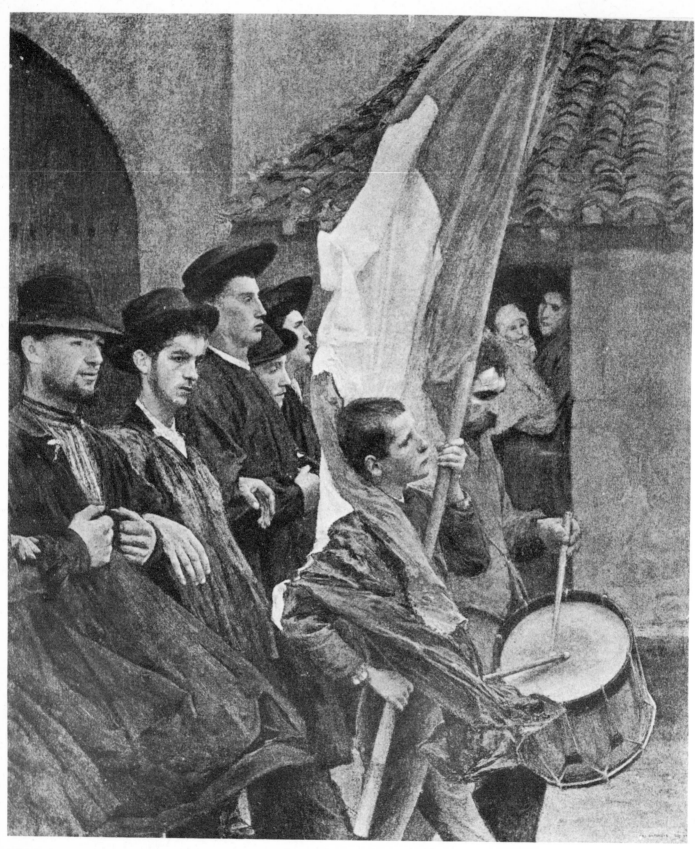

130. PASCAL DAGNAN-BOUVERET *Conscripts*. 1890.
All the major European nations except Britain maintained large conscript armies.

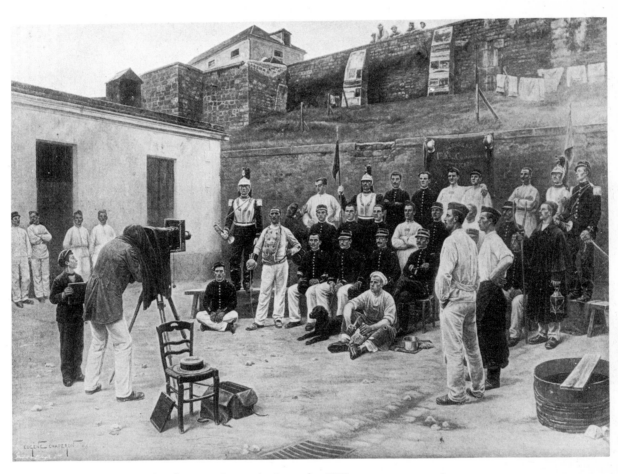

131. EUGENE CHAPERON *The Photographer at the Barracks*. 1899.
Conscripts and their instructors. Note the variety of trades represented: cook, bandsman, fencing instructor.

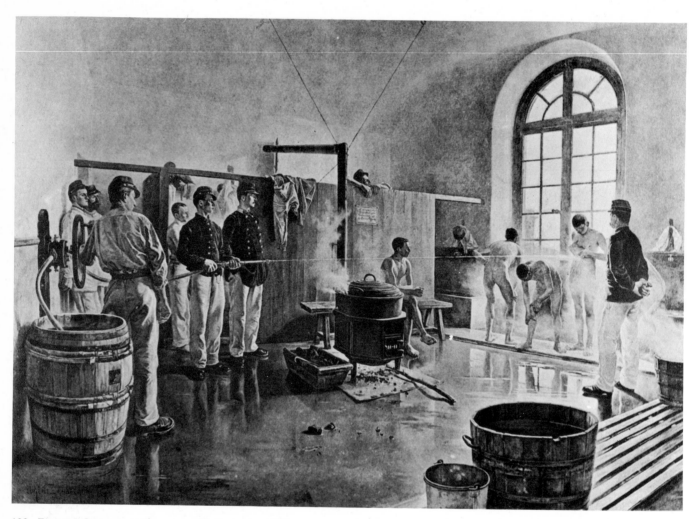

132. Eugene Chaperon *Shower at the Barracks.* 1887.

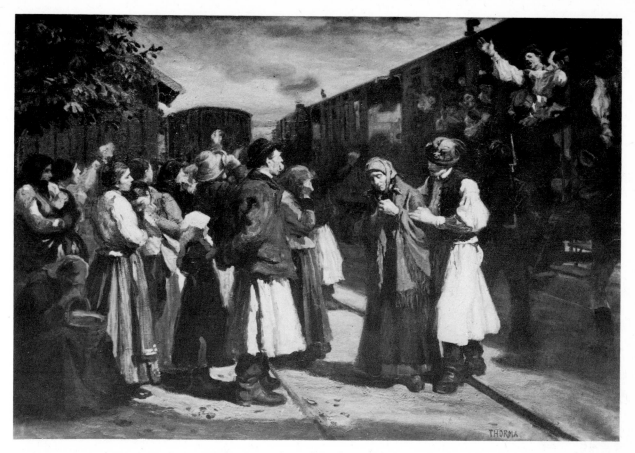

133. Janos Thorma *On October 1st*. 1903.

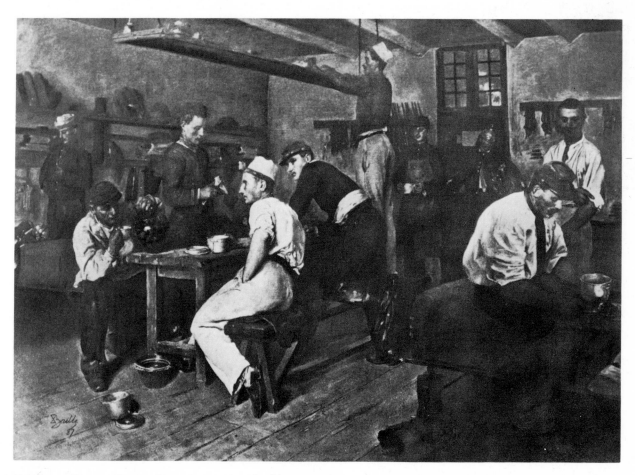

134. Louis Eugene Baille *Happy memories of soldiering*. 1887.

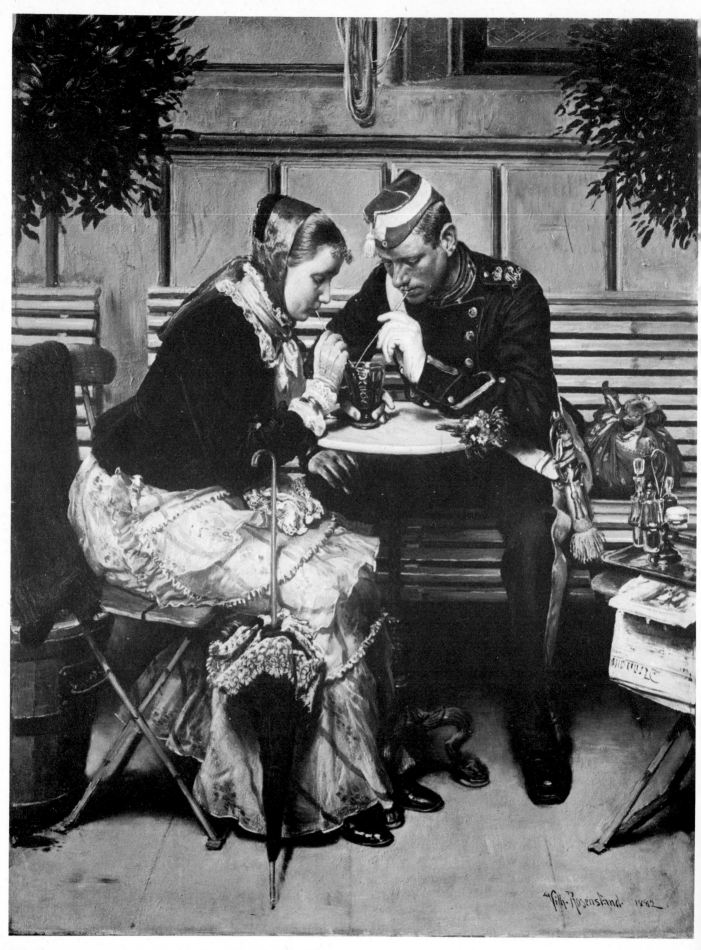

135. Vilhelm Rosenstand *Outside the "A Porta" Cafe.* 1882.

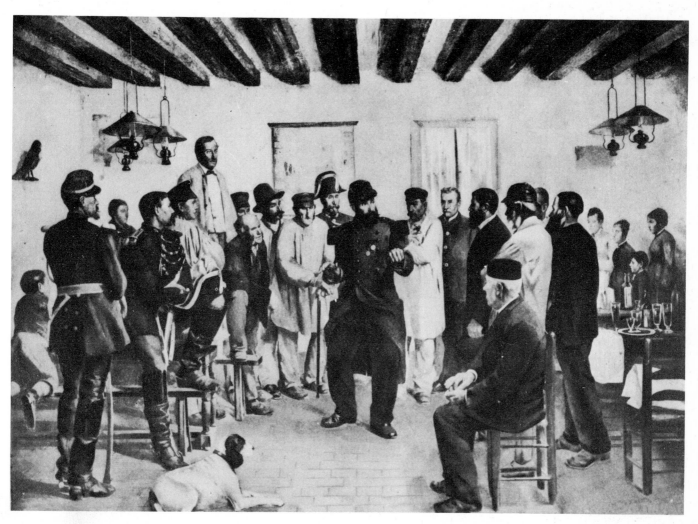

136. Désiré Lubin *Back Home*. 1887.
The soldier who has returned to his native village shows off his medals and tells stories of his campaigns.

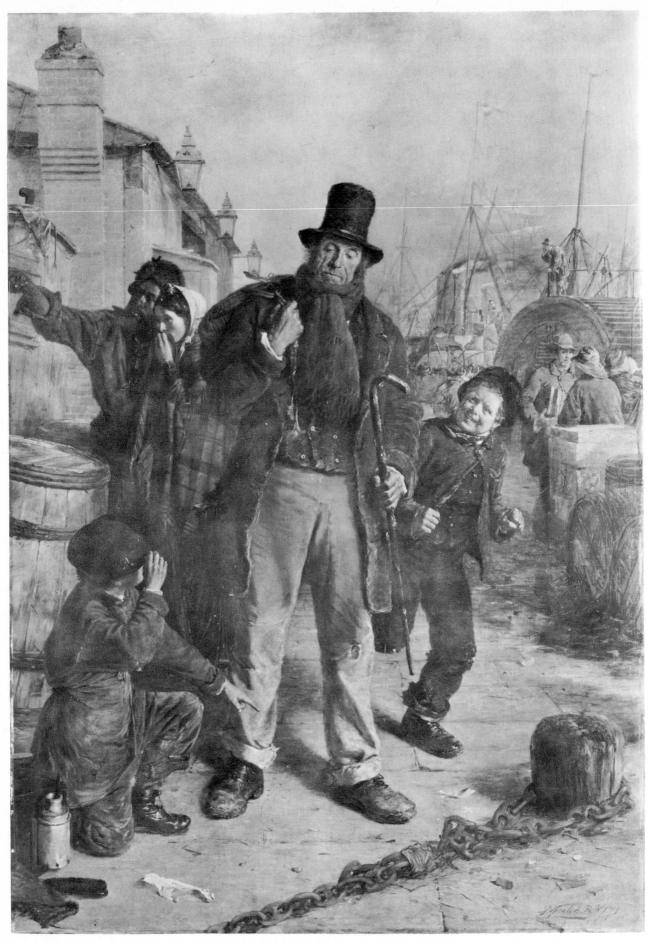

137. ERSKINE NICOL *An Irish emigrant landing at Liverpool.* 1871.
At this period both Liverpool and Glasgow had rapidly growing immigrant populations from Ireland.

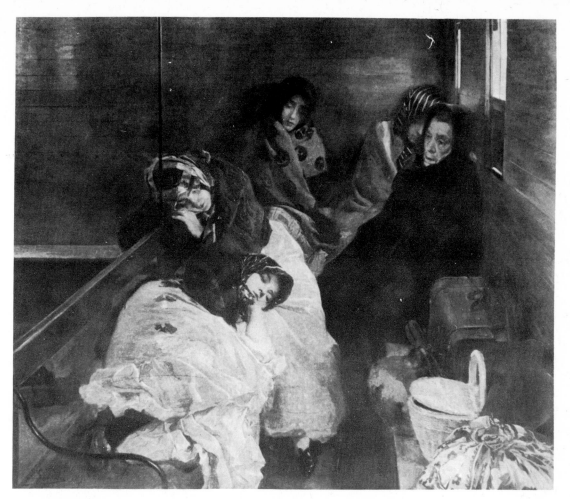

138. JOAQUIM SOROLLA Y BASTIDA *The Railway Waiting Room*. 1895.

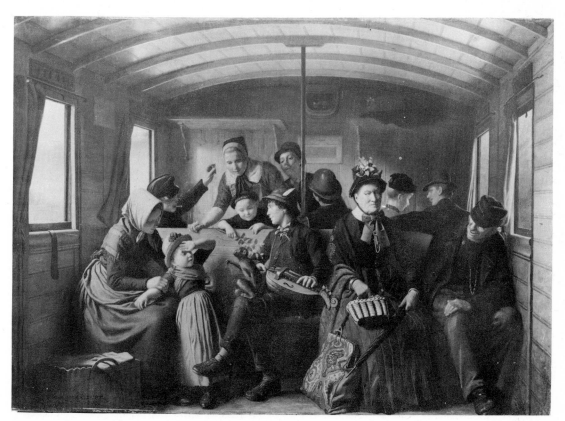

139. JOHANN JULIUS EXNER *The Third-Class Coach*. 1890.
The central figure is a traveling entertainer, with a hurdy-gurdy and a marmoset.

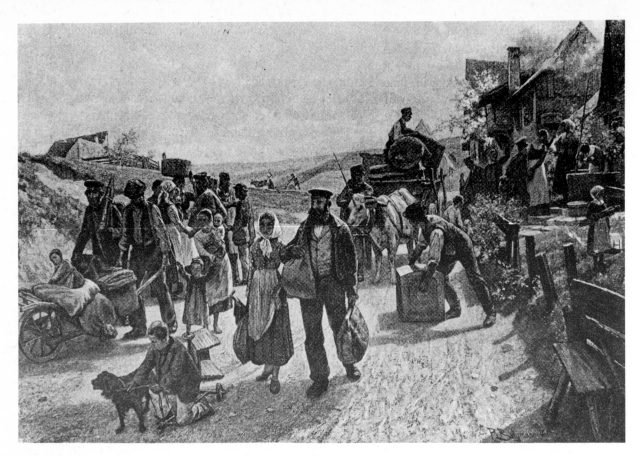

140. PAUL BORGMANN *Going to America*. c. 1888.
German emigrants at the start of their journey to the New World.

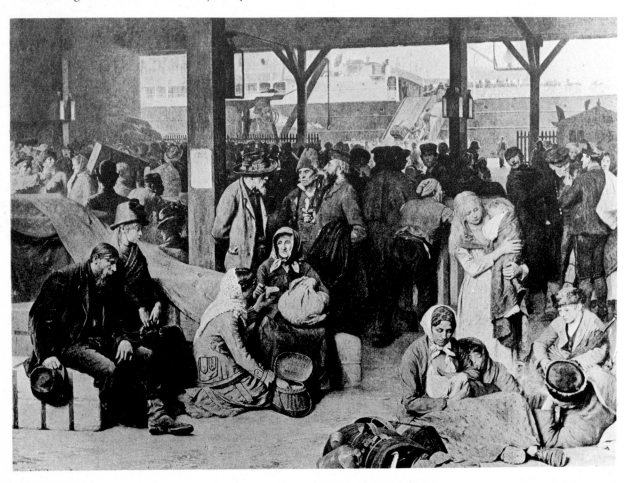

141. ALBERT PURRE DAWANT *Emigrants ready to embark, Le Havre*. 1887.

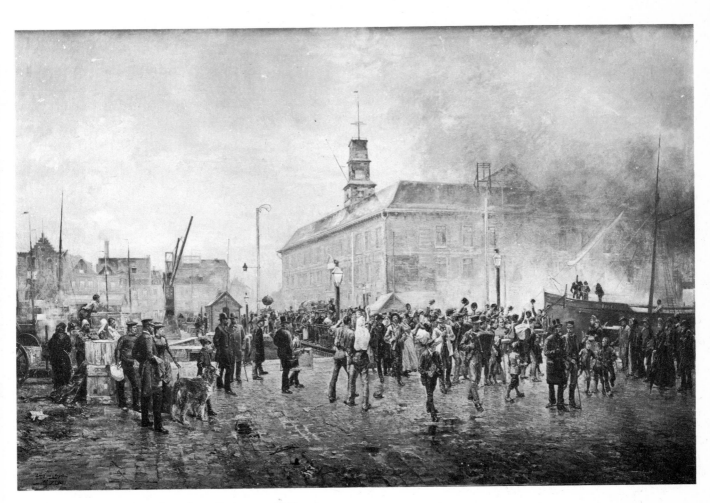

142. LOUIS VAN ENGELEN *The Belgian Emigrants*. 1890.

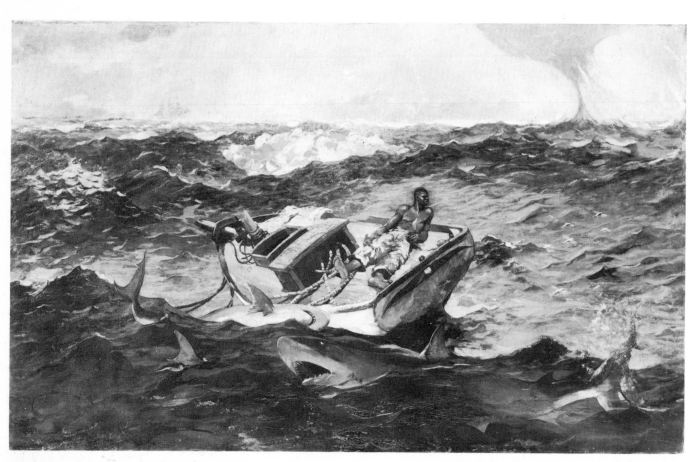

143. WINSLOW HOMER *The Gulf Stream.* 1899.

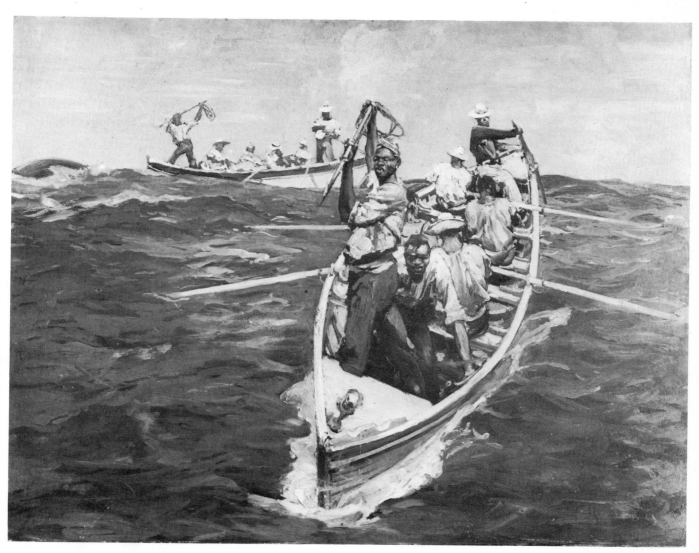

144. Frank Brangwyn *Harpooning The Whale*. c. 1895.

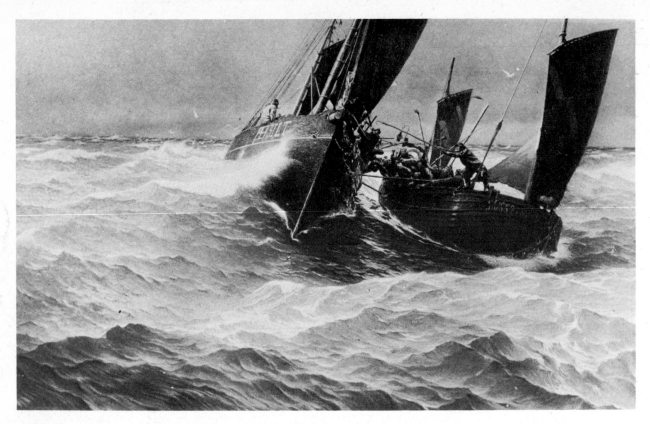

145. F. Tattegrain *The Stolen Nets, Herring Season.* c. 1905.

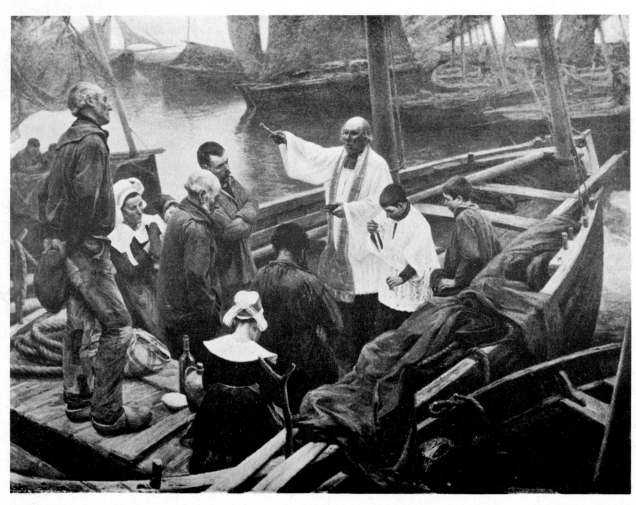

146. Emil Hirschfeld *Blessing of the New Boat.* c. 1898.

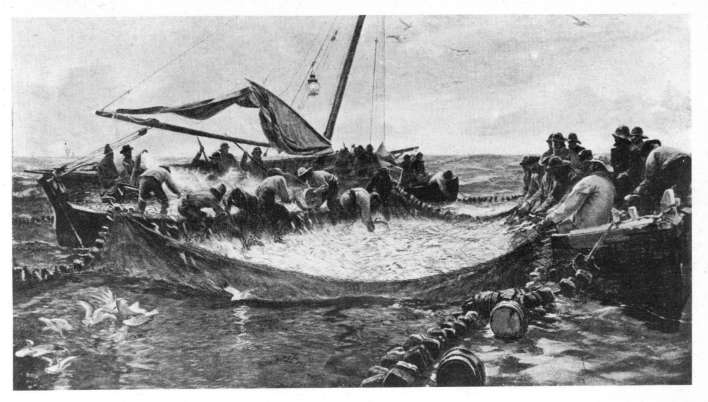

147. CHARLES NAPIER-HEMY *Pilchards*. c. 1897.

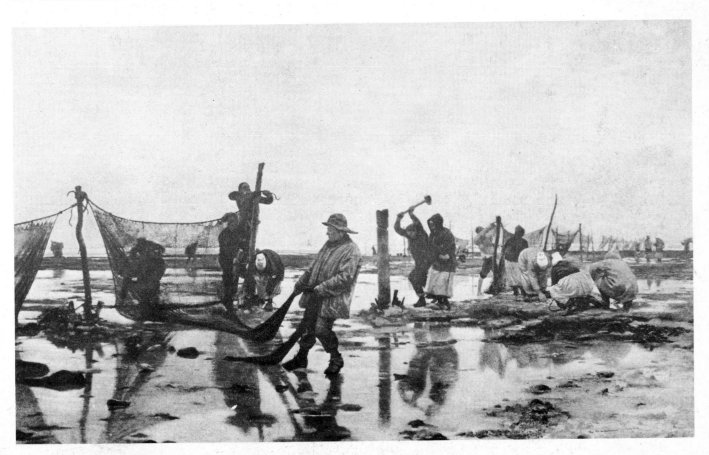

148. EDOUARD DANTAN *Drying the nets, Villerville*. c. 1886.

149. GOTTBART KUEHL *The Sail Maker.*

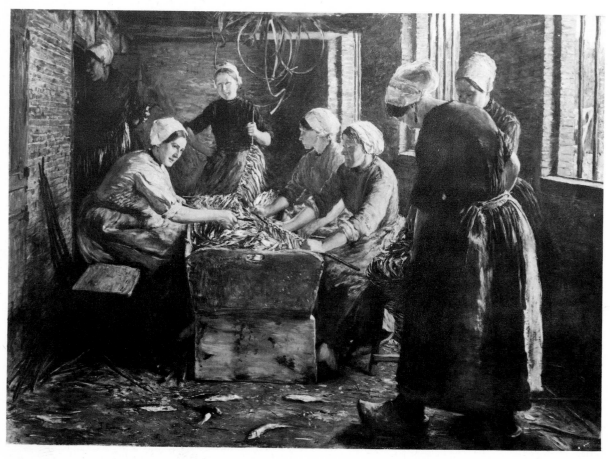

150. FRANZ SKARBINA *Smoking the Fish.* 1888.
Strung on rods, the fish are put in the smokehouse.

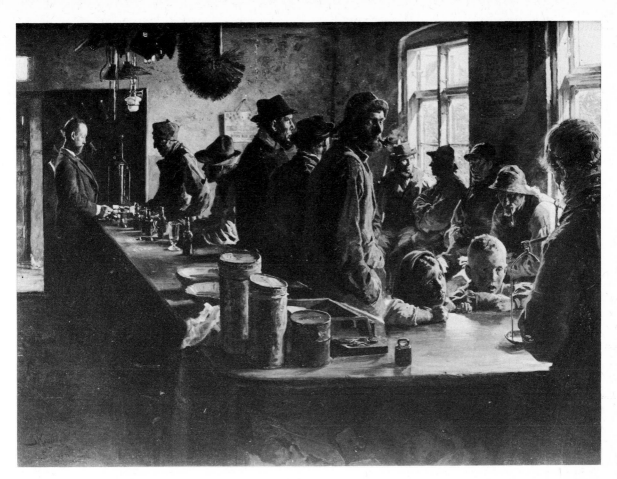

151. PAUL SEVERIN KRØYER *The Fisherman's Cafe.* 1882.

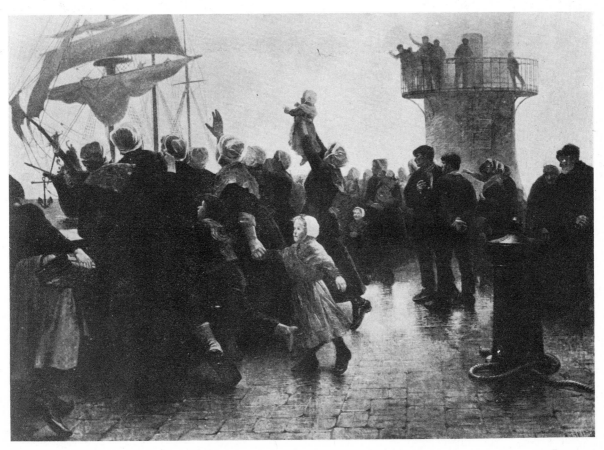

152. GUILLAIME ALBERT DEMAREST *Back from Iceland.* c. 1899.
The women and children welcome the return of their men from the codfishing grounds.

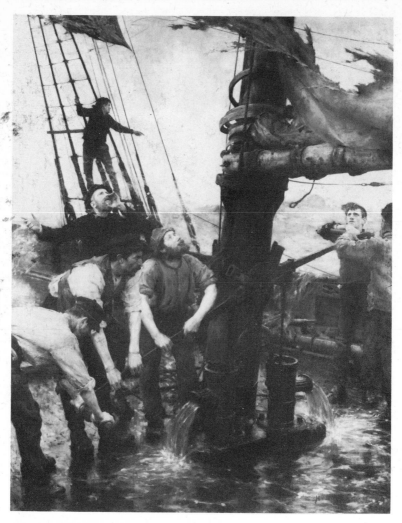

153. HENRY SCOTT TUKE *All hands to the pumps*. 1889.

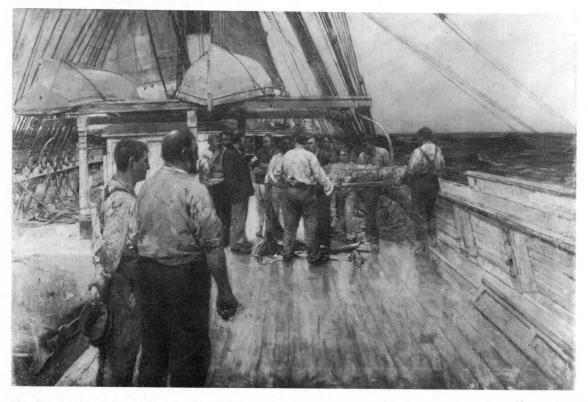

154. FRANK BRANGWYN *Funeral at Sea*. 1890's.

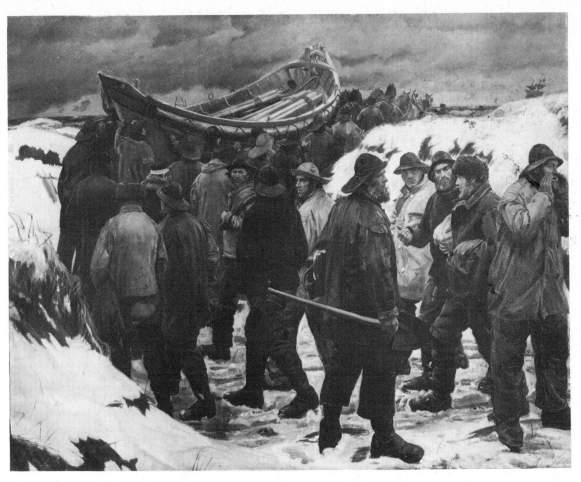

155. MICHAEL PETER ANCHER *Lifeboat taken through the dunes.* 1883.

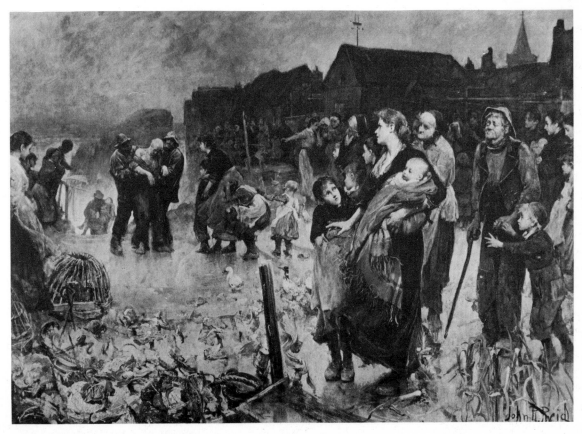

156. J. ROBERKAN REID *Rescued from the wreck.* c. 1890.

157. Jules Alexis Muenier *The Pedlar*. c. 1894.
On many remote farmsteads the visiting pedlar was a source of news and gossip, as well as of goods.

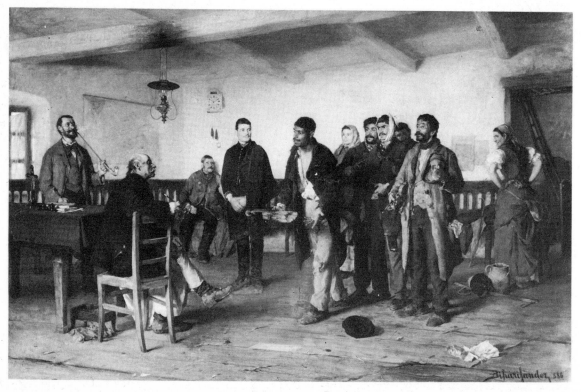

158. Sanclar Bihari *Before the Justice of the Peace*. 1886.
The arrested men are traveling gypsy musicians who have been engaged in a brawl.

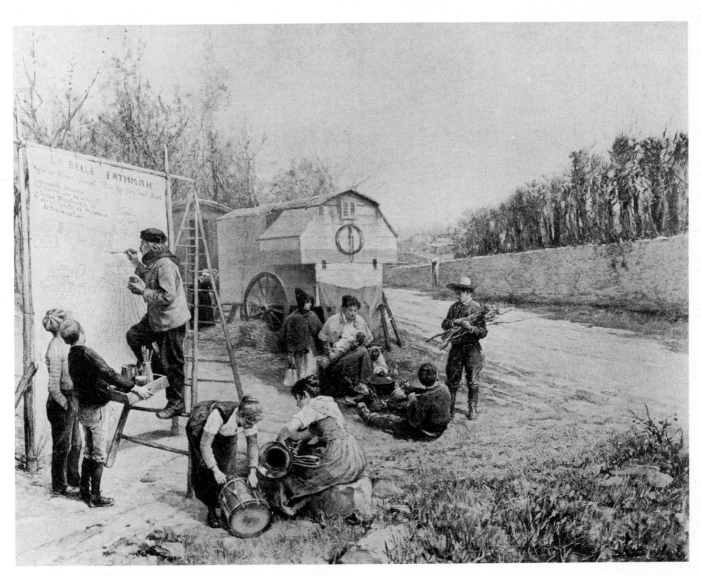

159. PIERRE MANE BEYLE *School of Misery—preparing the show.*

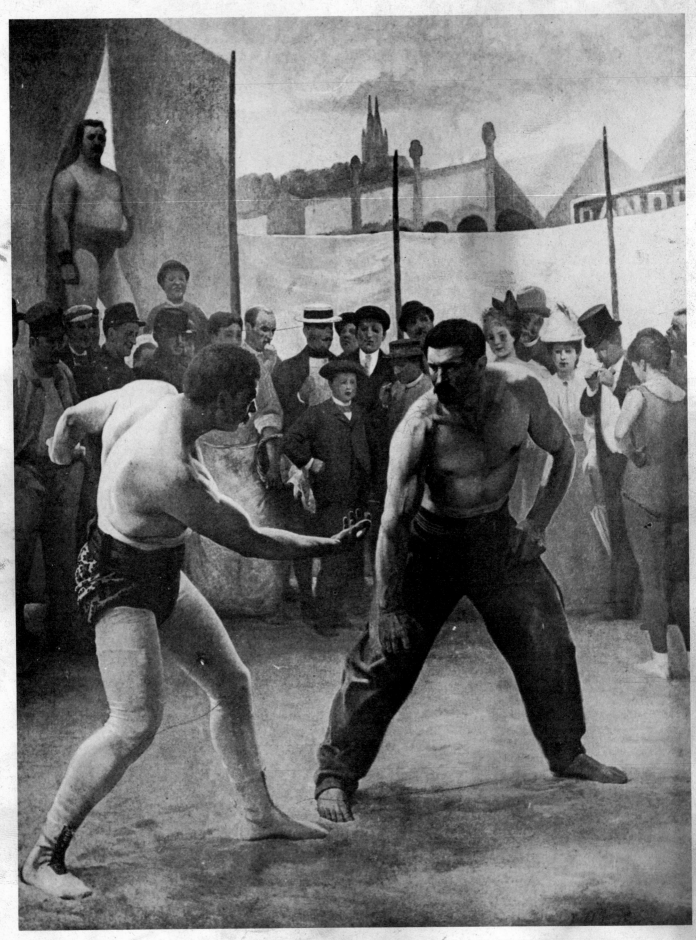

160. J. Gabriel Hubert-Sauzeau *Circus Wrestlers*. c. 1899.
The professional is on the left, his amateur challenger on the right.

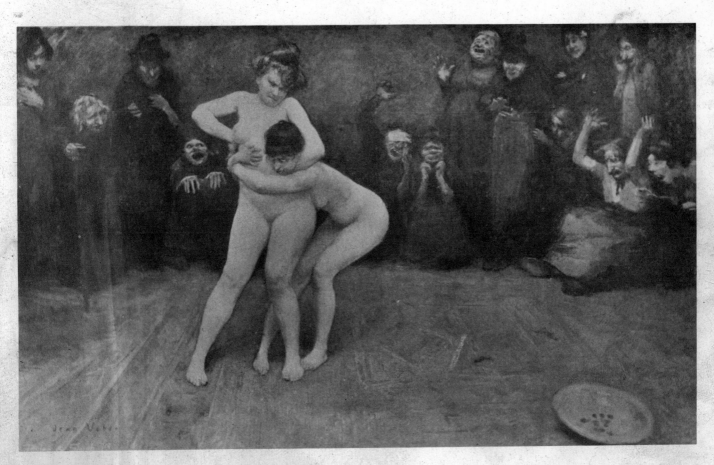

161. JEAN VEBER *Wrestlers in Devonshire*. 1899.
The one certain thing about this scene is that the naked women are wrestling for money.

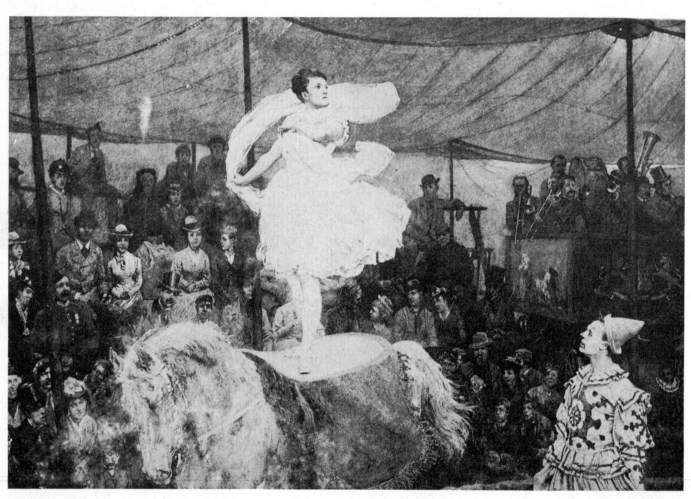

162. CHARLES GREEN *Country Circus*. c. 1897.
The theme of the circus fascinated many painters at this period, among them Tissot and Toulouse-Lautrec.

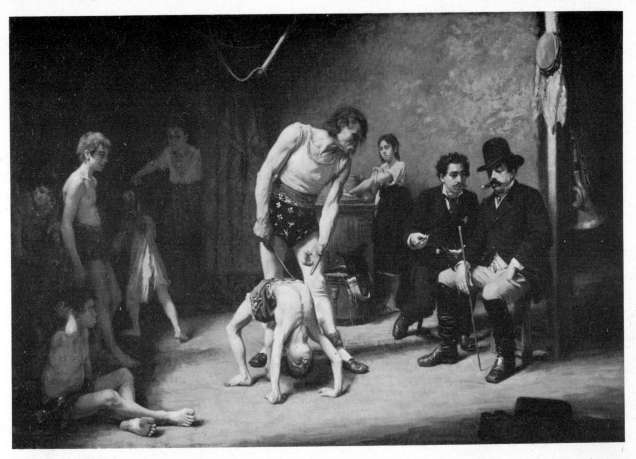

163. NILS FORSBERG *Auditioning for the Circus Director*. 1878.

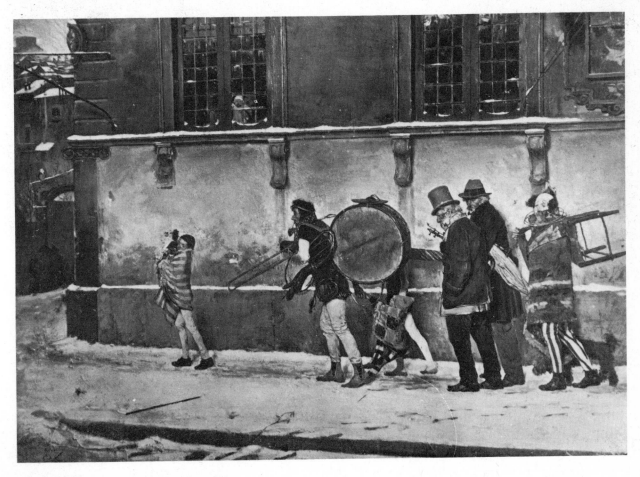

164. ROMERA RIBERA *Art in Misery*. 1873.
Daumier drew sheet entertainments of this type.

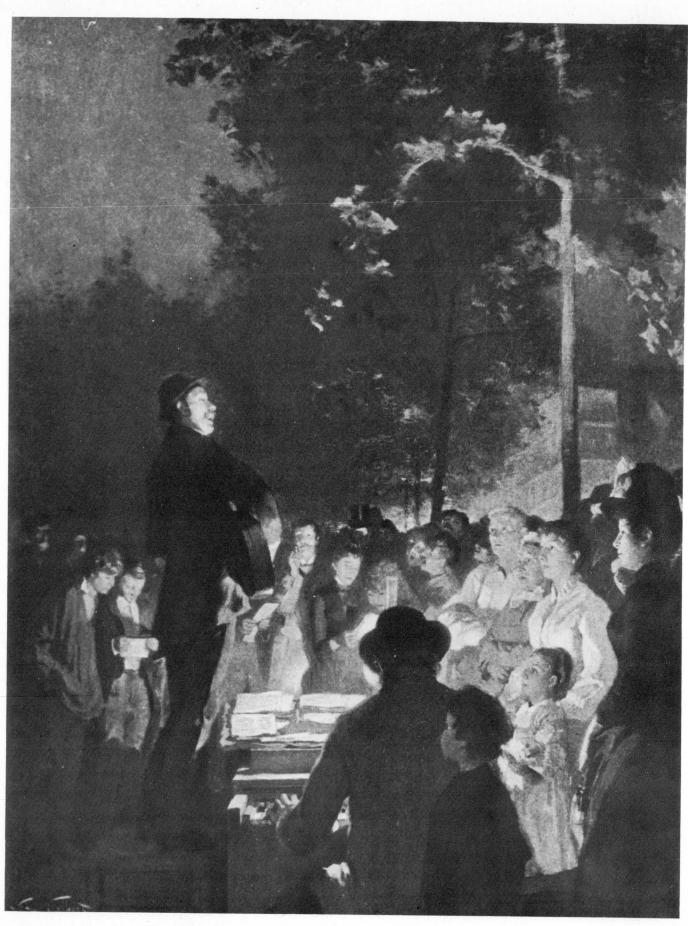

165. VICTOR GILBERT *The Song Pedlar*. 1886.
Selling songs was a profession that went back several centuries.

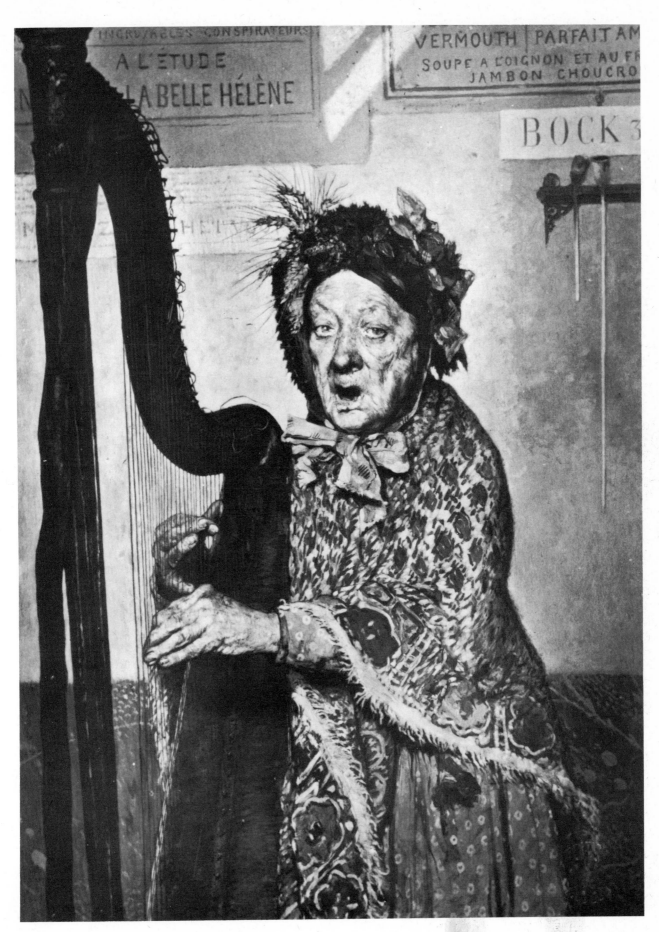

166. JAN VAN BEERS *The Fallen Star.* c. 1878.
The old woman is performing in a café. Part of the menu and a rack of clay pipes can be seen.

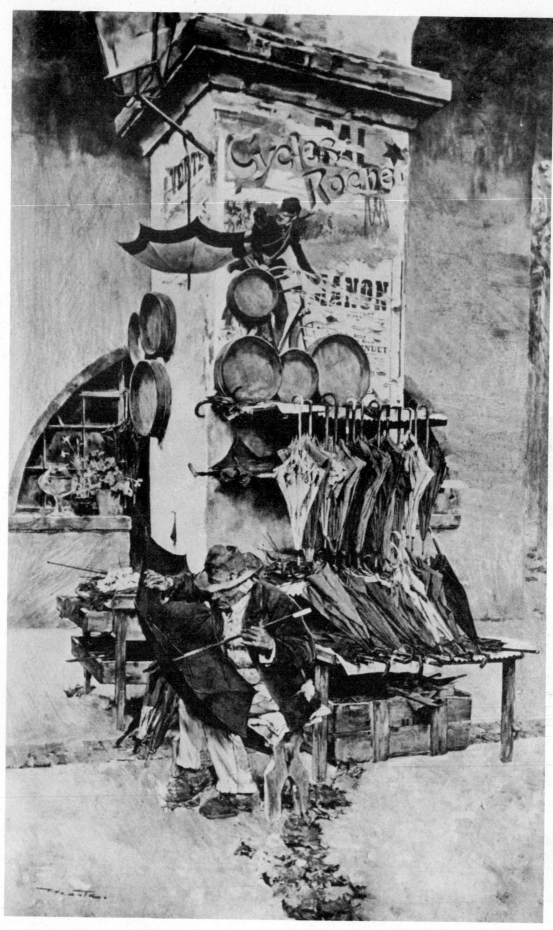

167. EDOUARD MENTA *Umbrella Repairer in the South of France.* c. 1895.

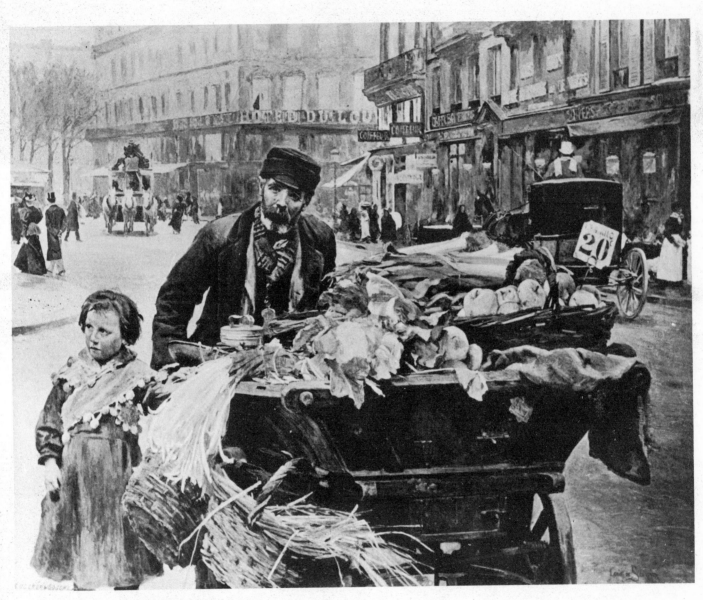

168. Louis de Schryver *Vegetable-stall holder*. c. 1895.
Nearly all produce was still seasonable.

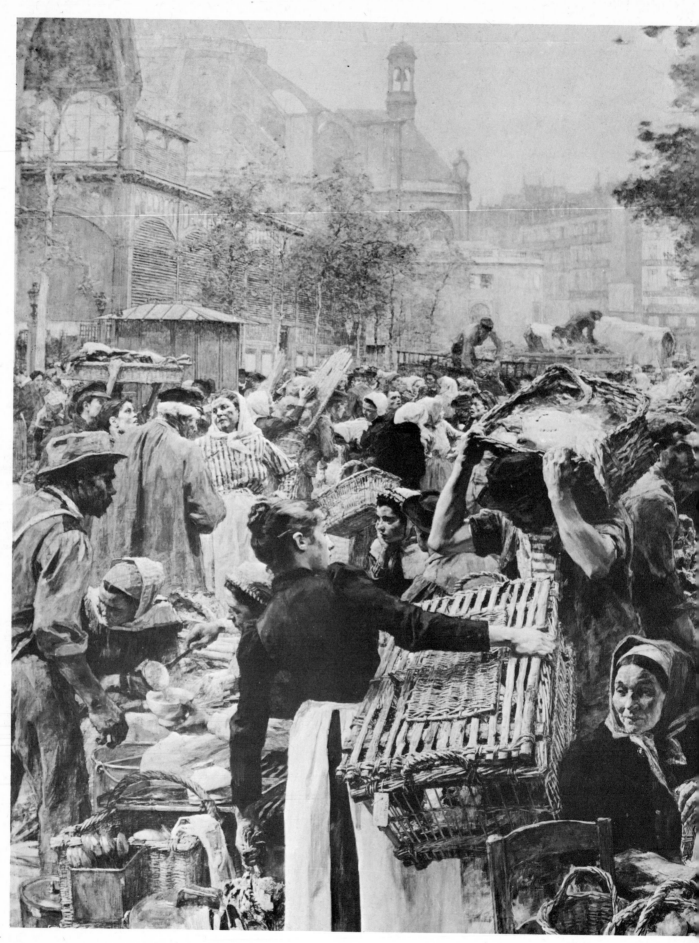

169. LEON LHERMITTE *Les Halles de Paris*. 1895.
Zola, too, was fascinated by what he called the "Belly of Paris."

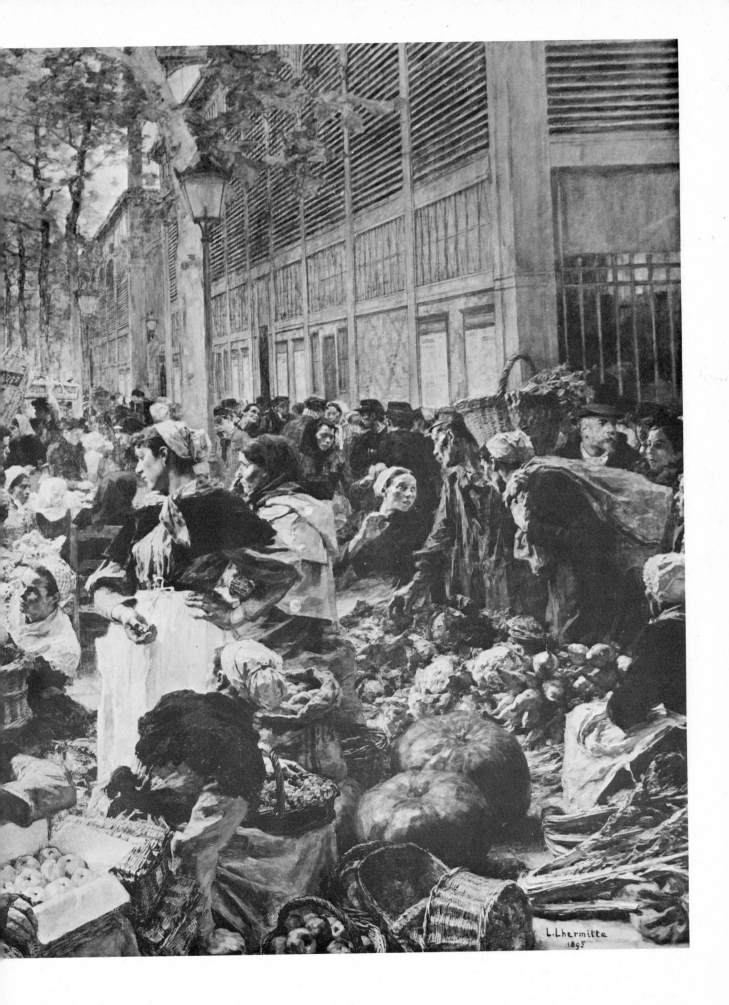

L.Lhermitte
1895

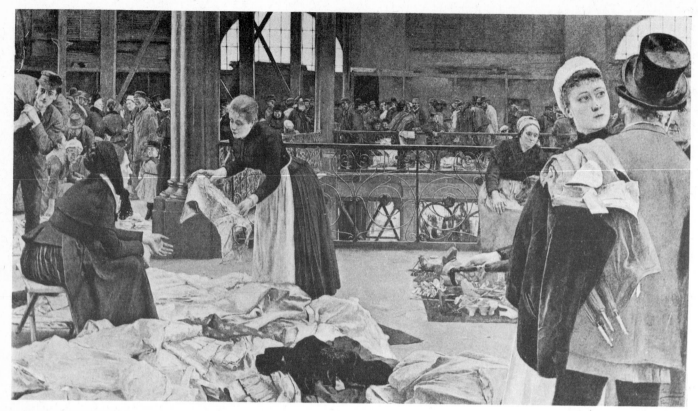

170. LUIS JIMÉNEZ *The "Carreau du Temple"*. 1890.
This was the Paris market for second-hand clothing.

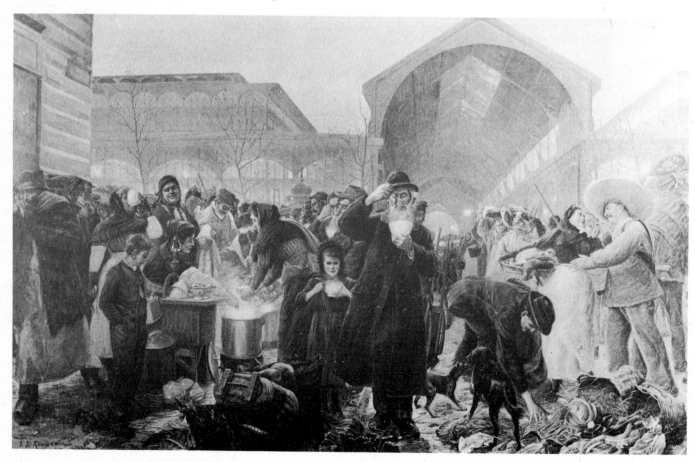

171. JEAN JACQUES ROUSSEAU *Soup Stall, Les Halles, Winter Morning*. 1897.

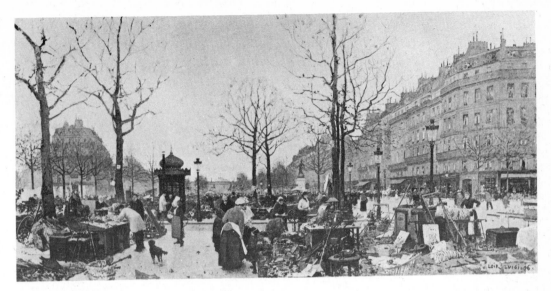

172. LUIGI LOIR *The Junk Market*. 1896.
Old metal work is the chief commodity.

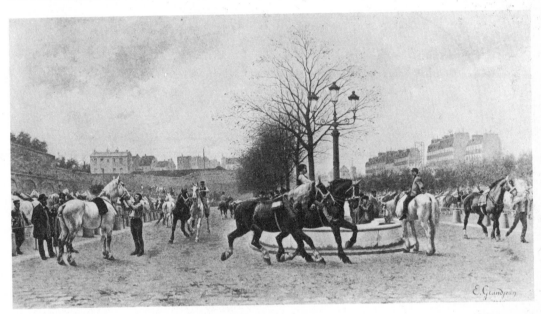

173. EDMOND GRANDJEAN *The Horse Market in Paris*. 1888.
At this date horses were still a major means of transportation.

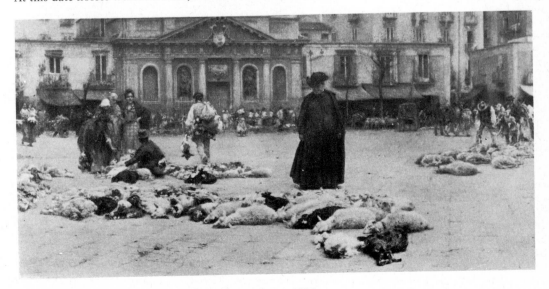

174. VINCENZO CAPRILE *Easter Market at Naples*. c. 1896.
At this time, even the poorest families tried to feast on the symbolic Paschal lamb.

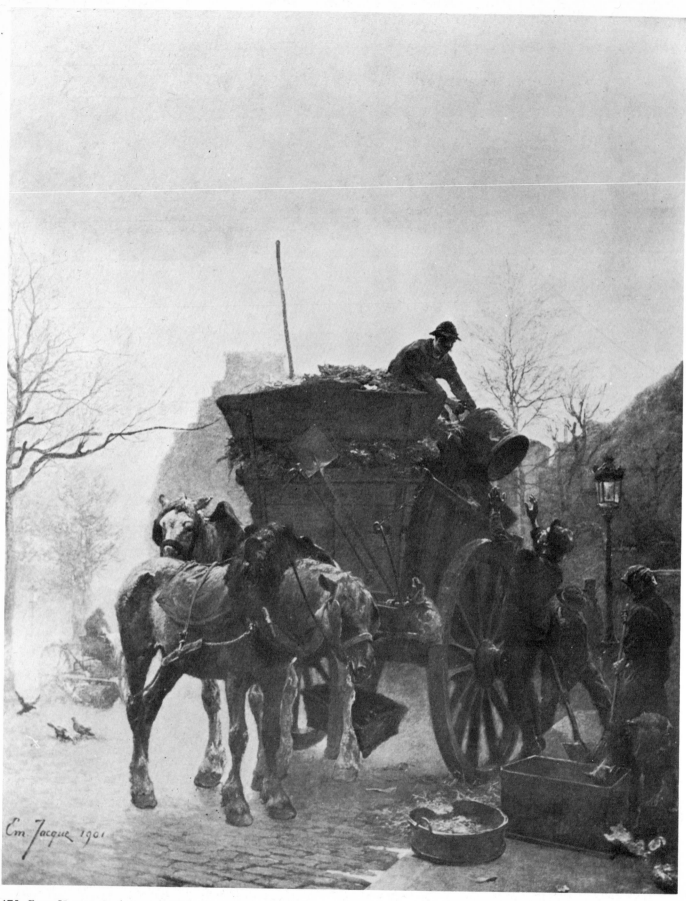

175. EMIL JACQUE *Garbagemen*. 1901.

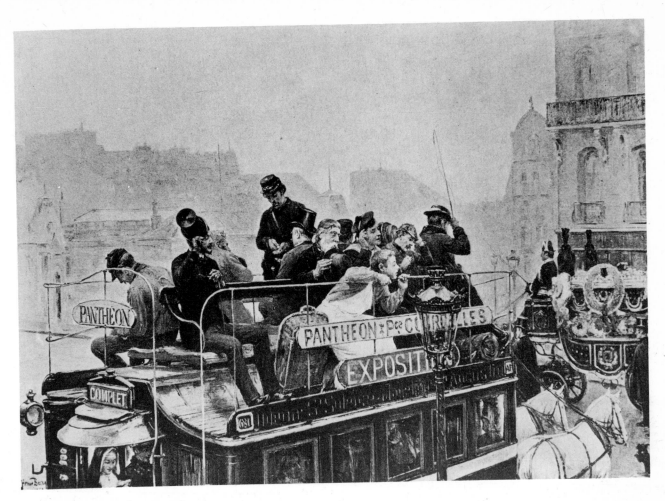

176. HENRY BACON *Equals*. 1889.
An English painter's vision of the Parisian horse-drawn bus.

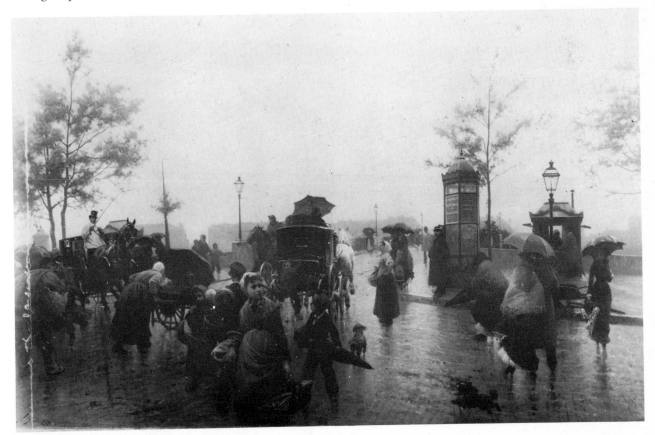

177. NICOLAS SICURD *The Bridge of the Guillotière, Lyon*. 1879.

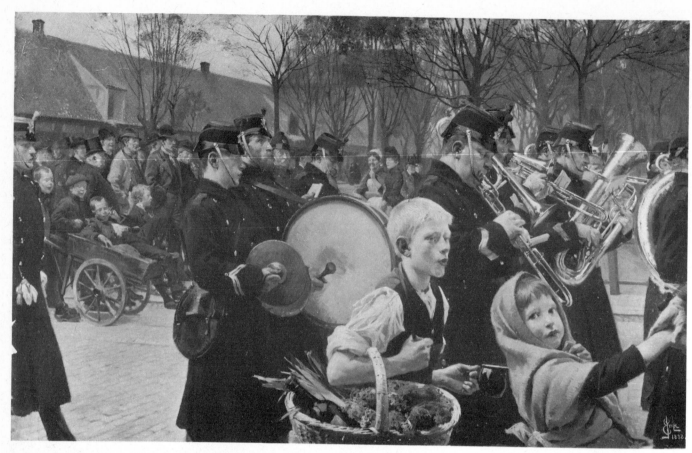

178. ERIK HENNINGSEN *The Changing of the Guard*. 1888.

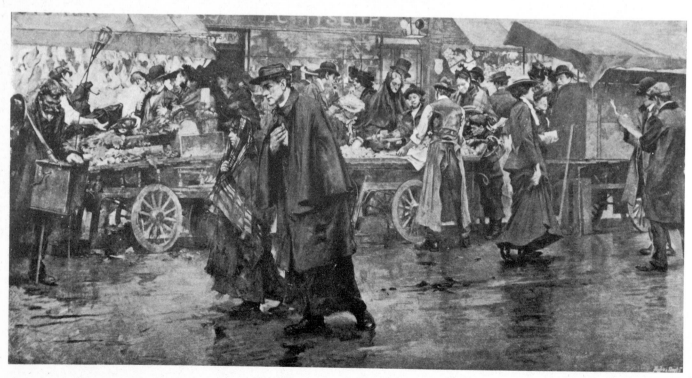

179. ALBERT CHEVALIER-TAYLOR *The Viaticum*. c. 1903.

180. EDOUARD DETAILLE *Victims of Duty*. c. 1894.

181. RENE CHOQUET *Poor Animal!* 1899.

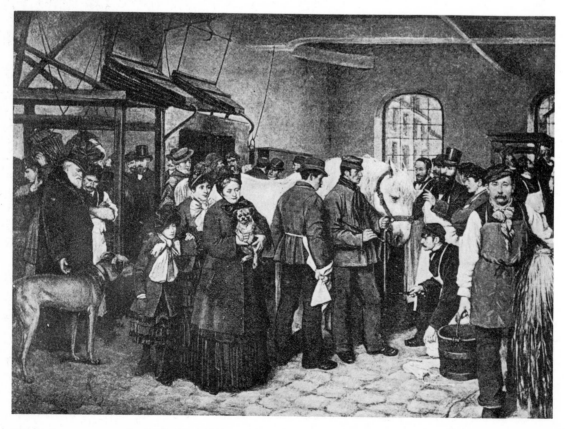

182. E. SEKLDRAYERS *At the Vet's.* c. 1892.

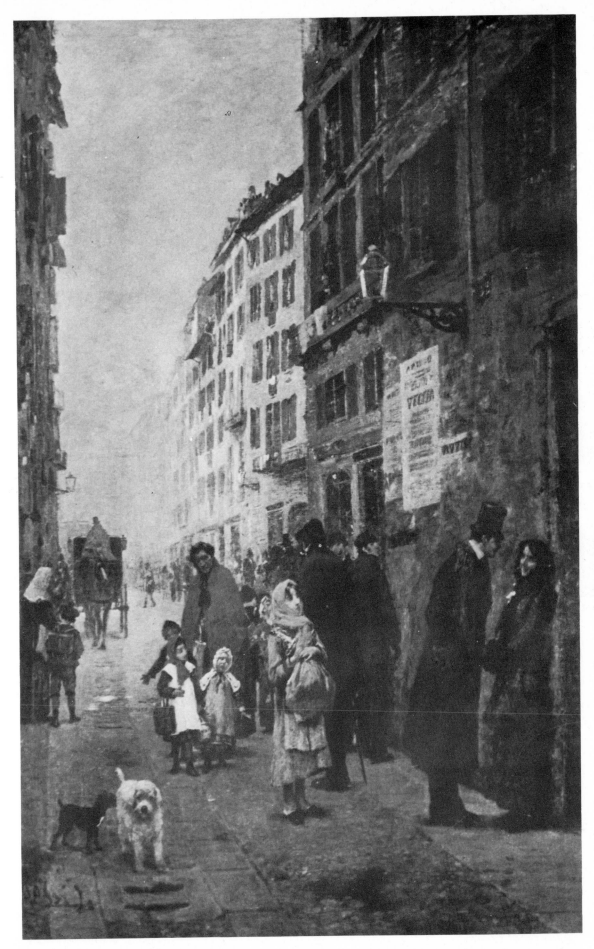

183. LUIGI ROSSI *In the Old Town, Milan.*
The smiling girl on the right, talking to the elegantly dressed man, is almost certainly a prostitute.

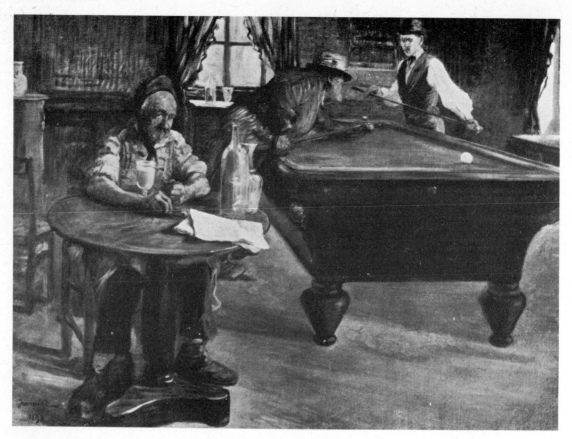

184. PIERRE GEORGES JEANNIOT *The Absinthe Drinker*. 1893.
Alcoholism was the curse of the poor in almost all great cities.

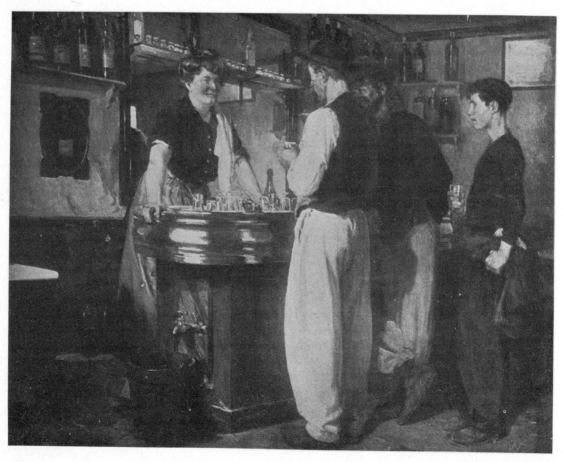

185. JULES PAGES *The Bistro*. c. 1905.

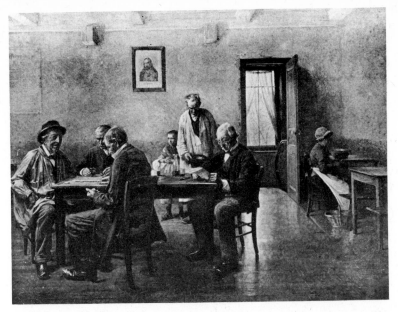

186. MARIE AUGUSTIN ZWILLER *"Ears they have, but they hear not."* 1896.

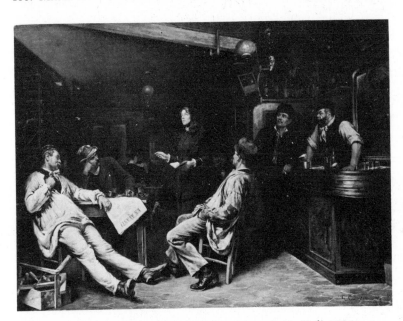

187. GUSTAV CEDERSTROM *Miss Booth visiting a Paris Café.* 1886.
A tribute to the widespread influence of the Salvation Army.

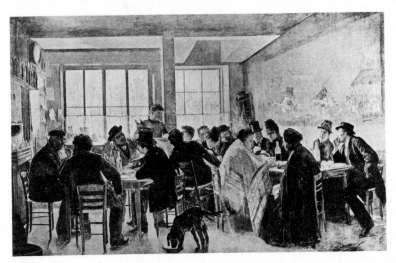

188. VICTOR MAREC *"Better here than over there—after the funeral."* 1886.
The mourners are drinking after a funeral at the church opposite.

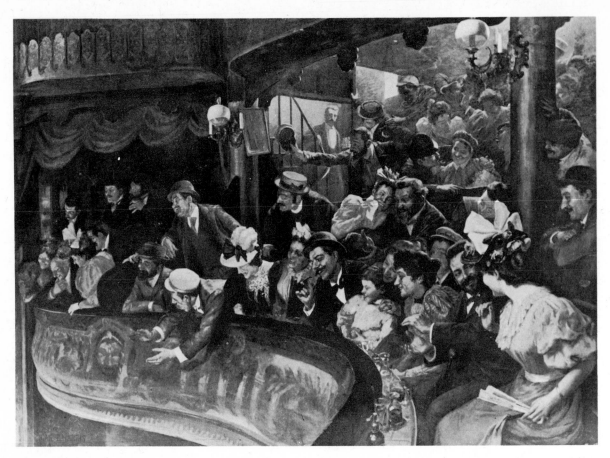

189. JUAN EDUARDO HARRIS *Matinée at the Gaîté Montparnasse.* c. 1897.

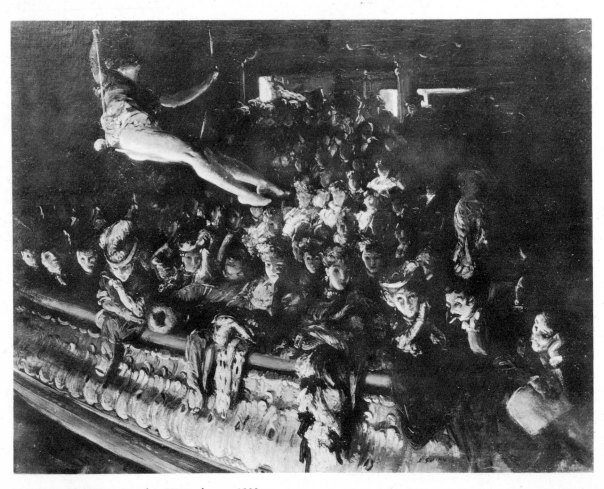

190. EVERETT SHINN *London Hippodrome.* 1902.

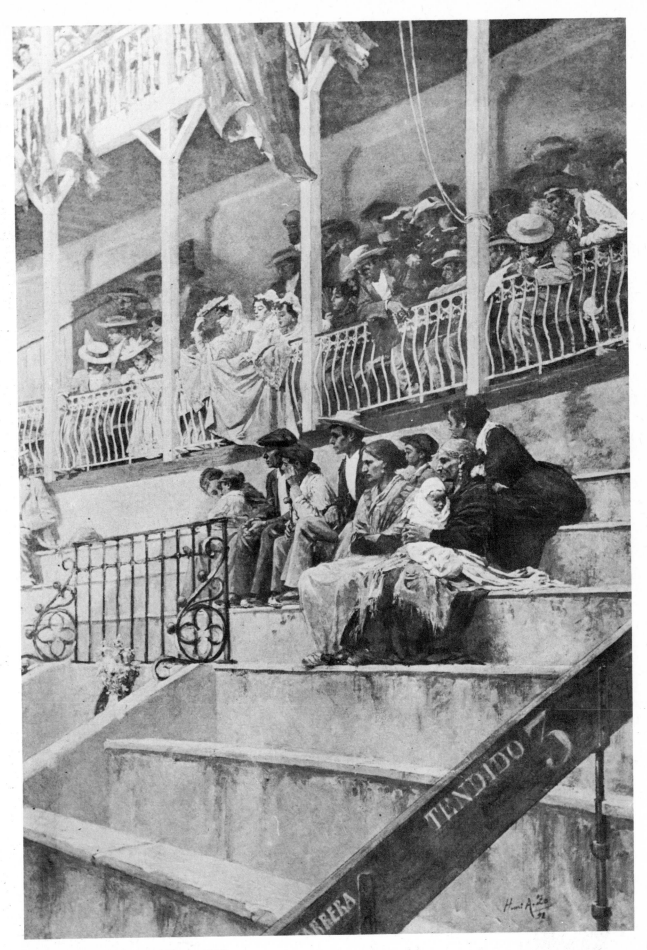

191. HENRI A ZO *Sun and Shade*. 1898.
At the bull ring, seats in the shade are the most expensive.

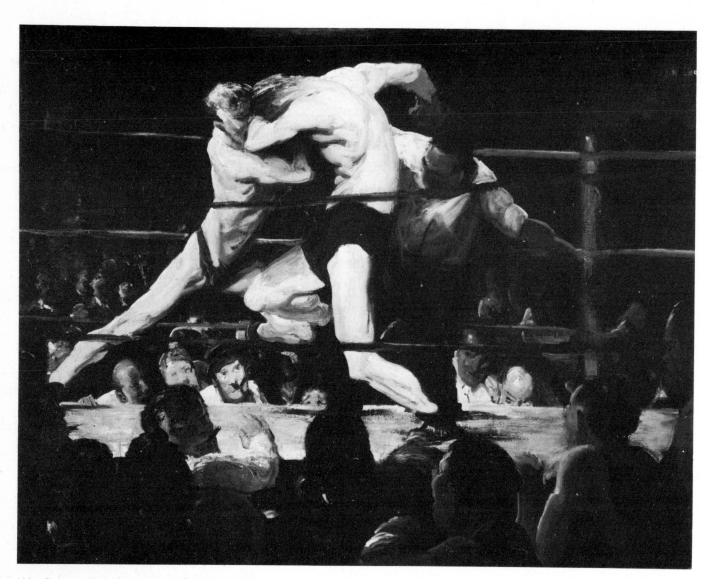

192. GEORGE BELLOWS *Stag at Sharkey's*. 1907.

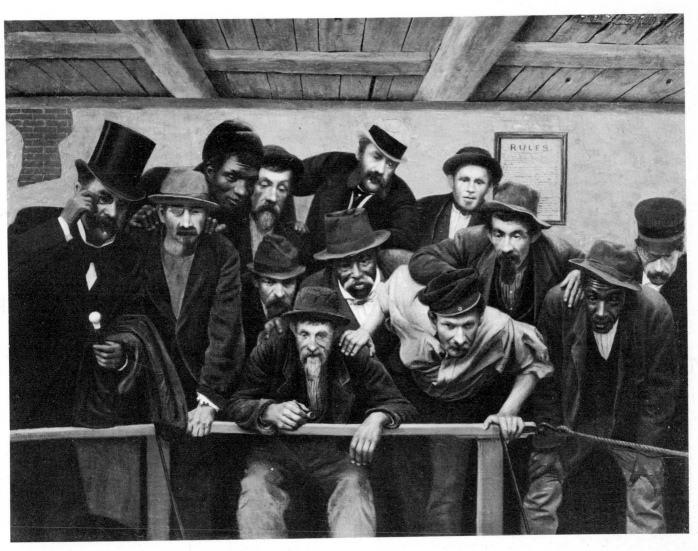

193. HORACE BONHAM *Nearing the issue at the cockpit.* 1870.
Cock-fighting united all classes—of males, naturally.

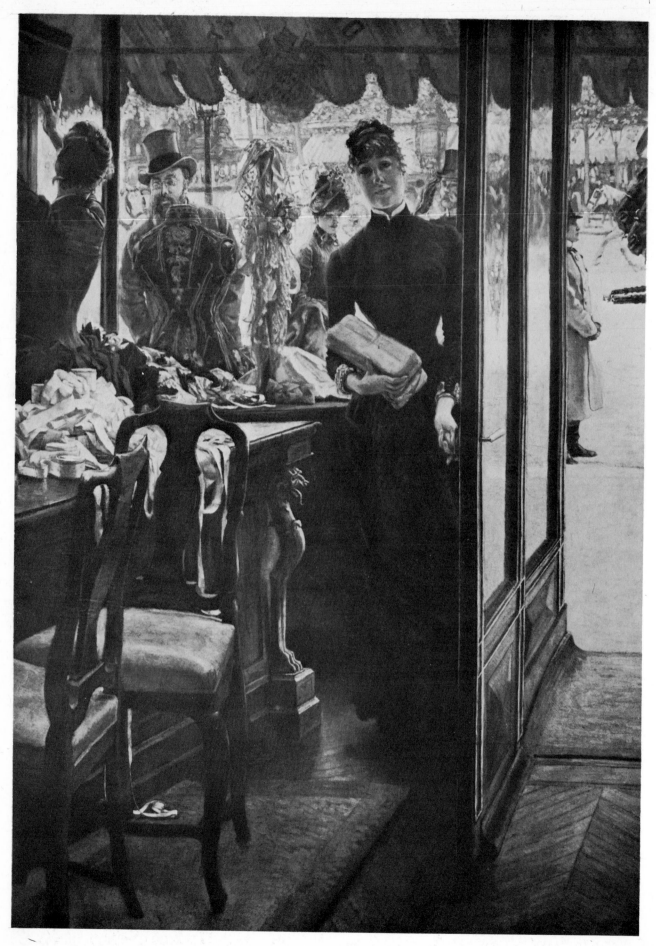

194. James Tissot *The Shop Assistant.* 1883-85.
Shop assistants worked extremely long hours. For a girl on her own, the alternative was probably
prostitution.

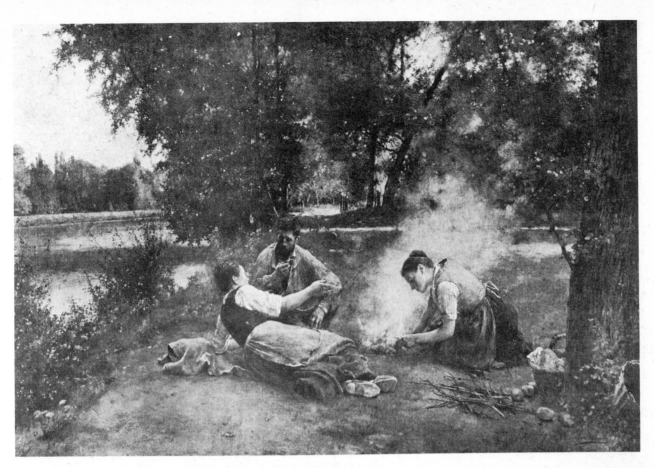

195. Luis Jiménez *Summer Picnic at Pontoise*. c. 1901.
As their clothes show, the picnickers belong to the working class.

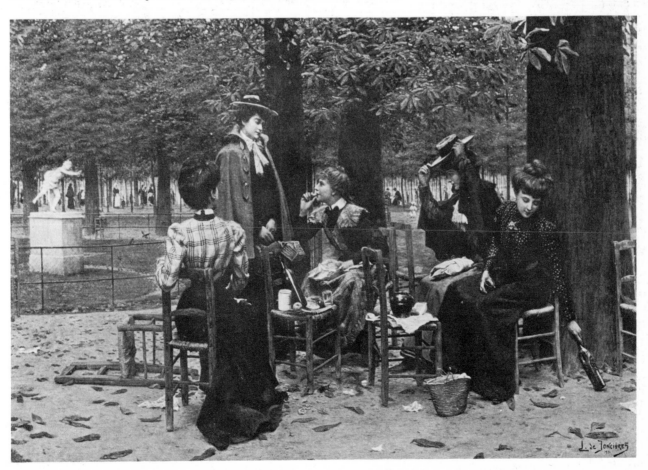

196. Leona de Joncières *Working Girls' Lunch*. 1901.
These are probably seamstresses from the great *couture* houses, snatching half an hour for lunch in the
Jardin des Tuileries.

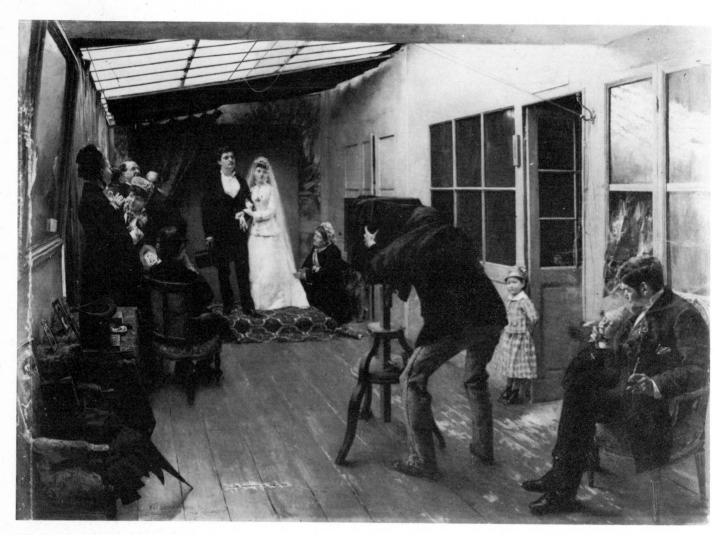

197. PASCAL DAGNAN-BOUVERET *A Wedding Party at the Photographer's.* 1879.

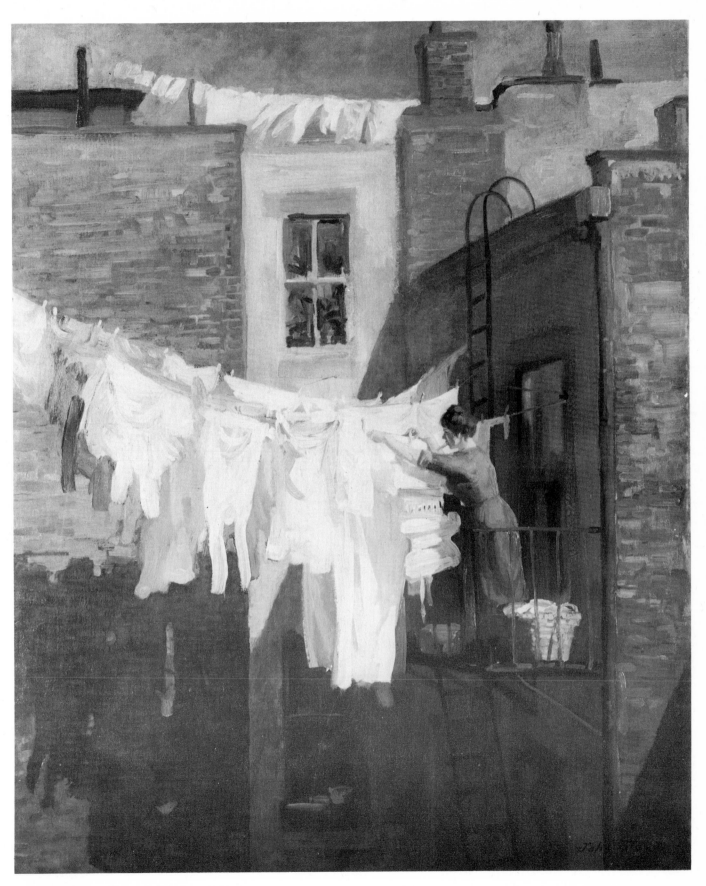

198. JOHN SLOAN *Woman's Work*. c. 1911.

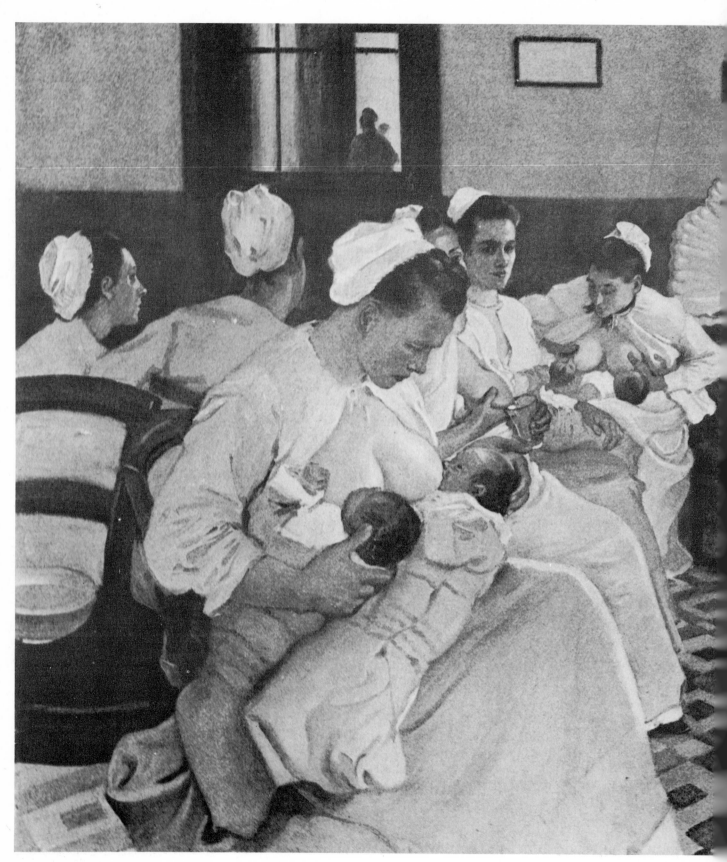

199. ERNEST DUEZ *Wet nurses feeding the sickly infants at the maternity hospital.* c. 1895.

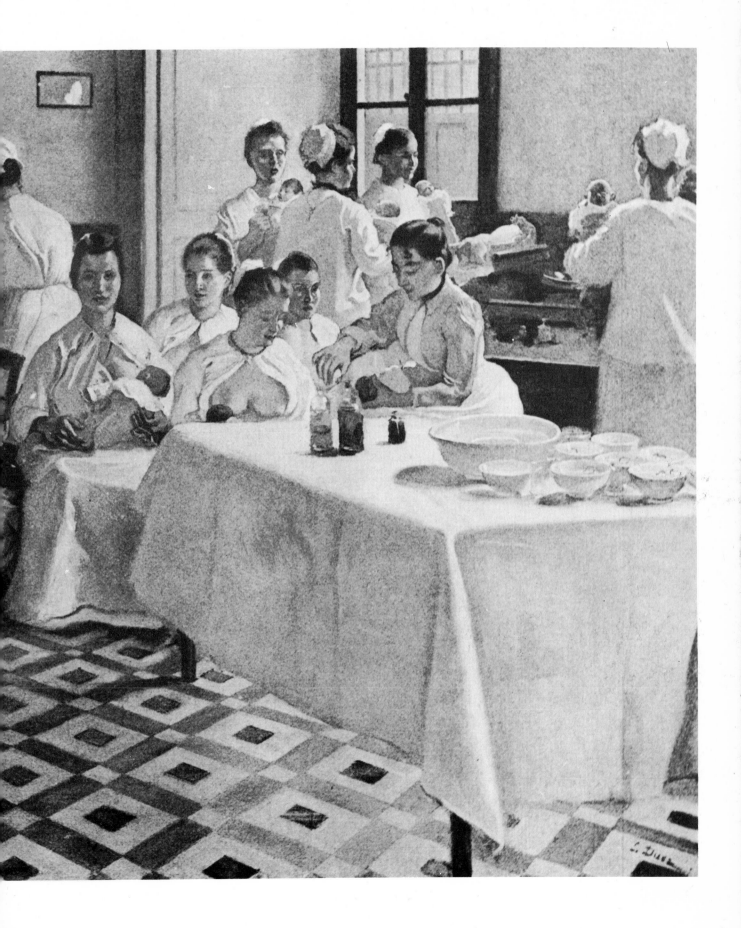

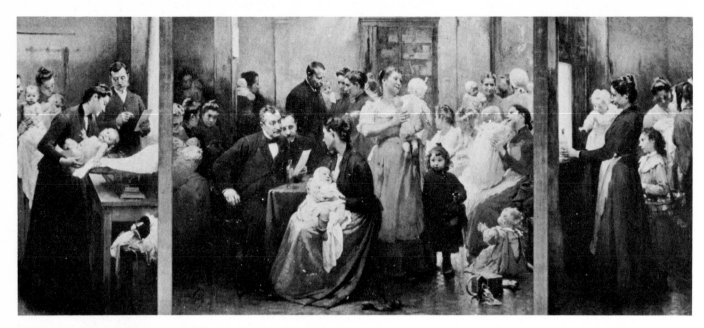

200. JULES JEAN GEOFFROY *A Children's Clinic in Belleville.* c. 1903.
Belleville was a poor district of Paris.

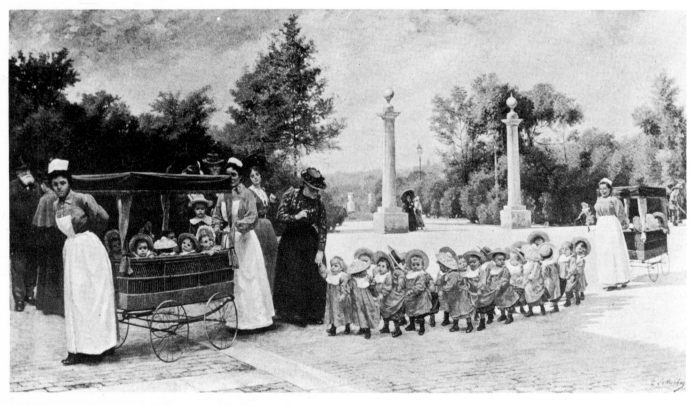

201. TUNLEON LOBRICHON *Infants from the Municipal Nursery.* c. 1901.

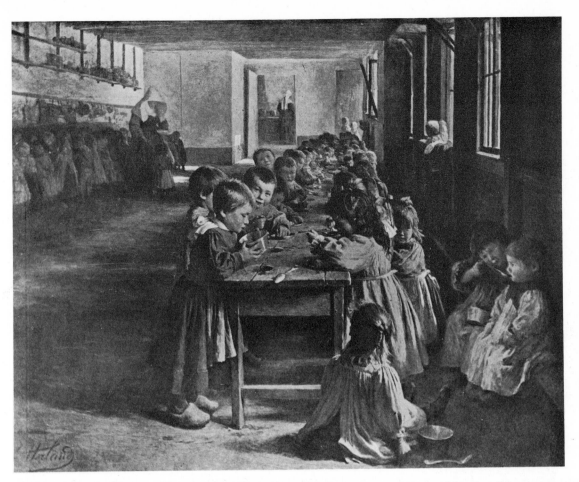

202. EMMA HERLAND *Soup at a Breton Orphanage.* c. 1901.

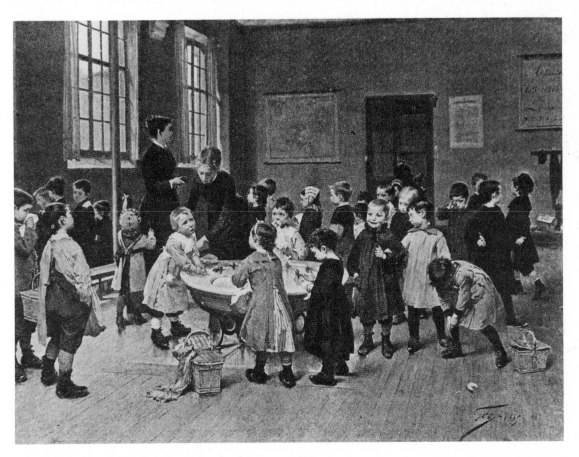

203. JULES JEAN GEOFFROY *Nursery School in Paris.* 1885.

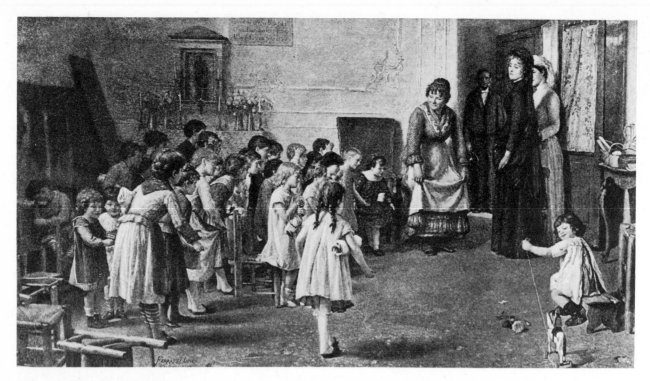

204. LUIGI FERRAZZI *Complimenti! Complimenti!* 1889.
The children at an orphanage greet a patron.

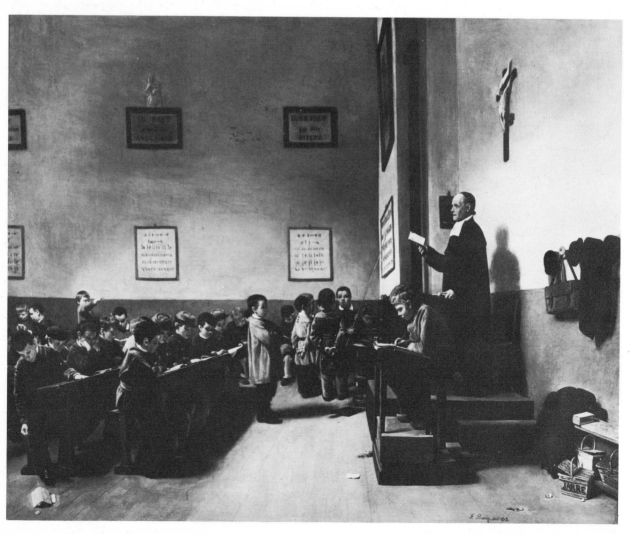

205. FRANCIS BONVIN *The Brothers' School.* 1873.
Bonvin was a specialist in clerical genre scenes.

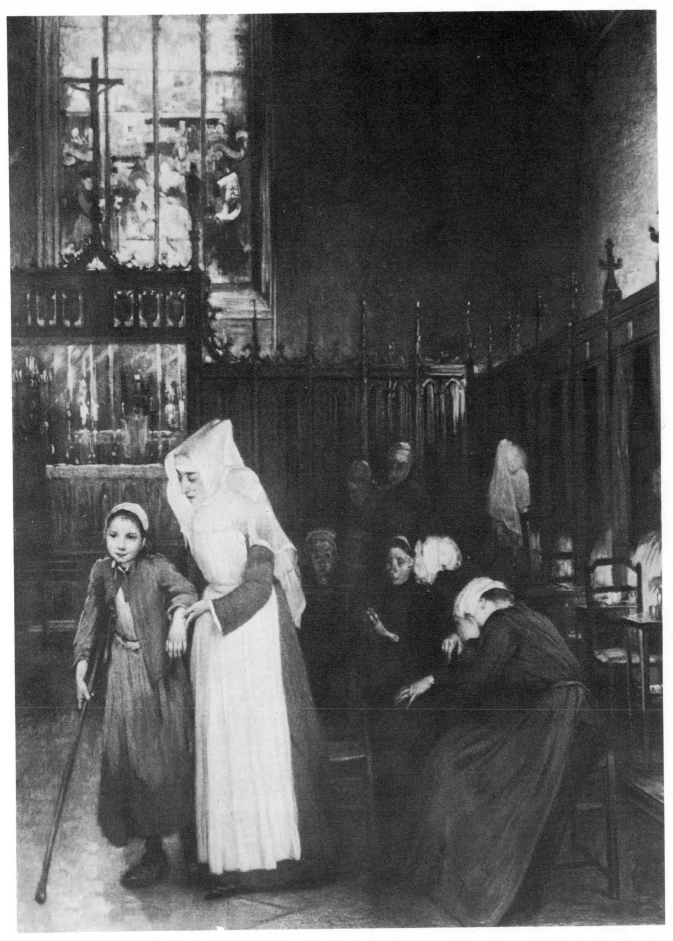

206. JULES JEAN GEFFROY *Convalescents in the "Gran Chambre des Pôvres," Hospice de Beaune.* c. 1904.
The Hospice de Beaune was a charitable foundation whose foundation dated from the Middle Ages.

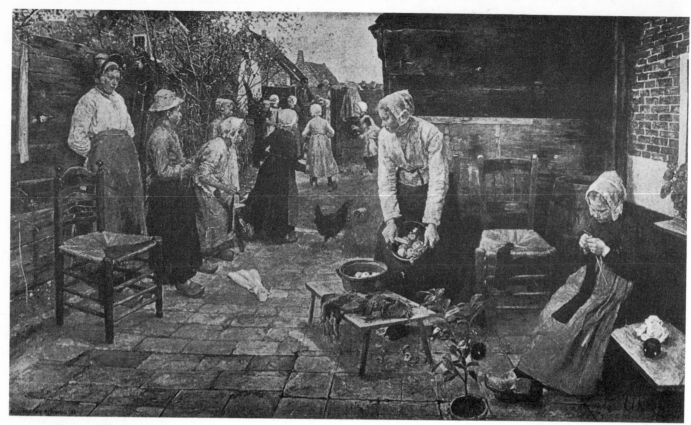

207. FRITZ VON UHDE *The Orphanage* c. 1886.

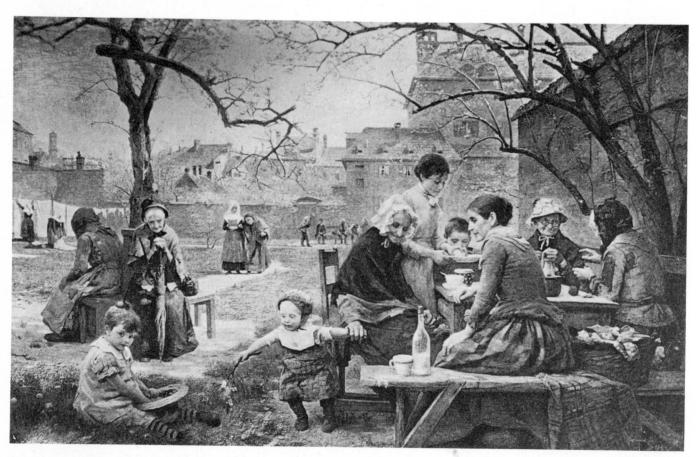

208. K. FRITHJOF-SMITH *In the Garden of the Alms House.* c. 1888.

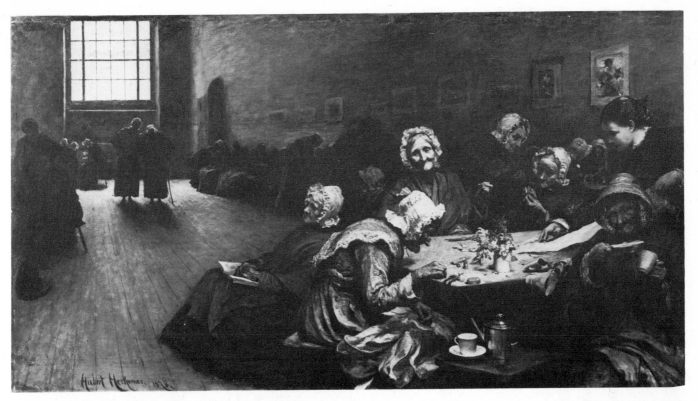

209. HOBERT VON HERKOMER *Eventide in the Westminster General*. 1878.
Ward for the aged in Westminster Hospital, London.

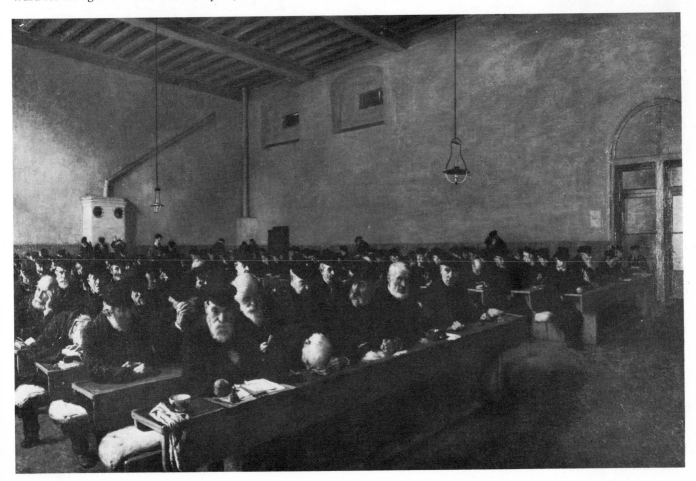

210. ANGELO MORBELLI *Their Last Days*.

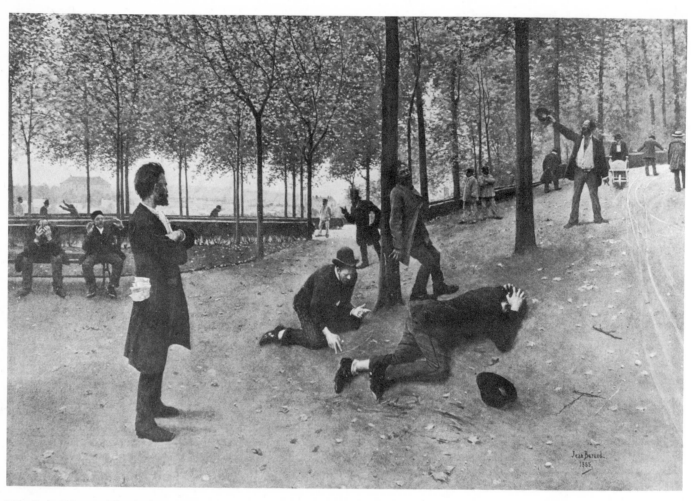

211. JEAN BÉRAUD *The Asylum*. 1885.
Treatment of mental disorder was still pre-Freudian and the chronically insane were often left to rot in institutions.

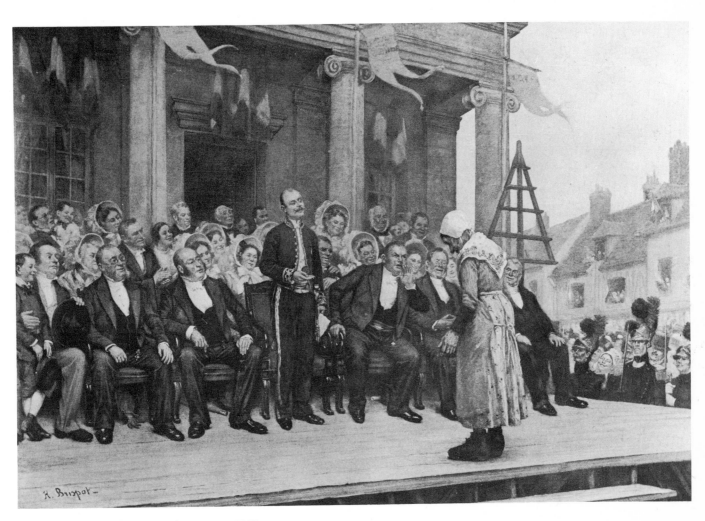

212. H. Brispot *Fifty Years of Service*. c. 1897.

A note on
the official French Exhibition System

The Salon, otherwise known as the Artistes Français, was the major exhibition of new painting and sculpture in France, and was held annually. The Salon, which traced its origin as far back as 1667, was officially administered until 1881, when the government withdrew. In that year a committee of ninety artists, elected by all those who had been represented at previous Salons, met to set up a society which was called the Artistes Français, and henceforth this took responsibility for the annual show. In 1889, following the Universal Exhibition of that year, a schism took place, and the Société Nationale des Beaux-Arts was founded. This, from 1890 onwards, held an annual exhibition of its own. Other annual exhibitions were those of the Artistes Indépendants (a group formed in 1884), and the Salon d'Automne, founded in 1903. A few years after the period covered by this book, the Salon des Tuileries was founded.

Young artists, in this centralized system, were greatly dependent on the help of those who taught them at the Ecoles des Beaux-Arts. The most important of these teachers, in the period covered here, was the celebrated academic painter Jean-Léon Gérôme (1824–1904). Gérôme was professor at the Beaux-Arts from 1863 onwards and had a highly successful career as a painter of historical and oriental subjects. He gave up painting for sculpture toward the end of his life, but remained extremely influential both through his actual instruction and through the help he gave his pupils.

A Register of Artists

I F THE READER NOTES a great similarity in the biographical details given here, especially in those provided for French artists, this is not entirely accidental. In the late nineteenth century, particularly in France, art became a profession which was both respected and accepted, and the successful artist followed a *cursus honorum* which was almost as minutely regulated as the career of a successful civil servant. The two Universal Exhibitions, held in Paris in 1889 and 1900, provided the world of art with a means of fixing the precise status of its members, and the medals and prizes distributed on these occasions were accorded a great deal of importance, by artists and by the general public alike.

Adler, JULES. *French.* Born in 1865. A pupil of Bouguereau, Robert-Fleury and Dagnan-Bouveret. Awarded a silver medal at the Paris Universal Exhibition of 1900. Chevalier of the Legion of Honor in 1907, officier in 1923. Exhibited at Pittsburgh, Brussels, Liège, Venice, Barcelona, Madrid and Tokyo. Founder-member of the Salon d'Automne. He was regarded as a specialist in painting the lives of the working class.

van Aken, LEO. *Belgian.* Born in 1857; died in 1904. Studied at the Antwerp Academy. Close to Struys (q.v.) in style.

Alberti, HENRI. *French.* Born in Paris in 1868, and began his career in 1894. He continued to exhibit until at least 1920. He was fond of introducing portraits of contemporary personalities into his genre-scenes.

Ancher, MICHAEL PETER. *Danish.* Born in 1849, and studied from 1871–5 at the Academy of Fine Arts in Copenhagen. He exhibited for the first time in 1874 and from 1875 onward specialized in scenes of Jutland life. He was awarded a gold medal at the Paris Universal Exhibition of 1889.

Angel, MANUEL. *Spanish.* A pupil of the Academia de San Fernando in Madrid who later settled in Havana.

Anker, ALBERT. *Swiss.* He studied with Gleyre at the Ecole des Beaux-Arts. He worked mostly in Paris for thirty years, but during this period paid two long visits to Italy, in 1863 and 1866. Finally returned to Switzerland in 1891, and became a painter of Swiss rustic life.

Anschutz, THOMAS POLLOCK. *American.* Born at Newport, Kentucky, in 1851; died at Fort Washington in 1912. Anschutz studied at the National Academy of Design, at the

Pennsylvania Academy of Fine Arts, and in Paris under Doucet and Bouguereau. He afterwards taught on the faculty of the Pennsylvania Academy of Fine Arts and was a member of the National Academy of Design.

Anthonissen, LOUIS JOSEPH. *Belgian.* Born in 1849; died in 1913. Studied at the Antwerp Academy and at the Ecole des Beaux-Arts in Paris. He exhibited at the Salon from 1897 to 1912 and also showed at the Salon des Indépendants.

Archipov, ABRAHAM EFIMOVITCH. *Russian.* Born in 1862; died in 1930. He studied at the School of Art in Moscow and the St. Petersburg Academy, and exhibited in Paris in 1900.

Arredondo y Calmache, RICARDO. *Spanish.* He lived and worked in various parts of Spain; exhibited in 1882 in Madrid, and at the Paris Universal Exhibition of 1900.

Bacon, JOHN HENRY FREDERICK. *British.* Born 1868; died 1930. He exhibited at the Royal Academy from 1889 onward, and showed his work in Paris at the Universal Exhibition of 1900.

Bail, ANTOINE JEAN. *French.* Born in 1830 and studied at the Ecole des Beaux-Arts in Lyons. He first exhibited at the Lyons Salon of 1854. A specialist in interiors.

Baille, LOUIS EUGÈNE. *French.* No dates for birth or death. He exhibited at the Paris Salon from 1885 to 1889.

van Beers, JAN. *Belgian.* Born in 1852 and studied at the Antwerp Academy. He worked first as a history painter, but from 1880 onward began to specialize in genre-scenes and portraits.

Bellows, GEORGE WESLEY. *American.* Born 1882; died 1925. He was a pupil of William Chase and Robert Henri; showed at the National Academy of Design from 1908, and exhibited in the Armory Show of 1913. He was associated with Everett Shinn (q.v.) and John Sloan (q.v.)

Benedito-Vives, MANUEL. *Spanish.* Born in Valencia, and became a pupil of Sorolla (q.v.). He exhibited at Munich in 1897, 1900 and 1905, and at the Paris Salon until 1914.

Béraud, JEAN. *French.* Born 1849; died 1935. One of the most typical of the French Belle Époque artists, now remembered chiefly for his genre-scenes and not for the pictorial series illustrating the life of Christ in modern dress which caused a stir among his contemporaries. He was one of the founders of the Société Nationale des Beaux-Arts.

Berndtson, GUNNAR FREDERIK. *Finnish.* Born in 1854; died in 1895. He studied at the Ecole des Beaux-Arts in Paris under Gérôme. Correspondent for the *Monde Illustré* in Egypt in 1882 and 1883. Showed at the Salon and was awarded a silver medal at the Paris Universal Exhibition of 1889.

Beyle, PIERRE MARIE. *French.* Born in 1839; died in 1902. He first exhibited at the Paris Salon of 1867. Thereafter he specialized in scenes of fairground life, Algerian scenes and pictures of the Normandy coast and Norman fishermen.

Bihari, SANDOR. *Hungarian.* Born 1856; died 1906. He studied in Vienna and then in Paris. His first exhibition work dates from 1880. He was celebrated for scenes showing the life of the Hungarian people.

Björk, GUSTAV OSCAR. *Swedish.* Born in 1860. After studying art at the Stockholm Academy he completed his studies in Paris, Munich, Venice and Rome.

Bogdanov-Nelski, NIKOLAI. *Russian.* He was born in 1868 and studied at the School of Art in Moscow. He is recorded as exhibiting in Moscow in 1908.

Bokelmann, CHRISTIAN LUDWIG. *German.* Born in 1844; died in 1894. He studied in Düsseldorf and became professor at the Karlsruhe Academy in 1893 and in Berlin the following year. He exhibited at the Royal Academy in London in 1887.

Bonham, HORACE. *American*. Born in 1835; died in 1892. He was a pupil of Bonnat in Paris.

Bonvin, FRANÇOIS. *French*. Born in 1817; died in 1887. Bonvin did not follow the usual route to artistic success. He learned drawing at a free school, then became a compositor and later was employed at the Paris Prefecture of Police. Meanwhile he conducted a course of artistic self-education in the museums. He first exhibited his work at the Salon of 1847, and soon became known as a specialist in genre-scenes. He traveled to Flanders and Holland and in 1870 received the Legion of Honor. He went blind after an operation in 1881, and was forced to stop painting. His work shows the influence of Dutch genre-painting and of Chardin.

Borgmann, PAUL. *German*. Born 1851. He studied in Berlin and Weimar, then traveled in Italy. Later he ran a private art school for young ladies in Karlsruhe.

Brangwyn, FRANK. *British*. Born 1867; died 1943. He was one of the chief British decorative painters of the period. He worked first for the firm of Morris & Co., where he designed tapestries, and later traveled round the world absorbing visual experience. His painting shows the influence of J. F. Millet. He became an A.R.A., in 1906, and was made a chevalier of the Legion of Honor in 1901.

Brispot, H. *French*. Born 1846; died 1928. A pupil of Bonnat. He exhibited at the Salon.

Brownell, FRANKLIN. *Canadian*. He was born at New Bedford, Mass., in 1857. Went to Paris where he was a pupil of Bouguereau and Robert-Fleury at the Ecole des Beaux-Arts. Later settled in Canada. Was Professor of the School of Art Association, Ottawa, and a member of the Royal Canadian Academy.

Brunet, JEAN JACQUES BAPTISTE. *French*. Born in 1850; died c. 1920. He was a pupil of Gérôme. He painted religious and historical pictures as well as scenes of contemporary life, and also worked for the *Figaro Illustré*. He showed at the Universal Exhibition in Brussels in 1910.

Buland, JEAN EUGÈNE. *French*. Born 1852; died 1927. He was a pupil of Cabanel at the Ecole des Beaux-Arts, and won the Prix de Rome. He worked for *Figaro Illustré*.

Caillebotte, GUSTAVE. *French*. Born 1848; died 1894. Studied under Bonnat, but nevertheless was generally classified as an amateur. He was rich by birth and collected the work of his friends Monet, Renoir, Sisley and Pissarro. His collection is now in the Louvre. As a painter he was attracted to scenes showing men at work, and also produced views of Paris.

Caprile, VINCENZO. *Italian*. Born in 1856. Educated at the Scuola di Belle Arti in Naples. He first exhibited in 1874. In his own day he was regarded as a typical representative of Italian verism.

Carpentier, EVARISTE. *Belgian*. Born 1845. He was the son of a peasant, but nevertheless managed to receive his artistic training at the Antwerp Academy. From 1872 onward he ceased to take his subjects from pagan mythology and began to specialize in history painting with occasional excursions into contemporary genre.

Carrier-Belleuse, PIERRE. *French*. Born in 1851. He was a pupil of Cabanel at the Ecole des Beaux-Arts, and first exhibited in the Salon in 1875. From 1885 onward he worked exclusively in pastel.

Cederström, GUSTAV OSCAR, *baron*. *Swedish*. He was born in 1845, and died in 1933. He studied art in Düsseldorf, then worked under Bonnat at the Ecole des Beaux-Arts. Served in the Swedish army from 1864–70. Exhibited in Stockholm from 1870 onward and first appeared in the Paris Salon in 1874.

Chaperon, EUGÈNE. *French*. Born in 1857. He was a pupil of Pils and Detaille at the Ecole des

Beaux-Arts and exhibited at the Salon from 1878 onward. He also worked for the principal French illustrated magazines. Chevalier of the Legion of Honor.

Charles, JAMES. *British*. Born 1851; died 1906. He exhibited from 1865 onward at the Royal Academy in London, and also showed his work at the Grafton Gallery and the New Gallery.

Choquet, RENÉ MAXIME. *French*. He was a pupil of Jules Lefebvre at the Ecole des Beaux-Arts. He became a member of the Artistes Français in 1896 and was still exhibiting in 1939.

Claus, EMILE. *Belgian*. Born in 1869; died in 1924. He had to overcome strong resistance from his father to the idea of his becoming an artist, and only began to make a reputation in the 1880's. He is a realist who has been compared both to Bastien-Lepage and to Monet.

Cogghe, RÉMY. *Belgian*. Born in 1854. He was a pupil of Cabanel at the Ecole des Beaux-Arts. He exhibited his work at the Paris Salon, receiving a medal in 1889, and was still exhibiting in 1926.

Col, JAN DAVID. *Belgian*. Born in 1822; died in 1900. He exhibited in Vienna and in Philadelphia, and was made a knight of the Order of Leopold in 1885. There are pictures by him in the museums of Chicago, Cincinnati and Montreal.

Cruikshank, WILLIAM. *Canadian*. Born in 1849; died in 1922.

Dagnan-Bouveret, PASCAL ADOLPHE JEAN. *French*. Born in 1852; died in 1929. He was a pupil of Gérôme at the Ecole des Beaux-Arts, and was also taught by Corot. He won second prize in the Prix de Rome in 1876. He made his first appearance at the Salon in the same year with two mythological subjects. He then switched to genre-painting and, finally, under the influence of Bastien-Lepage, to a more idealized way of dealing with contemporary subjects.

Dalsgaard, CHRISTIAN. *Danish*. Born 1824; died 1907. He studied at the Copenhagen Academy from 1841 and began exhibiting his work in 1847. In 1862 became Professor of Drawing at the Sorö Academy, in 1872 a member of the Danish Academy of Fine Arts, a Knight of Dannebrog in 1879.

Dantan, EDOUARD JOSEPH. *French*. Born 1848; died 1897.

Dawant, ALBERT PIERRE. *French*. Born 1852; died 1923. He was a commander of the Legion of Honor, and was awarded a gold medal at the Universal Exhibition of 1889.

Decamps, ALBERT. *French*. Born 1862; died 1908. He was a pupil of Vollon, and exhibited regularly at the Salon from 1893 to 1908.

Déchenaud, LOUIS ADOLPHE. *French*. Born 1868; died 1929. He was a pupil of Lefebvre, Boulanger and Benjamin Constant. Won second prize in the Prix de Rome competition in 1891 and first prize in 1894. Also won numerous awards at the Salon, which gave him a retrospective exhibition in 1928. Chevalier of the Legion of Honor in 1908, and elected Member of the Institute in 1918.

von Defregger, FRANTZ. *German*. Born in 1835. He studied at the Munich Academy under Piloty. In spite of his very modest origins (he was a shepherd in his youth), he soon made a reputation as a painter of popular life and also as a history painter. He was ennobled in 1883, and named professor at the Munich Academy. He exhibited at the Universal Exhibition of 1878, and served on the jury of the Universal Exhibition of 1900.

Delange, PAUL. *French*. Born in 1848. He studied under Gérôme at the Ecole des Beaux-Arts and first exhibited at the Salon in 1865.

Démarest, GUILLAUME ALBERT. *French*. Born in 1848; died in 1906. He was a pupil of J. P. Laurens. He exhibited at the Salon, obtaining a third-class medal in 1893, and a second-class medal in 1894.

Detaille, EDOUARD. *French*. Born 1848; died 1912. Detaille was a pupil of Meissonier and first exhibited at the Salon of 1867. Later he traveled in Spain and in Algeria. He became the semi-official painter of the French army, and was also responsible for decorations in the Hôtel de Ville and the Panthéon in Paris.

Dettman, LUDWIG JULIUS CHRISTIAN. *German*. Born in 1865. A pupil of the Berlin Academy from 1884 to 1890. Visited Paris in 1889 and later Antwerp and London. Became director of the Koenigsberg Academy and was awarded a silver medal at the Paris Universal Exhibition of 1900.

Duez, ERNEST ANGE. *French*. Born 1843; died 1896. A pupil of Pils. First exhibited in the Salon of 1868, but did not make a success until 1874. Died of a cerebral hemorrhage while riding a bicycle.

Eakins, THOMAS. *American*. Born 1844, died 1916. Eakins was taught by Gérôme and Bonnat in Paris; he went on to become the most eminent American realist of the late nineteenth century and was perhaps the greatest American painter. He was a famous and controversial teacher of art at the Philadelphia Academy.

Edelfeldt, ALBERT GUSTAF ARISTIDES. *Finnish*. Born 1854; died 1905. He trained in Antwerp, then studied under Gérôme in Paris. He settled in France and was given the Legion of Honor in 1887, becoming officer in 1889 and commander in 1901. He exhibited at the Royal Academy in London from 1881 onward. In 1901 he went to Russia to paint the children of Alexander III. He played an important political role in the history of Finland, protesting the constitutional changes of 1889.

van Engelen, ANTOINE FRANÇOIS LOUIS. *Belgian*. Born in 1856.

Etcheverry, HUBERT DENIS. *French*. Born 1867. He was a pupil of Bonnat and was awarded the Legion of Honor in 1906.

Exner, JOHANN JULIUS. *Danish*. Born 1825; died 1910. He was the son of a musician from Bohemia. He studied at the Copenhagen Academy from as early as 1838, at which time he was also apprenticed to a painter. First exhibited at the Copenhagen Salon of 1844. A specialist in scenes of Danish peasant life.

Ferraguti, ARNALDO. *Italian*. Born 1862. He lived in Rome and exhibited in Dresden, Munich and Vienna between 1887 and 1889.

Ferrazzi, LUIGI. *Italian*. He exhibited at Munich in 1883.

Fildes, SIR LUKE. *British*. Born in 1844. He studied at the Royal Academy Schools and first showed at the Royal Academy in 1867. He was elected Academician in 1887 and frequently exhibited abroad, notably at Paris. He worked as an illustrator for periodicals such as the London *Graphic* and *Once a Week*, and also supplied illustrations for the works of Dickens.

Fisher, S. MELTON. *British*. Born 1861. He showed at the Royal Academy from 1878 onward. Won a medal at the Paris Salon of 1896. He was well known as a watercolorist.

Fleischer, ERNST PHILIPP. *German*. Born in 1850. He was a pupil of Schnorr von Carolsfeld at Dresden and of Piloty at Munich. First exhibited at Dresden in 1870. Spent much time in Italy.

Forbes, STANHOPE ALEXANDER. *British*. Born 1857; died 1947. After schooling at Dulwich College studied art at the Lambeth College of Art and at the Royal Academy Schools. Spent several years in Britanny, finally settling in Cornwall where he became a founder-member of the Newlyn School. He first showed at the Royal Academy in 1874, and was elected A.R.A. in 1892 and R.A. in 1910. He won gold medals at the international exhibitions at Munich (1895), Paris (1900) and Berlin (1891).

Forsberg, Nils. *French.* Born in 1870. He was a pupil of Cormon and became a member of the Société des Artistes Français in 1901.

Fourié, Albert Auguste. *French.* Born 1854. He studied at the Ecole des Beaux-Arts and first exhibited, as a sculptor, at the Salon of 1877. Almost immediately after this he abandoned sculpture for painting.

Frédéric, Léon Henri Marie. *Belgian.* Born in 1856. Studied first in Brussels, then in Venice, Florence, Naples and Rome. He first exhibited at the Brussels Salon of 1878. He also showed at Munich, Nice and Paris, winning a bronze medal in the Paris Universal Exhibition of 1889, and a gold medal in that of 1900. A knight of the Order of Leopold.

Gallen-Kallela, Akseli Valdemar. *Finnish.* Born 1865; died 1921. He studied in Paris under Bouguereau and Robert-Fleury. He was an Associate of the Société Nationale des Beaux-Arts from 1891. Silver medal at the Universal Exhibition of 1889; gold medal at that of 1900. Chevalier of the Legion of Honor. Lived in Paris.

Geoffroy, Henry Jules Jean. *French.* Born in 1853; died in 1924. He first exhibited at the Salon of 1874. He won a gold medal at the Universal Exhibition of 1900. Chevalier of the Legion of Honor. Made a reputation as a painter of children.

Gérin, René. *French.* He exhibited at the Salon des Artistes Français from 1883–93.

Gierymski, Aleksandr. *Polish.* Born 1849; died 1901. He studied at the Warsaw School of Design, and later in Munich. He died in Rome.

Gilbert, Victor. *French.* Born 1847; died 1935. A regular exhibitor at the Salon who became chevalier of the Legion of Honor in 1926. He is represented by many pictures in French provincial museums. A specialist in market scenes.

Giron, Charles. *French.* Born 1850; died 1914. He lived and worked in Paris, but exhibited as far afield as Vienna and Dresden.

Gourse, Hippolyte Casimir. *French.* Born in 1870. A pupil of J. P. Laurens and Benjamin Constant. He was a member of the Société des Artistes Français.

Grandjean, Edmond Georges. *French.* Born 1844; died 1908. Entered the Ecole des Beaux-Arts in 1862. Exhibited in the Salon from 1865 onward, specializing in genre-scenes and portraits. Obtained an honorable mention at the Universal Exhibition of 1900.

Green, Charles. *British.* Born in 1840; died in 1898. Began his career as an illustrator, working for the *Illustrated London News* and the *Graphic.* Became a member of the Royal Watercolour Society and of the Society of British Artists. He exhibited frequently in London from 1862 onward, notably at the Royal Academy.

Gregory, Edward John. *British.* Born in 1850; died in 1909. He was a pupil of Herkomer (q.v.) He worked for the *Graphic* and exhibited at the Royal Academy from 1870 onward. He also exhibited his work in Munich and in Paris where in 1900 he was awarded a gold medal at the Universal Exhibition.

Gueldry, Ferdinand Joseph. *French.* Born 1858. A pupil of Gérôme. He first showed at the Salon of 1878 and thenceforth specialized in scenes showing factories and workshops. He was still exhibiting in 1933.

Guinier, Henri Jules. *French.* Born in 1867; died in 1927. He was a pupil of Lefebvre and of Benjamin Constant. Exhibited frequently at the Salon, often showing Breton scenes. Chevalier of the Legion of Honor.

Hagborg, August Wilhelm Nikolaus. *Swedish.* Born in 1852; died in 1925. He worked chiefly

in France and exhibited at the Salon from 1876 onward. He was a member of the jury for the Universal Exhibitions of 1889 and 1900. Chevalier of the Legion of Honor in 1893, and officer in 1901. Was regarded as being chiefly a specialist in marine painting.

Harburger, EDMUND. *German.* Born in 1846; died in 1906. He studied at the Munich Academy and afterwards lived in Munich. Exhibited in Munich, Vienna and Berlin, from 1873 onward.

Hardy, DUDLEY. *British.* Born in 1865; died in 1922. He was the son of the successful marine painter T. B. Hardy. Studied in Düsseldorf, Antwerp and Paris. He made a considerable reputation as an illustrator. Member of the Royal Society of British Artists and of the Royal Institute.

Harris, JUAN EDUARDO. *Chilean.* He was a pupil of J. P. Laurens at the Ecole des Beaux-Arts and was awarded an honorable mention at the Universal Exhibition of 1900.

Hennigsen, ERIK LUDWIG. *Danish.* Born in 1855; died in 1930. He studied at the Copenhagen Academy. Exhibited in Copenhagen and Vienna, and in Paris at the Universal Exhibition of 1889, where he was awarded a bronze medal.

Hennigsen, FRANS PETER DIDRIK. *Danish.* Born in 1850; died in 1908. He exhibited at Copenhagen and Berlin.

von Herkomer, SIR HUBERT. *British.* He was born in Bavaria in 1849, and died in 1914. He came to England in 1862, and began his career as an illustrator, working for the *Graphic.* Made his first success as a painter in 1874. In 1880 started to paint portraits, which brought him tremendous celebrity. He exhibited at the Universal Exhibition of 1872 and was made a chevalier of the Legion of Honor. In 1889 his work was again seen at a Universal Exhibition, and this time he was given a gold medal and made an officer of the Legion. Elected a Royal Academician in 1879.

Herland, EMMA. *French.* Born in 1856. She was a pupil of Lefebvre. She first exhibited at the Salon of 1879 and became a member of the Société des Artistes Français in 1886.

Hermann, HANS. *German.* Born in Hamburg in 1813; died in 1890.

Hirschfeld, EMIL BENEDICTOV. *Russian.* Born in 1867; died in 1922. He was a pupil of Bouguereau, Lefebvre and Robert-Fleury, and often exhibited in Paris. He was awarded a silver medal at the Universal Exhibition of 1900 and was made a chevalier of the Legion of Honor in 1910. He died at Concarneau, in Britanny.

Holl, FRANK. *British.* Born in 1845; died in 1888. A celebrated portraitist. He studied at the Royal Academy Schools and won a traveling scholarship in 1868. A.R.A. in 1878; R.A. in 1884.

Homer, WINSLOW. *American.* Born 1836; died 1910. Homer began as a lithographer and illustrator and later turned to painting. He visited Europe to complete his artistic education in 1867, by which time he was already a member of the National Academy. He was awarded a gold medal at the Paris Universal Exhibition of 1900. Many people regard him and Eakins (q.v.) as the two greatest painters of the American nineteenth century.

Hubert-Sauzeau, J. GABRIEL. *French.* Born in 1856. A member of the Société des Artistes Français from 1901 onward.

Jacque, CHARLES EMILE. *French.* Born in 1813; died in 1894. At the age of seventeen Jacque was apprenticed to a map-engraver. Disgusted with his prospects, he enlisted in the army for seven years, then went to England, where he made wood-engravings to illustrate Shakespeare and a history of Greece. Returning to France, he joined the Barbizon group. He first exhibited at the Salon in 1848, the year of revolution. In 1867 he was given the Legion of Honor. The *Big Flock* reproduced in this book was the picture with which Jacque returned to the Salon in 1888, after

an absence of eighteen years. It completely reestablished his reputation. He is perhaps better known as a graphic artist than he is as a painter.

Jacque, EMILE. *French.* Born in 1848; died in 1912. The elder son of Charles Emile Jacque (q.v.). He exhibited at the Salon, obtaining an honorable mention in 1889, and a third-class medal in 1891.

Järnefelt, EERO NIKOLAI. *Finnish.* Born in 1863. He was influenced by Bastien-Lepage's studies of peasants and was also a good portraitist.

Jeanniot, PIERRE GEORGES. *French.* Born in 1848. Made his debut in the Salon of 1878 as a watercolorist. He also worked as an illustrator, his most notable commission being to illustrate the Goncourt brothers' pioneering Naturalist novel, *Germinie Lacreteux*. During the 1880's he was widely regarded as the leader of a new school of French painters.

Jiménez, J. M. *Spanish.* This artist is *either* José Jiménez y Aranda, who was born in 1837 and died in 1903, having studied in Madrid and Rome and exhibited in Valencia, Seville and Paris in the period 1881–90; *or* he is Juan Jiménez y Martin, who was born in 1858 and exhibited frequently in France and Germany during the 1890's.

Jomas, LUCIEN HECTOR. *French.* Born in 1880. He studied at Valenciennes, then under Bonnat. A member of the Société des Artistes Français from 1904 and chevalier of the Legion of Honor. He often painted miners, and in World War I adapted his skills to painting battle scenes etc. These now decorate numerous public buildings in France.

de Joncières, LÉONCE. *French.* Born in 1871. He was a pupil of Gérôme and Bouguereau and became a chevalier of the Legion of Honor.

Jourdain, ROGER JOSEPH. *French.* Born in 1845; died in 1918. He was a pupil of Cabanel, Cabanne and Pils. He first exhibited in the Salon of 1869. A member of the Société des Artistes Français from 1883 onward. Chevalier of the Legion of Honor in 1889. Won a bronze medal at the Universal Exhibition of 1900.

Jungstedt, AXEL HARALD. *Swedish.* Born 1859; died 1933. Mostly known as a painter of rustic scenes.

Kernstock, KAROLY. *Hungarian.* Born 1873. He was awarded a bronze medal at the Paris Universal Exhibition of 1900.

Koehler, ROBERT. *American.* He was born in Germany in 1850 and emigrated to America at the age of three. After preliminary studies in the United States, he returned to Germany to study in Munich. He exhibited in Paris at the Universal Exhibition of 1889. Director for a time of the Minneapolis School of Fine Arts.

Krøyer, PEDER SEVERIN. *Danish.* Born in 1851; died 1909. He studied at the Copenhagen Academy and then under Bonnat in Paris. He also traveled to Spain and Italy. He was made chevalier of the Legion of Honor in 1888, and won a Grand Prix at both the Paris Exhibitions.

Kuehl, GOTTBART JOHANN. *German.* Born 1850; died 1915. He studied in Munich and later in Paris. Exhibited frequently in the Salon and also in Munich and Berlin. Chevalier of the Legion of Honor in 1900, officer in 1905. Professor at the Dresden Academy.

Larock, EVERT. *Belgian.* Born 1865; died 1901. A self-taught artist, exceptional for this period. He exhibited at the Paris Salon of 1893, and received an honorable mention.

van Leemputten, FRANS. *Belgian.* Born 1850; died 1914. Like Larock (q.v.) he was self-taught. He pursued a successful international career, exhibiting his paintings and winning awards at Antwerp, Amsterdam, Munich, Bremen, Berlin, Vienna, Brussels, Barcelona and Athens. He

taught at the Institut Supérieur des Arts in Antwerp. A knight of the Order of Leopold. He was also successful as a designer of posters.

Leibl, WILHELM MARIA HUBERTUS. *German.* Born 1844; died 1900. He studied at Munich under Piloty, worked for a year in Paris in 1869 but had to return home when war broke out the following year. A member of the Berlin Academy from 1892, exhibited at the Paris Universal Exhibition of 1889. He was influenced by Courbet, and was eventually the teacher of most of the creators of modernism in Germany.

Lhermitte, LÉON AUGUSTIN. *French.* Born 1844; died 1925. Lhermitte first exhibited at the Salon of 1864, and his talents as a painter of the countryside were quickly recognized. He won a Grand Prix at the Universal Exhibition of 1889. Legion of Honor 1884; promoted to officer of the Legion in 1894, and to commander in 1911. Member of the Institute, 1905. He was influenced by the work of J. F. Millet, but was more objective in attitude. His work can be compared to that of Roll, Bastien-Lepage and Raffaelli. He also shows traces of Impressionist influence in the clear coloring he employs for many of his pictures.

Liebermann, MAX. *German.* Born 1847; died 1935. Liebermann was the son of a rich industrialist and contrived to study painting in Berlin at a time when his father thought he was following a course in philosophy at the university. Later he studied art at Weimar with his father's consent. The sight of peasants working in the fields revealed to him his true vocation as an artist, which was to paint the beauty and nobility of familiar tasks. His first important picture, the *Women Plucking Geese* of 1872, which is reproduced in this book, caused an outcry when it was first exhibited in Germany. Liebermann moved to Paris, where he became friends with Munkcàczy. After this he visited Holland, where his work was warmly received. Holland was always to remain an important source of inspiration to him, though he chose to live in France for a number of years.

Lobrichon, TIMOLÉON MARIE. *French.* Born in 1831 and died in 1914. He first exhibited at the Salon of 1859. Subsequently he was to exhibit in Germany and even in Australia. Chevalier of the Legion of Honor in 1882. He was celebrated for his humorous scenes showing children.

Loir, LUIGI. *French.* Born of French parents at Goritz, Austria, in 1845; died in 1916. He first showed at the Salon in 1865 and was given the Legion of Honor in 1898.

Lubin, JULES DÉSIRÉ. *French.* Born in 1854. A pupil of Bonnat. He first exhibited in the Salon of 1874.

Malczewski, JACEK. *Polish.* Born in 1854; died in 1929. He was educated at the School of Fine Arts in Cracow and later at the Ecole des Beaux-Arts in Paris. Worked in Munich 1885–6. In 1896 became professor at the School of Fine Arts in Cracow, where he remained until 1900. He exhibited at the Paris Universal Exhibition of 1900, and also in Berlin and in Munich.

Marec, VICTOR. *French.* Born 1862; died 1926. A pupil of Gérôme and J. P. Laurens. Member of the Société des Artistes Français from 1899. Won a gold medal at the Universal Exhibition of 1889. Chevalier of the Legion of Honor in 1907.

Maximov, VASSILY. *Russian.* Born 1844; died 1911. He studied at the St. Petersburg Academy, of which he became a member in 1888.

Menta, EDOUARD. *French.* Born in 1858. Exhibited in Venice in 1887. He seems to have specialized in scenes of life on the French Riviera.

von Menzel, ADOLF. *German.* Born in 1815; died in 1905. He is still the best-known historical painter of the nineteenth-century German school.

Mertens, CHARLES. *Belgian*. Born 1865; died 1919. Studied at the Antwerp Academy. Exhibited in Paris in 1888 and at the Universal Exhibition of 1889, where he won a bronze medal. Chevalier of the Order of Leopold.

Miralles, JOSÉ. *Spanish*. Born 1851. He studied in Rome. Exhibited in the Paris Salon 1880–1912.

Morbelli, ANGELO. *Italian*. Born 1853; died 1919. He studied at the Accademia in Milan. A follower of Segantini and a specialist in paintings of old people's homes.

Muenier, JULES ALEXIS. *French*. Born in 1863. He exhibited his work in the Salon from 1887 onwards. Legion of Honor in 1895, gold medal at the Universal Exhibition of 1900.

von Munkàczy, MIHALY. *Hungarian*. Born in 1844; died in 1900. After difficult beginnings he was in Düsseldorf in 1868, and reached Paris in 1872. There he married a general's widow. His first important painting was exhibited in the Paris Salon of 1870. From 1878 onward he ceased to show in the Salon, but instead exhibited large religious compositions in his own studio. These brought him vast success.

Napier-Hemy, CHARLES. *French* (?) We have been unable to discover any information about this artist.

Nicol, ERSKINE. *British*. Born 1825; died 1904. He first studied in Edinburgh, then lived for several years in Ireland. He was a frequent Exhibitor at the Royal Scottish Academy and first showed at the Royal Academy in London in 1851. He was elected A.R.A. in 1867 and R.S.A. two years later. He is generally classified as a follower of Moreland and Mulready. His work became widely popular through reproductive engravings.

Pagès, JULES EUGÈNE. *American*. Born in 1867 in San Francisco. Studied under Benjamin Constant, Lefebvre and Robert-Fleury in Paris. Exhibited in the Paris Salon from 1895. Chevalier of the Legion of Honor in 1910, Professor at the Académie Julien from 1902.

Perret, AIMÉ. *French*. Born 1847; died 1927. He studied at the Ecole des Beaux-Arts in Lyons and first exhibited in the Salon of 1869. Chevalier of the Legion of Honor in 1894. One of the founders of the Société Nationale des Beaux-Arts.

Raffaëlli, JEAN FRANÇOIS. *French*. Born 1850; died 1924. He started as an actor, then entered Gérôme's studio and first exhibited at the Salon of 1870. He began by exhibiting genre-scenes, then switched to picturesque views of the Paris suburbs. Finally he returned to genre-painting, concentrating on scenes from bourgeois life. Chevalier of the Legion of Honor in 1889, officer in 1906. A gold medalist at the Universal Exhibition of 1900.

Reid, JOHN ROBERTSON. *British*. Born 1851; died 1926. He was a skillful marine painter who exhibited in London from 1876 onward, notably at the Royal Academy. He also showed at the Paris Universal Exhibitions of 1889 and 1900, and was awarded a gold medal on both occasions. He was a member of the Royal Institute of Painters in Watercolour.

Repin, ILYA. *Russian*. Born 1844; died 1930. Repin belongs to the second generation of Russian nationalist painters, but was more talented than any of those who had preceded him. He studied in Paris for a time, and it was here that he met the railroad millionaire Mamontov. Mamontov invited Repin to come and live with him on his estate at Abramstevo, and Repin became one of the founder-members of the art colony there, which represented the beginning of modern art in Russia.

Ribera-Cirera, ROMAN. *Spanish*. He studied in Rome from 1873–6, then spent a year in Paris.

Révéz, IMRE. *Hungarian*. Born 1859. Studied in Vienna and then under Munkàczy in Paris. Professor at the Budapest Academy in 1904.

Roberts, Tom. *Australian.* Roberts was born in England in 1856. He emigrated to Australia in 1869, and it was here that he received his early education as an artist. Returning to London, he studied at the Royal Academy Schools. In Australia once again, he became a pioneer of *plein air* Impressionism. His work was influenced by Monet and also by Whistler and Bastien-Lepage. He received little in the way of official recognition, but was founder and first president of the New South Wales Society of Artists. He made a final return to England in 1906.

Rosenstand, Vilhelm Jakob. *Danish.* Born 1838; died 1915. He studied at the Academy in Copenhagen.

Rosset-Granger, Edouard. *French.* Born in 1853. He was a pupil of Cabanel, and first exhibited at the Salon of 1878. He received medals at the Universal Exhibitions of 1889 and 1900 and was a chevalier of the Legion of Honor.

Rossi, Luigi. *Swiss.* Born 1853; died 1923. He exhibited chiefly in Milan, but appeared at the Paris Universal Exhibition of 1900. His works were often engraved, and he provided illustrations for the work of many French novelists.

Rousseau, Jean Jacques. *French.* Born 1861. This artist is not to be confused with the Barbizon painter Théodore Rousseau. He first exhibited at the Salon in 1878. Chevalier of the Legion of Honor in 1903. A member of the Société des Artistes Français and of the Société Nationale des Beaux-Arts.

Salmson, Hugo Frederik. *Swedish.* Born 1844; died 1894. He settled in Paris and first exhibited at the Salon of 1870. Chevalier of the Legion of Honor in 1879; officer in 1889. A specialist in rustic scenes from Picardy and Sweden.

Sargent, John Singer. *American.* Born 1856; died 1925. He was probably the most successful portrait painter of his day, with a dashing technique that owed much to Velasquez and also something to Manet. He was born in Europe and was educated in Florence, Rome and Nice; went to Paris in 1874 and became a pupil of the successful portraitist Carolus-Duran. He worked as Carolus-Duran's apprentice for five years, also traveling to Italy and to Spain. Moved to London in 1884 and kept his studio there, but also spent much time in the United States.

Savitsky, R. A. *Russian.* Born 1844; died 1905.

Schlabitz, Adolf. *German.* Born 1854. He studied in Berlin, then at the Beaux-Arts in Paris under Lefebvre and Boulanger.

Schmidth, Hans. *Danish* (?) Born 1839; died 1917.

Schönn, Alois. *Austrian.* Born in 1826; died in 1897. Studied in Vienna, then in Paris. He visited Italy, Hungary and the Middle East, finally settling in Vienna where he was highly successful with portraits and genre-scenes. Chevalier of the Legion of Honor in 1878, and awarded the Order of Franz-Joseph in 1882.

de Schryver, Louis Marie. *French.* Born 1862; died 1942. He first exhibited at the age of thirteen, in the Salon of 1876. He was a member of the Artistes Français from 1896 onward.

Sekldrayers, E. *Belgian.* (?) We have been unable to find any information about this artist.

Shinn, Everett. *American.* Born 1876; died 1953. Shinn was an associate of Robert Henri and a member of the rebel group called The Eight, who exhibited in 1908 in opposition to the National Academy. Though he was classified as belonging to the "Ash Can" school he also liked music hall and theater scenes.

Sicard, Nicolas. *French.* Died in 1920. He was an exhibitor at the Artistes Français, and was made chevalier of the Legion of Honor in 1900.

Simon, LUCIEN. *French*. Born in 1861; died in 1945. Exhibited regularly at the Salon and received a gold medal at the Universal Exhibition of 1900. He specialized in scenes of provincial life in Britanny.

Skarbina, FRANZ. *German*. Born 1849; died 1910. He studied first in Berlin, then in Paris where he exhibited at the Salon and received a bronze medal at the Universal Exhibition of 1900.

Sloan, JOHN. *American*. Born 1871; died 1951. He studied with Anschutz (q.v.) at the Pennsylvania Fine Arts Association and taught at the Art Students League. He exhibited with The Eight in 1908, and later at the New York Armory Show of 1913. Like Shinn (q.v.), he is classified as a member of the "Ash Can" school.

Smith, GEORGE. *British*. Born 1829; died 1901. He studied at the Royal Academy Schools and worked as an assistant on the frescoes in the Houses of Parliament. He exhibited at the R.A. from 1847 to 1887 and was a favorite painter of the Prince Consort.

Smith, WILHELM. *Swedish*. Born 1867; died 1949. He was a pupil of Bonnat and exhibited at the Paris Salon.

Smith-Hald, FRITHJOF. *Norwegian*. Born 1846. Studied at the Karlsruhe Academy. Lived in Paris, returning to Norway for vacations. Exhibited in Berlin and Munich.

Soriano-Fort, JOSÉ. *Spanish*. We have been unable to discover any information about this artist.

Sorolla y Bastida, JOAQUIN. *Spanish*. Born in 1863; died in 1923. Traveled widely in France and Italy, and worked in Rome from 1884–8. Exhibited frequently in Paris. One of the Spanish artists most closely related to Impressionism.

Stevens, ALFRED. *Belgian*. Born 1828; died 1906. He studied in Paris with Gérôme, and subsequently became well known as an exhibitor at the Paris Salon. He became chevalier of the Legion of Honor in 1895, and officer in 1901. Stevens's reputation has survived that of nearly all his "academic" contemporaries, thanks to the subtle elegance of his work.

Struys, ALEXANDRE THÉODORE HONORÉ. *Belgian*. Born 1852. He studied at the Antwerp Academy, and then spent several years in Weimar before settling in Malines. He won a gold medal at the Paris Universal Exhibition of 1889 and a Grand Prix at that of 1900. Member of the Antwerp Academy from 1897.

Tamworth-Wells, HENRY. *British*. Born 1828; died 1903. He first exhibited in 1846. Up to 1860 he showed miniatures almost exclusively, but he then became a well-known portrait painter in oils.

Tattegrain, F. *French*. Born in 1852; died in 1915. He first studied law and took his doctorate before turning to art. He showed at the Salon from 1875 to 1914.

Tayler, ALBERT. CHEVALIER. *British*. Born 1862; died 1925. He entered the Slade School in 1879 and later studied in Paris under J. P. Laurens and Carolus-Duran. He was a frequent exhibitor at the Paris Salon.

Thorma, JANOS. *Hungarian*. Born 1870; died 1937. Studied in Paris and was an exhibitor at the Salon. He specialized both in *plein air* landscape and in realistic historical painting. His picture *The first of October* won gold medals in both Paris and Munich.

Tiren, JOHAN. *Swedish*. Born 1853; died 1911. He was a member of a well-known family of Swedish artists, and specialized in scenes showing Lapps.

Tissot, JAMES. *French*, but English by adoption. Born in 1836; died in 1902. Tissot was a pupil of Flandrin and first exhibited in the Salon of 1859. He fought in the war of 1870, then emigrated to England, where he settled in St. John's Wood in London. At this period he painted many

scenes of fashionable life, most of them containing the figure of the woman with whom he lived. Crushed by her premature death, he abandoned the worldly subjects associated with his name in order to work on a series of illustrations of the life of Christ. After working on these for ten years in Palestine, he exhibited them with enormous success in Paris and London.

Toma, GIOACCHINO. *Italian.* Born 1836 or 1838; died 1891. He exhibited at Naples, Turin and Paris. He is represented in the Palazzo Pitti, Florence; the Galleria d'Arte Moderna, Rome; and the Museo Nazionale in Naples.

Tornöe, WENZEL ULRIK. *Danish.* Born 1844; died 1907. Studied at the Copenhagen Academy and is well represented in Danish museums.

Tuke, HENRY SCOTT. *British.* Born 1858; died 1929. He was a pupil of Poynter and Alphonse Legros at the Slade, and later studied in Paris. He returned to England in 1883 and settled in Cornwall. Exhibited at the Royal Academy from 1879 onward and was elected A.R.A. in 1900.

von Uhde, FRITZ. *German.* Born in 1848; died in 1911. He served for ten years in the Saxon cavalry before turning painter. He studied in Munich and under Munkàczy in Paris. Like Munkàczy, he made a considerable reputation as a religious painter.

Ulrich, CHARLES FREDERIC. *American.* Born 1858; died 1908. He studied in Germany. In 1889–90 he was in Venice and in 1899–1902 in Rome.

Vautier, BENJAMIN. *Swiss.* The chief rival of Defregger (q.v.), whose near-contemporary he was; a slow, meticulous worker who produced only about five pictures a year. He divided his time between his native Switzerland and Düsseldorf, Germany, but painted subjects drawn mostly from the life of the Black Forest and Alsace. He liked to show peasants in confrontation with townspeople or officialdom.

Veber, JEAN. *French.* Born in 1868; died in 1928. A pupil at the Ecole des Beaux-Arts, first exhibited at the Salon of 1890. He made a reputation for the satirical element in his work, and worked as a caricaturist for papers such as *Rire* and *L'Assiette au Beurre*, in addition to making paintings and lithographs. Chevalier of the Legion of Honor in 1897.

Vives y Aimer, RAMON BENEDITO. *Spanish.* He trained at the Academy in Barcelona.

Weir, JOHN FERGUSON. *American.* Born 1841; died 1928. Son of the painter Robert Walker Weir. He exhibited in Paris and was awarded a bronze medal at the Universal Exhibition of 1900.

Wilhelmson, CARL WILHELM. *Swedish.* Born 1866; died 1928. He first studied in Gothenberg, then went to Paris in 1889 and remained there until 1897. Studied at the Beaux-Arts and exhibited at the Salon. He was awarded a silver medal at the Universal Exhibition of 1900. After his period in Paris he returned to live in Sweden but made two visits to Spain. A specialist in pictures of Swedish popular life.

Willumsen, JENS FERDINAND. *Danish.* Born in Copenhagen in 1863. A pupil of Krøyer (q.v.) at the Copenhagen Academy. Also worked as a sculptor, engraver, ceramist and writer on art.

Wyczolkowski, LEON. *Polish.* Born 1852; died 1936. He studied at Warsaw, then at Munich and finally at Cracow. He became professor, in 1897, at the Academy in Cracow. One of his lithographs won a silver medal at the Paris Salon of 1900.

Zo, HENRI. *French.* Born 1873; died 1933. He was a pupil of Bonnat, and exhibited at the Salon from 1895 onward. He was awarded a silver medal at the Universal Exhibition of 1900, and became chevalier of the Legion of Honor in 1910. He painted decorations for the Opéra Comique in Paris. As an easel-painter he specialized in Spanish popular scenes.

Zorn, ANDERS LEONARD. *Swedish.* Born 1860; died 1920. He studied at the Academy in

Stockholm, then went to Spain. By 1882 he was in London, where he remained until 1884, exhibiting at the R.A. He then returned to the Iberian Peninsula, reaching Sweden again in 1885. He first exhibited in Paris at the Salon of 1888 and was given the Legion of Honor the next year. From 1888 to 1896 Zorn lived in Paris and was an immensely fashionable portraitist. He also visited America on numerous occasions, where he found many wealthy sitters. After 1896 he returned to Sweden and settled there permanently.

Zwiller, MARIE AUGUSTIN. *French.* Born in 1860. He was first an industrial designer, then a teacher of drawing at Mulhouse in Alsace. Later he studied at the Beaux-Arts under Lefebvre. He exhibited at the Salon from 1882 onward. He was awarded a bronze medal at the Universal Exhibition of 1900, and became chevalier of the Legion of Honor in 1910. He specialized in scenes of Alsatian life.

Index of Illustrations

243

16. J. F. Raffaeli: At the Bronze Foundry
1886—49·5 × 49·1″ (126 × 115 cm)
Lyon, Musée des Beaux Arts

17. A. von Menzel: The Knife Grinder
1881—12·3 × 16·3″ (31·5 × 41·5 cm)
Hamburg, Kunsthalle

18. C. Mertens: The Wafer Seller
189?—28·2 × 36·1″ (72 × 92 cm)
Antwerp, Kunstmuseum

19. M. Liebermann: The Cobbler's Shop
1881—25·1 × 31·2″ (64 × 79·5 cm)
Berlin, Staatliche Museen

20. G. Caillebotte: Finishing the Floorboards
1875—size unobtained
Paris, Louvre Museum

21. F. Brownell: The Photographer
1896—23·2 × 19·5″ (59 × 49·5 cm)
Ottawa, National Gallery of Canada

22. W. Tornoe: The China Repairer
1891—24·7 × 30·6″ (63 × 78 cm)
Copenhagen, Kunstmuseum

23. G. Toma: The Poor Man's Family
Date unknown—28·2 × 40·8″ (72 × 104 cm)
Courtesy Christies

24. A. Struys: Visiting the sick
c. 1895—size unknown
Whereabouts unknown

25. J. S. Sargent: The Bead Stringers of Venice
Undated—22 × 32·2″ (56 × 82 cm)
Dublin, National Gallery of Ireland

26. M. von Munkaczy: Charpie Makers
1871—56 × 77·2″ (142·2 × 196·2 cm)
Budapest, Hungarian National Gallery

27. M. Liebermann: Women working at a canned
food factory
1879—19·2 × 25·7″ (49 × 65·5 cm)
Leipzig, Museum für Bildenden Künste

28. J. Miralles: Curtain Seamstresses
c. 1891—21·1 × 39·3″ (64 × 100 cm)
Barcelona, Museo de Arte

29. A. Zorn: The Large Brewery
1890—26·7 × 39·3″ (68 × 100 cm)
Göteborg, Konstmuseum

30. E. Rosset-Granger: The Sugar Crushing
Machine
1891—size unknown
Whereabouts unknown

31. S. Melton-Fisher: Clerkenwell Flower-makers
c. 1902—size unknown
Whereabouts unknown

32. A. J. Archipov: Laundry Women
1901—35·7 × 27·5″ (91 × 70 cm)
Moscow, Gretyakov Gallery

33. E. Harburger: The Seamstress
1887—size unknown
Whereabouts unknown

34. L. J. Anthonissen: Ironing at Trouville
1888—23·7 × 32·6″ (60·5 × 83 cm)
Pau, Musée des Beaux Arts

35. R. Gérin: The Manicure
c. 1896—size unknown
Whereabouts unknown

36. M. von Munkaczy: The Pawnbroker
c. 1891—64 × 86·2″ (162·5 × 219 cm)
New York, Metropolitan Museum

37. F. Henningsen: The Pawnshop
1893—35·3 × 53·9″ (90 × 137 cm)
Copenhagen, Konstnueum

38. F. Henningsen: Evicted Tenants
1892—62 × 86·4″ (158 × 220 cm)
Copenhagen, Konstmuseum

39. S. A. Forbes: By Order of the Court
Date unknown—size unknown
Liverpool, Walker Art Gallery

40. L. Fildes: Applicants for admission to a Casual
Ward
1874—54 × 96″ (137·1 × 243·8 cm)
Egham, Royal Holloway College

41. A. Stevens: Licensed Begging
Undated—50·3 × 39·3″ (128 × 100 cm)
Antwerp, Royal Museum of Fine Art

42. J. Adler: The Mother
1899—size unknown
Whereabouts unknown/photo Giraudon

43. J. Soriano Fort: Hopeless
c. 1897—size unknown
Whereabouts unknown

44. H. Alberti: Winter morning: collecting the
homeless
c. 1898—size unknown
Whereabouts unknown

45. E. Larock: The Village Idiot
1892—58·1 × 47·5″ (148 × 121 cm)
Antwerp, Royal Museum of Fine Art

46. E. Larock: Picking coal from the tip
Undated—26·7 × 42·4″ (68 × 108 cm)
Antwerp, Royal Museum of Fine Art

47. M. von Munkaczy: Arrest of the Night Tramps
1872—63·4 × 86·4″ (161·5 × 220 cm)
Budapest, Hungarian National Gallery

48. F. Holl: Newgate, Committed by Trial
1878—61·2 × 84·7″ (155·5 × 215·2 cm)
Egham, Royal Holloway College

49. J. Béraud: St. Lazare prison, the girls' room
1886—size unknown
Whereabouts unknown

50. J. Béraud: The Public Meeting
1884—size unknown
Whereabouts unknown

51. K. Kernstok: The Agitator
1897—66·5 × 86·6″ (168·9 × 220 cm)
Budapest, Hungarian National Gallery

52. I. Repin: Arrest of the Revolutionary
1880/89—Size unknown
Moscow, Tretyakov Gallery

53. L. H. Jonas: The "Roufions"—A strike at Anzin
c. 1907—size unknown
Whereabouts unknown

54. L. Bokelmann: Strike
1888—size unknown
Whereabouts unknown

55. D. Hardy: The Dock Strike, London 1889
1890—size unknown
Whereabouts unknown

56. J. MALCZEWSKI: A Step Nearer Siberia
1883—16.7 × 20.2″ (22.5 × 51.5 cm)
Warsaw, National Museum

57. J. MALCZEWSKI: On their way to Siberia
1896—size unknown
Whereabouts unknown

58. Artist unknown: The Prisoner in his cell
Moscow, Tretyakov Gallery

59. D. LUBIN: Judicial Inquest at the Village
1886—size unknown
Whereabouts unknown

60. S. BIHARI: A Speech to the Electors
Date and size unknown
Whereabouts unknown

61. M. ANGEL: The Contractor's Inspection
c. 1897—size unknown
Whereabouts unknown

62. B. VAUTIER: The Landlord's Visit
1871—31.4 × 53.8″ (80 × 137 cm)
Whereabouts unknown

63. Artist unknown: A Russian landlady
Moscow, Tretyakov Gallery

64. H. GUINIER: Dedicated to the Virgin
c. 1898—size unknown
Whereabouts unknown

65. J. BRUNET: The Newlyweds Return Home
c. 1892—size unknown
Whereabouts unknown

66. A. FOURIÉ: A wedding lunch at Yport
1886—size unknown
Musée de Rouen

67. J. CHARLES: Signing the marriage register
c. 1895—93.6 × 70.5″ (237.8 × 179 cm)
Bradford Art Gallery

68. E. BULAND: Homage to the Virgin, the day after
the wedding
1885—size unknown
Whereabouts unknown

69. C. BOKELMANN: The Christening
c. 1892—41.2 × 58.9″ (105 × 150 cm)
Liège Musée des Beaux Arts

70. L. A. DÉCHENAUD: The Golden Wedding
1909—65.2 × 80.5″ (166 × 205 cm)
Dijon, Musée des Beaux Arts

71. L. LHERMITTE: Washerwomen
1891—size unknown
Whereabouts unknown

72. E. CLAUS: The Flax Field
1887—50.3 × 77.8″ (128 × 198 cm)
Antwerp, Royal Museum of Fine Art

73. H. F. SALMSON: Picardy—the Beetroot Field
1879—size unknown
Whereabouts unknown

74. E. CARPENTIER: Washing the turnips
Undated—51 × 76.6″ (130 × 195 cm)
Liège, Musée des Beaux Arts

75. L. LHERMITTE: The Gleaners
1877—size unknown
Whereabouts unknown

76. C. E. JACQUE: The Large Flock
1880—102.2 × 82.5″ (259.7 × 209.5 cm)
Norfolk, Chrysler Art Museum

77. F. TATTEGRAIN: Artois—The Burning Farm
c. 1893—size unknown
Whereabouts unknown

78. E. JÀRNEFELT: Fighting the forest fire
1893—51.4 × 65.8″ (131 × 167.5 cm)
Helsinki, Ateneum

79. L. WYCZOTKOWSKI: Fishermen
1891—size unobtained
Warsaw, National Gallery

80. W. CRUIKSHANK: Breaking a Road
1894—35 × 68″ (88.9 × 172.7 cm)
Ottawa, National Gallery of Canada

81. J. TIRÉN: Collecting a shot reindeer
1892—58.9 × 94.7″ (150 × 241 cw)
Stockholm, National Museum

82. F. VON DEFREGGER: Sharing the soup
1891—size unknown
Whereabouts unknown

83. W. HOMER: Hound and Hunter
Undated—28.2 × 48.1″ (71.7 × 122.2 cm)
Washington, National Gallery of Art

84. K. D. SAVITZKY: Brigands of the Volga
1874—size unknown
Whereabouts unknown

85. T. POLLOCK ANSHUTZ: The Cabbage Patch
1879—24 × 17″ (60.9 × 43.1 cm)
New York, Metropolitan Museum

86. L. DE SCHRYVER: Gardener preparing for market
1896—size unknown
Whereabouts unknown

87. L. LHERMITTE: The Harvesters' Payday
1882—size unknown
Château-Thierry Town Hall/photo Bulloz

88. S. A. FORBES: Lighting-up Time
c. 1901—48 × 68″ (121.9 × 172.7 cm)
Whereabouts unknown

89. G. BERNDTSON: A Rest on the way to the fair
1886—33.6 × 46.1″ (85.5 × 117.5 cm)
Helsinki, Ateneum

90. L. LHERMITTE: The Apple Market, Landerneau
c. 1878—33.7 × 47.2″ (85.7 × 120 cm)
Philadelphia Museum of Art

91. H. C. GOURSE: Pig Market in the Pyrenees
1900—size unknown
Whereabouts unknown

92. A. SCHÖNN: Market in Cracow
1869—22 × 17.6″ (56 × 45 cm)
Wien, Ostereichische Galerie

93. J. D. COL: Barber's Day
1873—26.7 × 38.9″ (68 × 99 cm)
Antwerp, Royal Museum of Fine Art

94. A. ZORN: Midsummer Dance
1897—55 × 38.5″ (140 × 98 cm)
Stockholm, National Museum

95. L. SIMON: Walking the Greasy Pole
c. 1902—size unknown
Whereabouts unknown

96. C. GIRON: Wrestlers' Festival in the Swiss Alps
c. 1906—size unknown
Whereabouts unknown

97. O. BJÖRCK: Feeding the Cows
1890—41.2 × 55″ (105 × 140 cm)
Stockholm, National Museum

98. M. LIEBERMANN: Plucking the Geese
1872—46·9 × 67″ (119·5 × 170·5 cm)
Berlin, Staatliche Museen

99. A. DECAMPS: The Apprentice Weaver
c. 1896—45·1 × 55″ (115 × 140 cm)
Abbeville, Musée Boucher de Perthes

100. W. LEIBL: The Spinner
1892—25·5 × 29″ (65 × 74 cm)
Leipzig, Museum für Bildende Künste

101. M. LIEBERMANN: The Flax Barn at Laren
Date unknown—size unknown
Whereabouts unknown

102. M. LIEBERMANN: Weavers
Undated—22·4 × 30·6″ (57 × 78 cm)
Frankfurt, Städelsches Kunstinstitut

103. N. BOGDANOV-NELSKI: Home
Undated—55·4 × 43·6″ (141 × 111 cm)
Warsaw, National Gallery

104. A. GALLEN-KALLELA: The Sauna
1899—47·1 × 31·8″ (120 × 81 cm)
Helsinki, Ateneum

105. H. SCHMIDT: The Country Grocer
1909—15·9 × 23·5″ (40·5 × 60 cm)
Copenhagen, Konstmuseum

106. W. HOMER: The Country Store
1872—11·5 × 18″ (29·2 × 45·7 cm)
Washington, Hirschhorn Museum, Smithsonian Institution

107. A. SCHLABITZ: Church Choir in the Tyrol
c. 1890—size unknown
Whereabouts unknown

108. M. B. VIVES: The Sermon
1907—63·6 × 70·7″ (162 × 180 cm)
New York, the Hispanic Society

109. A. ANKER: The Apothecary
1879—31·4 × 48·7″ (80 × 124 cm)
Basel, Kunstmuseum

110 J. J. GEOFFROY: The Doctor's Round—Infants Clinic
Date unknown—size unknown
Paris, Musée de l'Assistance Publique

111. A. PERRET: The Prizes
1890—size unknown
Whereabouts unknown

112. A. ANKER: The Village School
1896—40·8 × 68·9″ (104 × 175·5 cm)
Basel, Offentliche Kunstsammlung

113. R. JOURDAIN: Monday
c. 1878—size unknown
Whereabouts unknown

114. W. SMITH: Osteria
1902—59·3 × 78·6″ (151 × 200 cm)
Stockholm, National Museum

115. R. COGGHE: Flemish Bowls
1897—size unknown
Whereabouts unknown

116 L. VAN AKEN: Archers
c. 1901—55 × 72·3″ (140 × 184 cm)
Antwerp, Royal Museum of Fine Art

117. A. J. BAIL: The Wind Band
1881—40·8 × 58·1″ (104 × 148 cm)
Lyon, Musée des Beaux Arts

118. C. WILHELMSON: Church-goers in a boat
1909—72·7 × 77″ (185 × 196 cm)
Stockholm, National Museum

119. E. B. HIRSHFIELD: Procession of Our Lady of the Sea
c. 1900—size unknown
Whereabouts unknown

120. I. REPIN: Procession
Date unknown—size unknown
Moscow, Tretyakov Gallery

121. A. GIERYMSKI: Jewish Religious Celebration, Warsaw
1888—39·6 × 51·8″ (101 × 132 cm)
Warsaw, National Gallery

122. F. VAN LEEMPUTTEN: Distribution of Bread at the Village
1892—25·1 × 30·6″ (64 × 78 cm)
Antwerp, Royal Museum of Fine Art

123. I. RÍVÉZ: Panem
1899—72·3 × 88·4″ (184 × 225 cm)
Budapest, Hungarian National Gallery

124. A. HAGBORG: Funeral in Normandy
c. 1893—size unknown
Whereabouts unknown

125. A. PERRET: The Viaticum, Burgundy
1879—size unknown
Whereabouts unknown

126. B. M. MAXIMOV: The Death Bed
1881—size unobtained
Moscow, Tretyakov Gallery

127. A. EDELFELT: The Child's Funeral
1879—47·1 × 80·5″ (120 × 205 cm)
Helsinki, Ateneum

128. C. DALSGAARD: Inspecting the gravestone
1873—38·3 × 41·4″ (97·5 × 105·5 cm)
Copenhagen, Konstmuseum

129. A. GIERYMSKI: The Child is dead
1894—55 × 76·2″ (140 × 194 cm)
Warsaw, National Gallery

130. P. DAGNAN-BOUVERET: Conscripts
1890—size unknown
Whereabouts unknown

131. E. CHAPERON: The Photographer at the Barracks
1899—size unknown
Whereabouts unknown

132. E. CHAPERON: Shower at the Barracks
1887—size unknown
Whereabouts unknown

133. J. THORMA: On October 1st
1903—60·7 × 84·4″ (154·5 × 215 cm)
Budapest, Hungarian National Gallery

134. L. E. BAILLE: Happy memories of soldiering
1887—size unknown
Whereabouts unknown

135. V. ROSENSTAND: Outside the "A Porta" Café
1882—34·9 × 27·5″ (89 × 70 cm)
Stockholm, National Museum

136. D. LUBIN: Back Home
1887—size unknown
Whereabouts unknown

137. E. NICOL: An Irish emigrant landing at Liverpool
1871—55·7 × 39·7″ (141·6 × 100·9 cm)
Glasgow Art Gallery

138. J. SOROLLA Y BASTIDA: The Railway Waiting
Room
1895—size unknown
Whereabouts unknown

139. J. EXNER: The Third-Class Coach
1890—29·4 × 42″ (75 × 107 cm)
Copenhagen, Konstmuseum

140. P. BORGMANN: Going to America
c. 1888—size unknown
Whereabouts unknown

141. A. P. DAWANT: Emigrants ready to embark,
Le Hâvre
1887—size unknown
Whereabouts unknown

142. L. VAN ENGELEN: The Belgian Emigrants
1890—101·3 × 155·2″ (258 × 395 cm)
Antwerp, Royal Museum of Fine Art

143. W. HOMER: The Gulf Stream
1899—28·5 × 49·1″ (72·3 × 124·7 cm)
New York, Metropolitan Museum

144. F. BRANGWYN: Harpooning the Whale
c. 1895—22·2 × 30·5″ (56·5 × 77·4 cm)
Adelaide, Art Gallery of South Australia

145. F. TATTEGRAIN: The Stolen Nets, Herring Season
c. 1905—size unknown
Whereabouts unknown

146. E. HIRSCHFELD: Blessing of the New Boat
c. 1898—size unknown
Whereabouts unknown

147. C. NAPIER-HEMY: Pilchards
c. 1897—size unknown
Whereabouts unknown

148. E. DANTAN: Drying the nets, Villerville
c. 1886—size unknown
Whereabouts unknown

149. G. KUEHL: The Sail Maker
Undated—64·4 × 51·8″ (164 × 132 cm)
Lübeck, Museum für Kunst

150. F. SKARBINA: Smoking the Fish
1888—27·1 × 39·1″ (69 × 99·5 cm)
Warsaw, National Gallery

151. P. S. KRØYER: The Fishermen's Café
1882—30·6 × 43·2″ (78 × 110 cm)
Copenhagen, Hirschsprung Collection

152. G. A. DEMAREST: Back from Iceland
c. 1899—size unknown
Whereabouts unknown

153. H. S. TUKE: All hands to the pumps
1889—73 × 56″ (185·4 × 142·2 cm)
Greenwich, National Maritime Museum

154. F. BRANGWYN: Funeral at Sea
189?—61 × 92″ (155 × 234 cm)
Glasgow Art Gallery

155. M. ANCHER: Lifeboat taken through the dunes
1883—67·2 × 86·8″ (171 × 221 cm)
Copenhagen, Konstmuseum

156. J. R. REID: Rescued from the wreck
c. 1890—size unknown
Whereabouts unknown

157. J. A. MUENIER: The Pedlar
c. 1894—size unknown
Whereabouts unknown

158. S. BIHARI: Before the Justice of the Peace
1886—43·7 × 65·7″ (111·1 × 167 cm)
Budapest, Hungarian National Gallery

159. P. M. BEYLE: School of Misery—preparing the show
1894—size unknown
Whereabouts unknown

160. J. G. HUBERT-SAUZEAU: Circus Wrestlers
c. 1899—size unknown
Whereabouts unknown

161. J. VEBER: Wrestlers in Devonshire
1899—size unknown
Whereabouts unknown

162. C. GREEN: Country Circus
c. 1897—size unknown
Whereabouts unknown

163. N. FORSBERG: Auditioning for the Circus Director
1878—56·9 × 84·2″ (145 × 214·5 cm)
Göteborg, Konstmuseum

164. R. RIBERA: Art in Misery
1873—size unknown
Whereabouts unknown

165. V. GILBERT: The Song Pedlar
1886—size unknown
Whereabouts unknown

166. J. VAN BEERS: The Fallen Star
c. 1878—size unknown
Whereabouts unknown

167. E. MENTA: Umbrella Repairer in the South of
France
c. 1895—size unknown
Whereabouts unknown

168. L. SCHRYVER: Vegetable-stall holder
c. 1895—size unknown
Whereabouts unknown

169. L. LHERMITTE: Les Halles de Paris
1895—size unobtained
Paris, Petit Palais/photo Bulloz

170. L. JIMÉNEZ: The "Carreau du Temple"
1890—size unknown
Whereabouts unknown

171. J. J. ROUSSEAU: Soup Stall, Les Halles,
Winter Morning
1897—size unknown
Whereabouts unknown

172. L. LOIR: The Junk Market
1896—size unknown
Whereabouts unknown

173. E. GRANDJEAN: The Horse Market in Paris
1888—size unknown
Whereabouts unknown

174. V. CAPRILE: Easter Market at Naples
c. 1896—size unknown
Whereabouts unknown

175. E. JACQUE: Garbagemen
1901—size unknown
Whereabouts unknown

176. H. BACON: Equals
1889—size unknown
Whereabouts unknown

177. N. SICARD: The Bridge of the Guillotière, Lyon
1879—39·3 × 25·1″ (100 × 64 cm)
Lyon, Musée des Beaux Arts

178. E. HENNINGSEN: The Changing of the Guard
1888—35·5 × 58·5″ (90·5 × 149 cm)
Copenhagen, Konstmuseum

179. A. CHEVALIER-TAYLER: The Viaticum
c. 1903—31 × 60″ (78·7 × 152·4 cm)
Whereabouts unknown

180. E. DETAILLE: Victims of Duty
c. 1894—size unknown
Whereabouts unknown

181. R. CHOQUET: Poor Animal!
1899—size unknown
Whereabouts unknown

182. E. SEKLDRAYERS: At the Vet's
c. 1892—size unknown
Whereabouts unknown

183. L. ROSSI: In the Old Town, Milan
Date and size unobtained
Milan, Cassa di Risparmio

184. P. G. JEANNIOT: The Absinthe Drinker
1893—size unknown
Whereabouts unknown

185. J. PAGES: The Bistro
c. 1905—size unknown
Whereabouts unknown

186. M. A. ZWILLER: "Ears they have, but they hear not"
1896—size unknown
Whereabouts unknown

187. G. CEDERSTRÖM: Miss Booth Visiting a Paris Café
1886—63 × 86·2″ (160·5 × 219·5 cm)
Göteborg, Konstmuseum

188. V. MAREC: "Better here than over there"—after the funeral
1886—size unknown
Whereabouts unknown

189. J. E. HARRIS: Matinée at the Gaîté Montparnasse
c. 1897—size unknown
Whereabouts unknown

190. E. SHINN: London Hippodrome
1902—25·5 × 34·2″ (64·7 × 86·9 cm)
Chicago Art Institute

191. H. A. ZO: Sun and Shade
1898—size unknown
Whereabouts unknown

192. G. W. BELLOWS: Stag at Sharkey's
1907—36¼ × 48¼″ (92 × 122·5 cm)
Cleveland Museum of Art

193. H. BONHAM: Nearing the issue at the cockpit
1870—size unknown
Washington, Concoran Art Gallery

194. J. TISSOT: The Shop Assistant
1883–5—57·5 × 40″ (146 × 101·5 cm)
Toronto, Ontario Art Gallery

195. J. M. JIMÉNEZ: Summer Picnic at Pontoise
c. 1901—size unknown
Whereabouts unknown

196. L. DE JONCIÈRES: Working Girls' Lunch
1901—size unknown
Whereabouts unknown

197. P. DAGNAN-BOUVERET: A Wedding Party at the Photographer's
1879—32·2 × 47·1″ (82 × 120 cm)
Lyon, Musée des Beaux Arts

198. J. SLOAN: Woman's Work
c. 1911—31·6 × 25·7″ (80·3 × 65·4 cm)
Cleveland Museum of Art, gift of Amelia Elizabeth White

199. E. DUEZ: Wet nurses feeding the sickly infants at the maternity hospital
c. 1895—size unknown
Whereabouts unknown

200. J. J. GEOFFROY: A Children's Clinic in Belleville
c. 1903—size unknown
Whereabouts unknown

201. T. LOBRICHON: Infants from the Municipal Nursery
c. 1901—size unknown
Whereabouts unknown

202. E. HERLAND: Soup at a Breton Orphanage
c. 1901—size unknown
Whereabouts unknown

203. J. J. GEOFFROY: Nursery School in Paris
1885—size unknown
Whereabouts unknown

204. L. FERRAZZI: Complimenti! Complimenti!
1889—size unknown
Whereabouts unknown

205. F. BONVIN: The Brothers' School
1873—28·7 × 36·2″ (73 × 92 cm)
Puerto Rico, Ponce Art Museum

206. J. J. GEOFFROY: Convalescents in the "Gran Chambre des Pôvres", Hospice de Beaune
c. 1904—size unknown
Whereabouts unknown

207. F. VON UHDE: The Orphanage
c. 1886—size unknown
Whereabouts unknown

208. K. FRITHJOF-SMITH: In the garden of the Alms House
c. 1888—size unknown
Whereabouts unknown

209. H. VON HERKOMER: Eventide in the Westminster General
1878—43·4 × 58·3″ (110·5 × 148·5 cm)
Liverpool, Walker Art Gallery

210. A. MORBELLI: Their Last Days
Undated—39·3 × 63·4″ (100 × 161·5 cm)
Turino, Museo Civico

211. J. BÉRAUD: The Asylum
1885—size unknown
Whereabouts unknown

212. H. BRISPOT: Fifty Years of Service
c. 1897—size unknown
Whereabouts unknown

The paintings of which whereabouts are unknown have all been reproduced in books devoted to the major exhibitions of their time. We would gratefully read any details of their location.

Photographic work at the British Library and the Victoria & Albert Museum by Miki Slingsby.